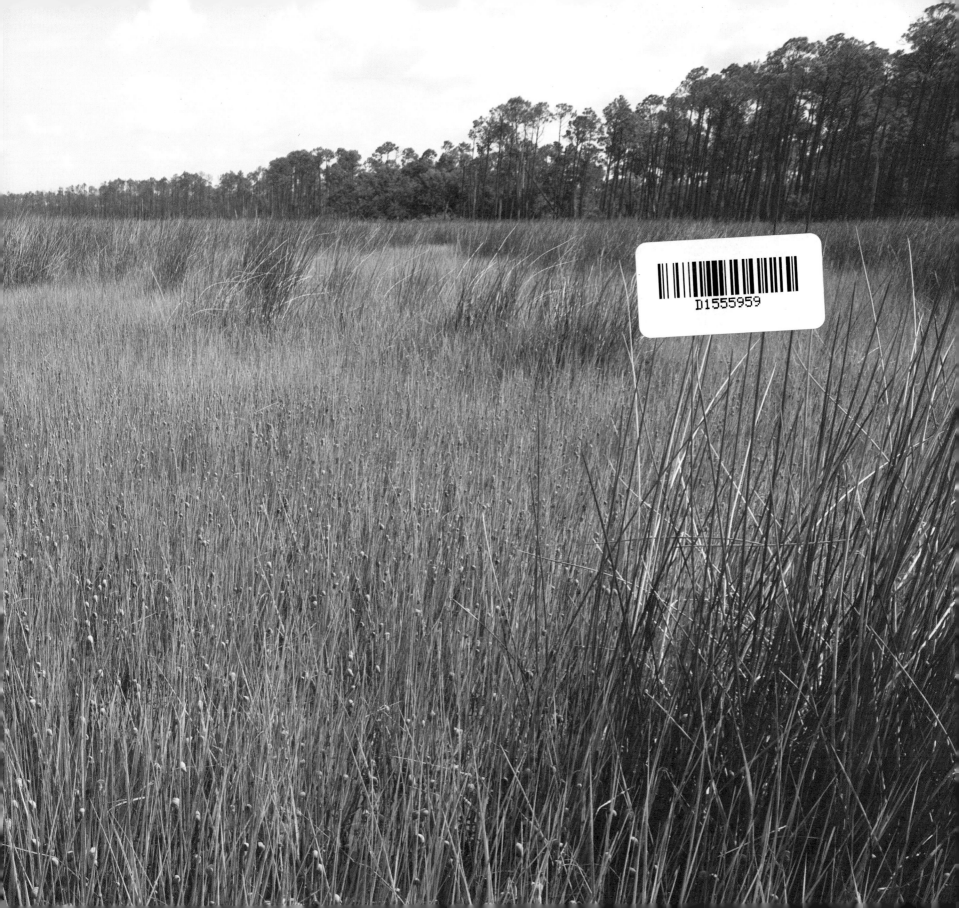

Why We Are Here

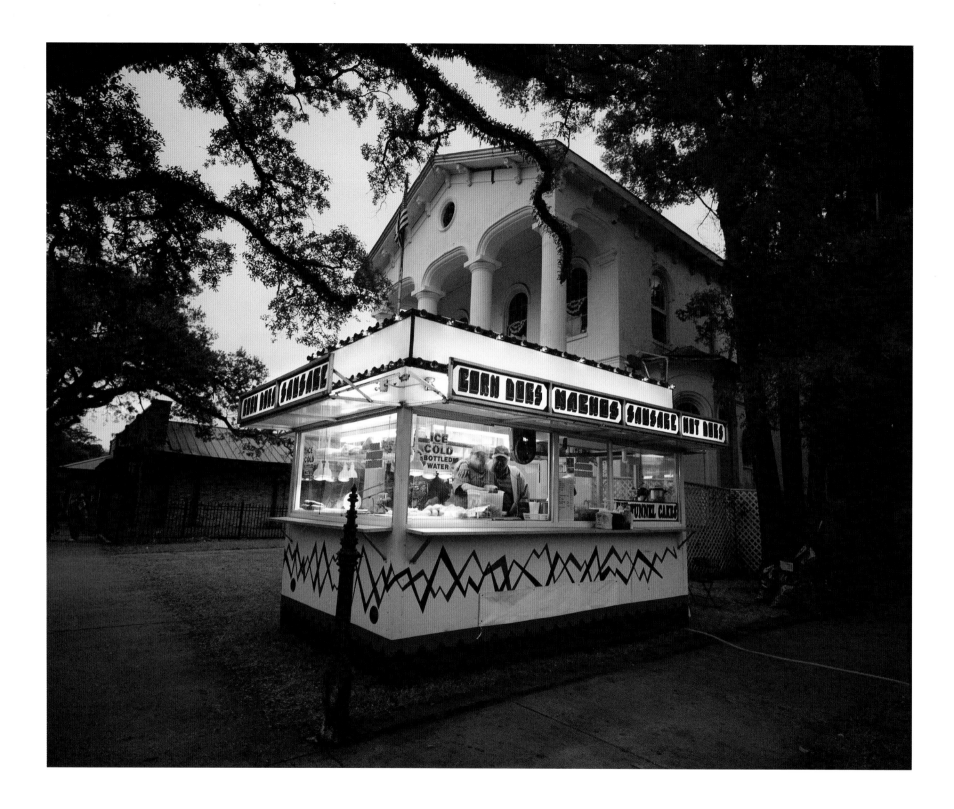

Why We Are Here

MOBILE AND THE SPIRIT OF A SOUTHERN CITY

Edward O. Wilson and Alex Harris

LIVERIGHT PUBLISHING CORPORATION

A division of W. W. Norton & Company

New York • London

FRONTISPIECE:
MARDI GRAS NACHO STAND,
AMERICAN LEGION YARD,
GOVERNMENT STREET, MOBILE

Copyright © 2012 by Edward O. Wilson and Alex Harris
Maps copyright © 2012 by David Cain

For information about permission to reproduce selections from this book, write to
Permissions, Liveright Publishing Corporation, a division of W. W. Norton & Company,
Inc., 500 Fifth Avenue, New York, NY 10110

For information about special discounts for bulk purchases, please contact W. W. Norton
Special Sales at specialsales@wwnorton.com or 800-233-4830

Manufacturing by RRDonnelley Shenzhen
Book design by David Skolkin
Editorial services: George F. Thompson Publishing
Production manager: Julia Druskin

Library of Congress Cataloging-in-Publication Data

Wilson, Edward O.
Why we are here : Mobile and the spirit of a Southern city / Edward O. Wilson and Alex
Harris. — 1st ed.
 p. cm.
Includes bibliographical references.
ISBN 978-0-87140-470-1 (hardcover)
1. Mobile (Ala.) — Description and travel. 2. Mobile (Ala.) — Pictorial works. 3. Natural
history — Alabama — Mobile. 4. Wilson, Edward O. — Homes and haunts — Alabama —
Mobile. 5. Wilson, Edward O. — Family. 6. Mobile (Ala.) — Biography. 7. Mobile (Ala.) —
Social life and customs. 8. Social change — Alabama — Mobile — History. I. Harris, Alex,
1949— II. Title.
F334.M6W55 2012
976.1'22 — dc23

2012012405

Liveright Publishing Corporation
500 Fifth Avenue, New York, N.Y. 10110
www.wwnorton.com

W. W. Norton & Company, Ltd.
Castle House, 75/76 Wells Street, London W1T 3QT

1 2 3 4 5 6 7 8 9 0

People must belong to a tribe; they yearn to have a purpose larger than themselves. We are obliged by the deepest drives of the human spirit to make ourselves more than animated dust, and we must have a story to tell about where we came from, and why we are here.

—EDWARD O. WILSON,
CONSILIENCE: THE UNITY OF KNOWLEDGE

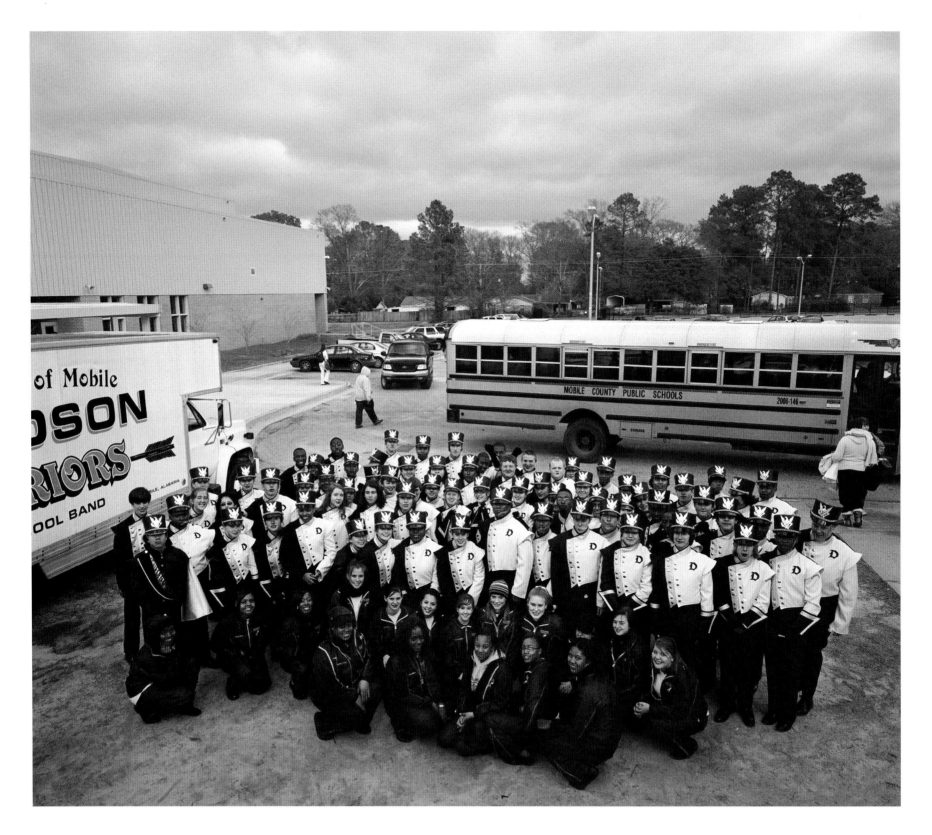

DAVIDSON HIGH SCHOOL BAND, MOBILE

Contents

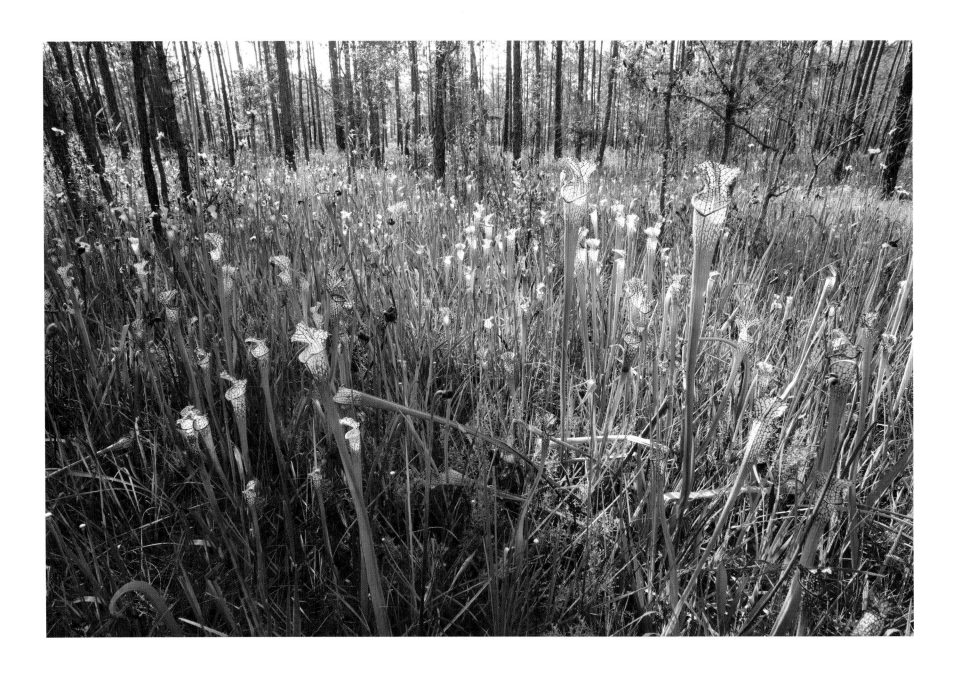

WHITE TOP PITCHER PLANTS, SPLINTER HILL BOG, BALDWIN COUNTY

Introduction

EDWARD O. WILSON

M<small>Y ENTIRE ADULT LIFE</small> has been spent at Harvard University, first as a graduate student and then as a professor, far from my home state of Alabama, far from the environment in Mobile and Tuscaloosa that shaped my passions and character. Life at Harvard has thus been less than a fully satisfying existence. Admire it, yes, thrive there as a scientist and teacher, of course; but I found it impossible to fall in love with Harvard. Harvard, like ethnic and class-ridden Greater Boston around it, is too much like New York City—too big, too fragmented, too complicated, and too little endowed with a sense of common heritage.

Over the years, I grew to thinking about the difference between my two homes—one familiar and one adopted—and decided that I am not a Harvard professor who was born and grew up in Alabama; I am an Alabamian who, like tens of thousands of other Alabamians, went up north after World War II to work. Now, at this time in my life and career, it is natural to return to where my heart has always lived, close to the memory of Mobile's landscapes and my people.

This emotional exile of living up north came to an end, at least partially, when I met Alex Harris. A native of Atlanta, a founder of the documentary studies program at Duke University, and one of America's great thematic photographers, Alex made it possible for me to go home again. In early meetings, we perceived that Mobile is a city small enough to be encompassed

intellectually and old enough to have experienced a full epic cycle of tragedy and rebirth. It remains endearingly idiosyncratic yet tied to distinct regions: the central Gulf Coast, roughly from New Orleans to Tallahassee, and the larger South, from Houston and Little Rock to Louisville, Richmond, Savannah, and Orlando.

At various times over a two-year period, while I revisited Mobile's history and Alex photographed its contemporaneity, we visited Mobile separately and together. We talked a great deal about the people and culture and how both the city and its physical setting came to be. Our aim was to cut more deeply than a traditional documentary description about a place. We wanted to express Mobile's impact on the senses, to capture its mood and its ambience and—all together, if you will—its spirit: all the attributes that made me miss Mobile from my home at Harvard and all the events that make Mobile unique today among cities in the American South.

As time passed, Alex and I realized something else: to achieve our goal we would need to meld into a single work two of the creative arts, literature and photography. That task became feasible when we recognized that each of the two arts is a separate dimension and is expressed at a very different degree of resolution. History, as expressed in narrative non-fiction, is inevitably a long passage of time told in fragments and, at times, sweeping observations. Thematic photography, in contrast, though planned, is instantaneous and minutely exact in composition and detail. But both arts ultimately reveal a picture whose individual components present an overall sense of place: a continuum, as when remembrance of a person's life leads to the instantaneity of conscious thought and the gift of enlightenment.

I spoke of this quest when I wrote, in *Consilience: The Unity of Knowledge*, about the need for all human beings to have a story that tells about where we come from and why we are here. Alex Harris and I are pleased to share with you our story about a place called Mobile.

A Sense
of Place

BY ALEX HARRIS

MOBILE BAY AT FAIRHOPE

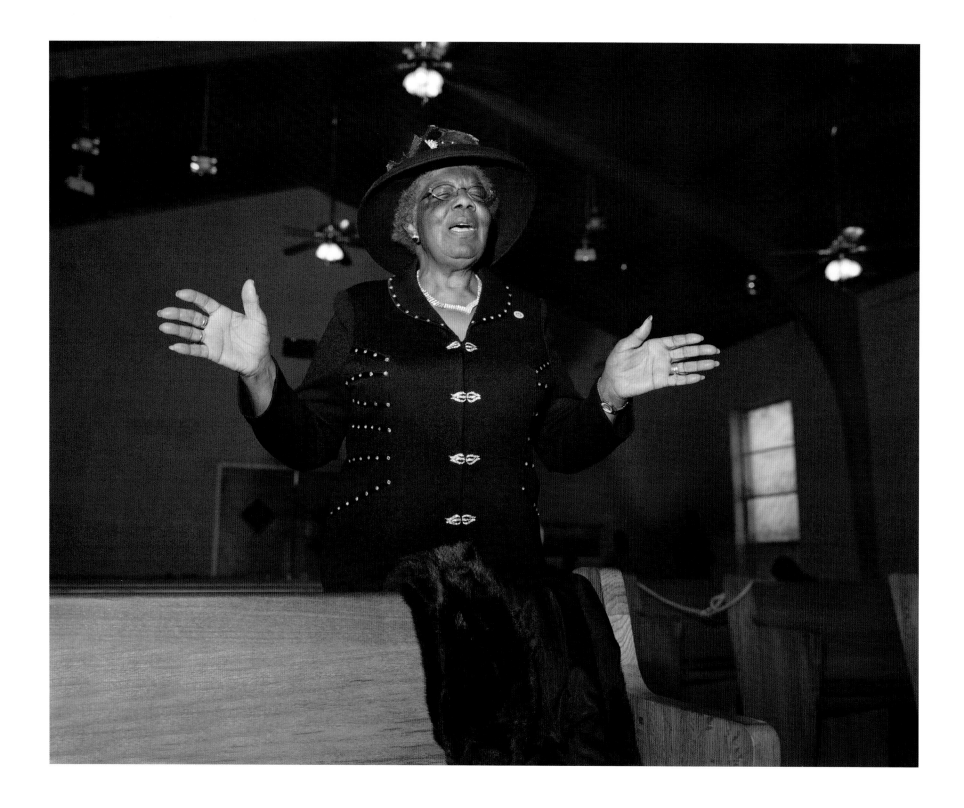

WORD OF LIFE COMMUNITY CHURCH, SOUTH ATMORE AVENUE, MOBILE

ROBERT HUNTER, SPRING HILL

THE EDGE OF GRAND BAY, MOBILE

MARDI GRAS TRAILER PARKING UNDER I-10, MOBILE

DAVIDSON HIGH SCHOOL BAND MEMBERS KELANTE BUSKEY AND CLIFFORD ATCHISON, BEFORE THE ORDER OF LASHE MARDI GRAS PARADE, MOBILE

UMS-WRIGHT BULLDOGS FOOTBALL PRACTICE, MOBILE

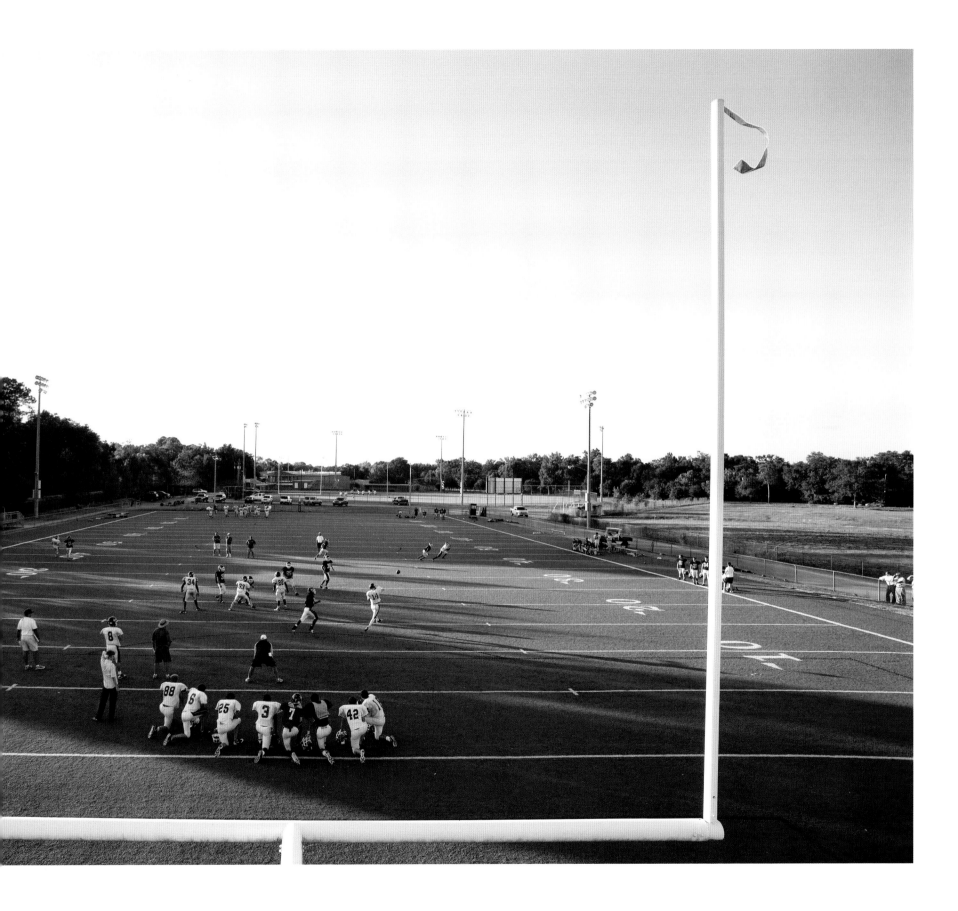

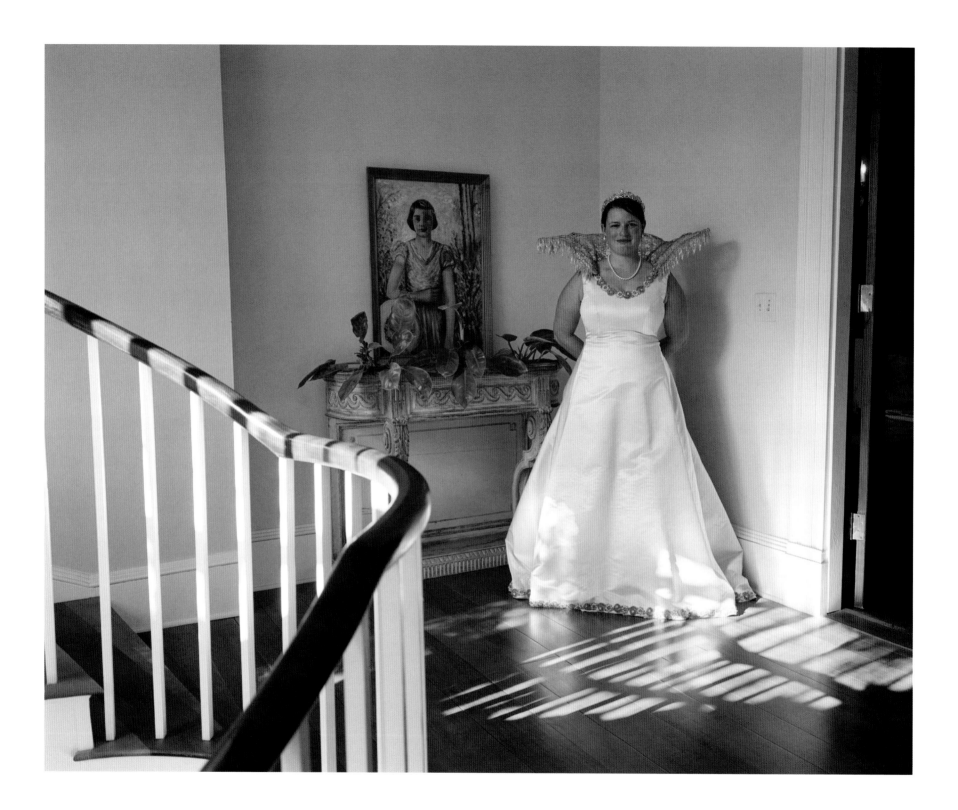

MARGARET LANGDON HAMILTON IN HER MARDI GRAS GOWN, MOBILE

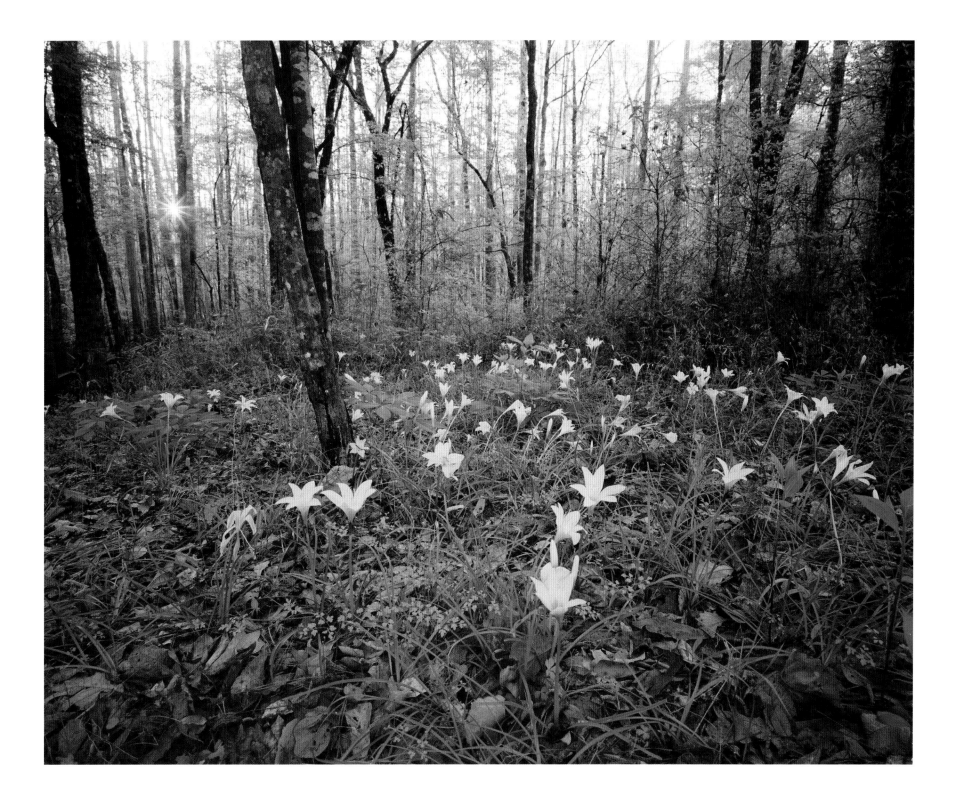

ATAMASCO LILLIES, MUD SWAMP AT HAL'S LAKE NEAR CARLTON

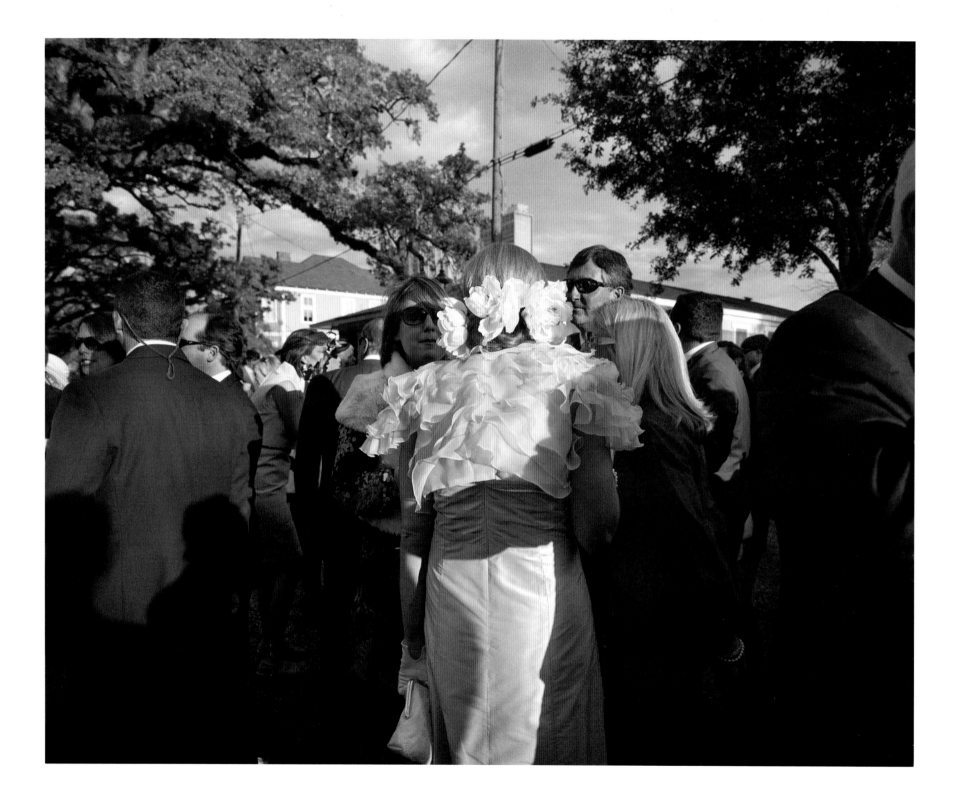

ORDER OF MYTHS PARTY, MOBILE

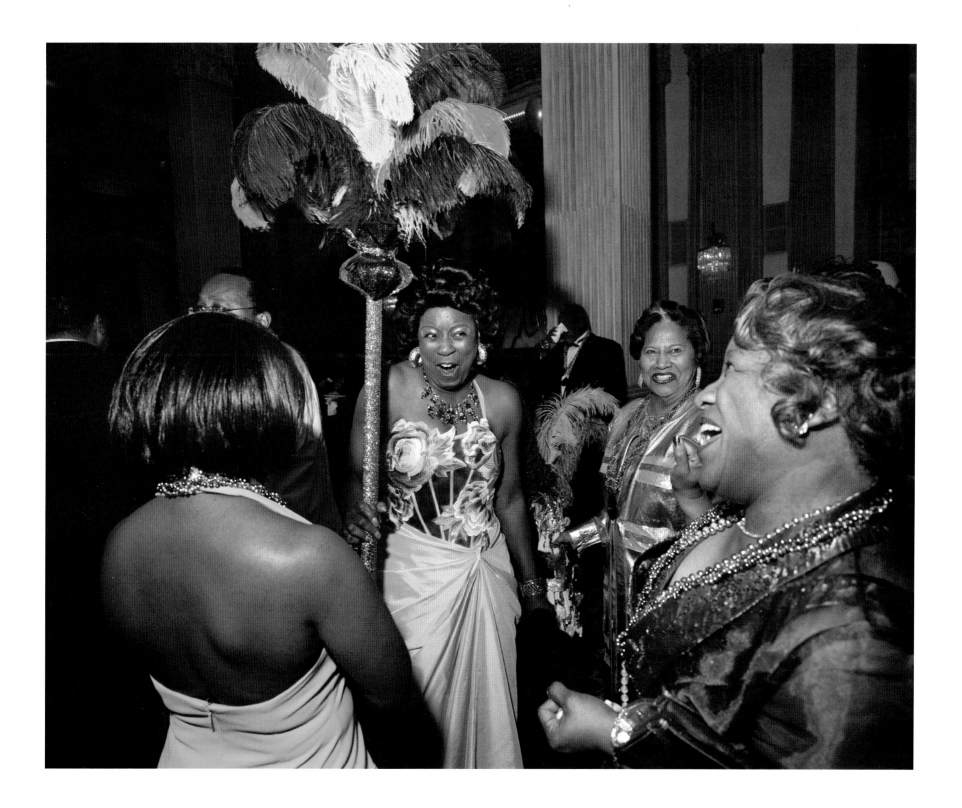

GRAND MARSHAL'S RECEPTION, BATTLE HOUSE RENAISSANCE HOTEL, MOBILE

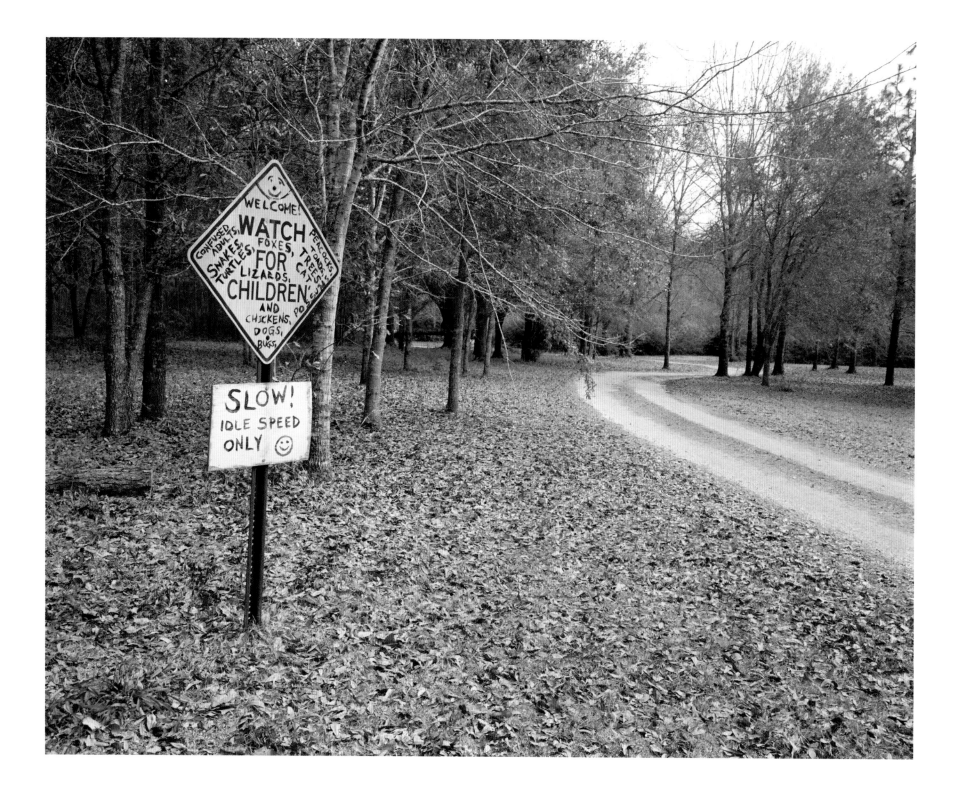

FAIRHOPE

WELCOME

I wake early—before the first revelers go looking for coffee—with photography on my mind. It's a cold February day. In fact, this is the second coldest Mardi Gras in Mobile, Alabama, since 1899.

I drive down Dauphin Street, take a right on Broad and then a left on Government. The day is overcast but getting brighter. Colorful plastic beads hang from the limbs of small trees lining the street. Food vendors are setting up hand-painted stands advertising nachos, corn dogs, and funnel cakes. One stand decorated with an eye-catching, red zigzag pattern sits like an oversized lawn ornament on the grass of the old American Legion building. I pass the Spanish Plaza, then the Carnival Museum. Everywhere city workers in their deep blue uniforms are sweeping up trash from yesterday's parades. I have my camera around my neck and consider stopping, but this morning there isn't time. I am driving out of the city to make a portrait. In some ways that appointment is a relief. With so much to photograph, it would be hard to know what to choose.

Government Street dips into the old Bankhead Tunnel, then emerges on the Old Spanish Trail Causeway. I pass the USS *Alabama*, a huge, gray World War II–era battleship and now a popular tourist attraction, then Felix's Fish Camp, famous for its seafood gumbo and crab soup. The land around the causeway narrows. To my right gray clouds make it hard to tell

where the water ends and the sky begins over the huge expanse of Mobile Bay. To my left is 300 square miles of marsh, swamp, and bottomland forest called the Mobile-Tensaw Delta, a wetland jungle just emerging in the light of a cold, misty fog. Within fifteen minutes, I've not only driven across the bay, but passed through the towns of Spanish Fort, Daphne, and Fairhope. I then drive by several farms and what's left of an old pecan orchard before turning slowly onto a dirt driveway.

Two signs—one above the other, yellow and white—are planted in the ground to the left of the road. On the yellow sign in black capital letters I see a mixture of handwritten and printed words: "Welcome. Watch for Children, confused adults, snakes, turtles, foxes, lizards, possums, peacocks, toads, trees, chickens, dogs, and bugs." The white one reads: "Slow! Idle speed only."

Here is a prescription for taking photographs for a book about Mobile and the surrounding Gulf Coast with the great naturalist and scholar of human nature Edward Wilson. At the end of this driveway and in a few minutes it will be time to make a portrait. For now I need to slow down and trust my instincts. The signs and dirt driveway will be my first photograph of the day.

CONSILIENCE

When I first set foot in Mobile, I felt as if I was coming home. Like Wilson, I grew up in the South, and I too have been deeply influenced by the layered culture and landscape of the region. Wilson and I speak the same language. From our first conversations about creating this book, it was clear we also shared an overall vision about how to collaborate and integrate our work. As a writer he would look deep and long into the history of Mobile, weaving his own story and the accounts of his Mobilian ancestors into his observations and research about the area stretching almost five centuries into the past. With my camera I would approach that history in another way, photograph-ing a cross-section of contemporary Mobilians, looking at their lives, fami-lies, institutions, and natural environment. Wilson's writing would inform my search and deepen the meaning of my pictures. My pictures would help to illuminate his words and perhaps shed light on his personal history.

In 1941, by the age of twelve, Wilson was already studying snakes and other reptiles, amphibians, birds, small mammals, and insects in the riparian and hardwood forests around Mobile. By thirteen, he'd discovered the Boy Scouts of America and was well on his way to becoming an Eagle Scout. Everything about the Scouts drew him in: the camaraderie, work ethic, competition, rules, uniforms, and, most of all, their focus on the natural world. Being a Boy Scout justified and encouraged Wilson's fascination with nature.

On my first visit to Mobile, I photographed members of three Scout troops meeting at the confluence of the Mobile-Tensaw Delta to explore the flora and fauna of Five Rivers State Park. The park sits just above the same causeway across Mobile Bay where Wilson rode his bike as a boy in search of his own natural discoveries. If being a Scout and capturing snakes were absolutely formative experiences for young Ed, then as a photographer I would try to evoke this by portraying contemporary Scouts in the same place.

When I make a photograph, I'm often asking myself a question. It can be a narrow question such as: I wonder how it feels to hold a snake? Or, if I am really on to something, the questions become broader, questions an evolutionary biologist like Wilson might ask: What advantage would it give a boy—his family, tribe, or even species—if he can overcome his natural fear of snakes? A great evolutionary biologist like Wilson looks for facts but makes leaps of discovery by thinking in metaphors. The best pictures likewise combine fact and metaphor. For instance, the subject of a picture might be four Boy Scouts and a rat snake in Mobile, Alabama, but a picture can also transcend its moment and help us to think about our evolving relationship as humans to the natural world.

Asking big questions has been at the heart of Wilson's work since, as a young teen, he began to study ants in the vacant lot next to his family home on Charleston Street in Mobile. Over the last seven decades, he has scrutinized the living creatures, plants, and processes of the Earth, and managed to weave together nothing less than a new grand narrative about life on this planet. In recent years, Wilson has returned to his research on how *Homo sapiens* became the dominant creatures on Earth, to rethink and rewrite the history of our species.

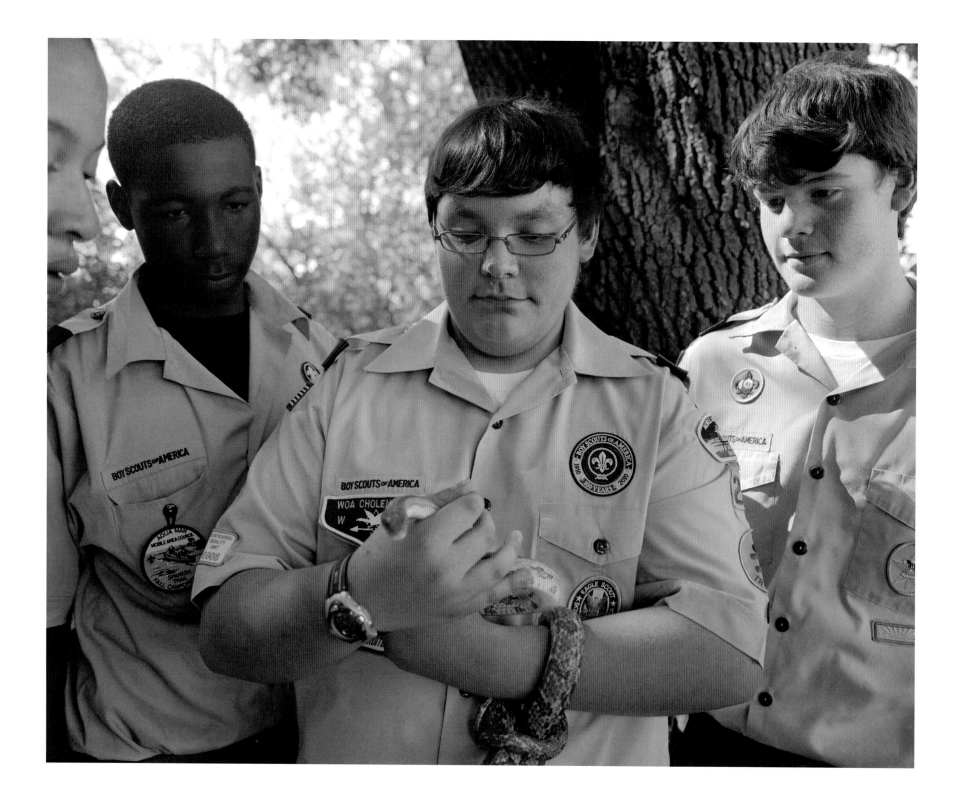

THOMAS HARING HOLDING A RAT SNAKE AT FIVE RIVERS STATE PARK, WITH *(LEFT–RIGHT)* ANTONIO HOLMES, CHRISTIAN ROBINSON, AND CONNER McCLERRY

Imagine then how Wilson might approach a study of the one place he cares about above all others. Imagine if that place were his home ground where both his mother's and father's family stories have played out over the last two centuries. And what if Wilson yearned to revisit this place that set him on his course in life as a scientist, conservationist, and writer, to look at his home again for himself—and for the rest of us—from a new perspective? These were my thoughts as I started to work with Wilson on this book.

Long before we began this collaboration, I became aware of Edward Wilson. In 1991, the University of New Mexico Press had published *River of Traps*, my book with the writer William deBuys, another combination of photographs and words that tells the story of an extraordinary man and his connection to his particular place in the world. The place is a tiny Hispanic village in northern New Mexico where the man, Jacobo Romero, knew the land as only a farmer can know his home ground. We created that book as a new kind of documentary history connected to place. *River of Traps* was nominated that year for the Pulitzer Prize in general non-fiction. When the prize was announced, I learned our book was a finalist. The winner was a scientist named Edward Wilson for a book called *The Ants.*

You could say that it has taken me twenty years to get over that defeat by Wilson and then to join forces with him for a book about his connection to his particular place in the world, to render in photographs the story of a man who knows the land as only an evolutionary biologist can know his home ground. Or you could say that together, Wilson and I are now trying to create a new kind of documentary history connected to place, as we look at a mid-sized American city in a way that has not previously been attempted.

If I were to define our joint effort succinctly, I'd use the word "consilience," popularized by Wilson himself to describe the unity of knowledge. In our book, we bring together different approaches to understanding the world, try to evoke the human condition in one place over time. Individually and collaboratively, Wilson and I combine as many perspectives as we can muster—visual and verbal, artistic and scientific, intuitive and cerebral, objective and subjective, contemporary and historical—to create a book that is as much about the meaning of place as it is about a place itself. At the heart of our efforts is the acknowledgment—expressed brilliantly and painfully by

James Agee writing late into the night from the porch of an Alabama share-cropper's cabin in 1936—that even one person's life is too complex ever to be rendered fully or completely understood. And yet it is our very human impulse to try.

I began this project with a small assignment in mind. A friend of mine and colleague of Wilson's asked if I'd take a picture in Mobile as a gift for Edward Wilson's eightieth birthday. Perhaps, he suggested, I could photograph Wilson's old Washington Square neighborhood in Mobile or find an example of the pitcher plant bogs Wilson had described visiting as a boy. I'd never met Wilson and arranged a lunch with him at Harvard where he had taught biology for almost fifty years.

The first thing I noticed about Wilson—perhaps because of the incongruous setting of the Harvard faculty club—was his Deep Southern accent and genuinely courteous manner, which suggested a bygone era. Before we'd stood with our plates at the buffet, the subject of Mobile launched Wilson into an adventure story that played out over an Alabama landscape so distinctive and vivid that the countryside itself became another character in his tale.

Over our meal in Cambridge that day, Wilson described the vast long-leaf pine forests that once surrounded Mobile and stretched across the entire Southeast, and a huge, wild river delta that flowed into a city that had waned and waxed under the flags of five different nations. As we ate, he populated his stories with snakes, fire ants, mound-building Indians, and Spanish kings. While we were drinking coffee, I could swear his Southern accent took on an even deeper inflection when the conversation turned to his family and his childhood memories of Mobile. He wove some of his own ancestors into the story of the city and beamed as he spoke about characters like his great-grandfather, William Christopher Wilson, a river pilot and Civil War blockade-runner. By the time lunch was over, I was no longer planning to take one birthday photograph. Wilson and I had decided to work on this book together.

Though I was at first unsure of my direction as a photographer in Mobile, I was often reminded of that initial conversation over lunch. People in and

LONGLEAF PINES, KNOLL PARK, FAIRHOPE

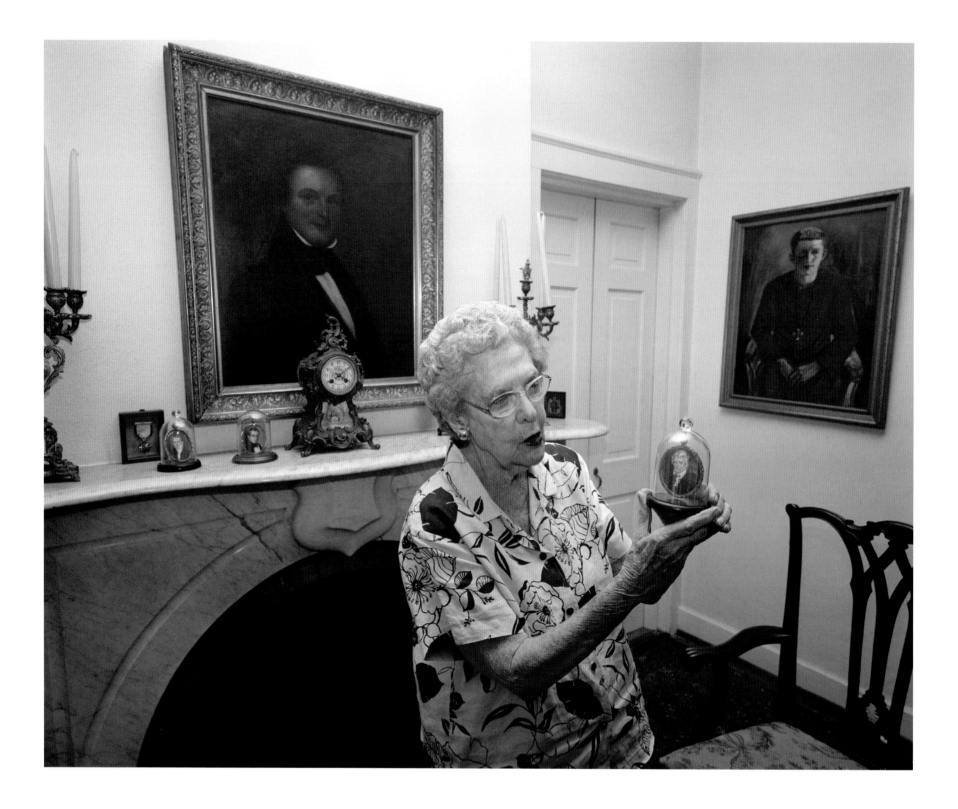

EMMA BUCK ROSS ST. JOHN, MOBILE

around the city, like Wilson, told me their histories as connected to family and to place — history, family, and place so interwoven as to be inseparable.

When, for example, Emma Buck Ross St. John gave me a guided tour of her family and ancestors by talking about the paintings and photographs lining her living-room walls, she became especially animated as she held up a miniature of her great-great-great uncle, Charles Carter Langdon, a nineteenth-century agronomist, newspaper publisher, and former mayor of Mobile (1848–51). Langdon opposed breaking away from the Union before the Civil War, she said, but once Alabama formally seceded, Langdon easily chose his allegiance. When St. John described the wounds Langdon received as a Confederate soldier, her voice held the pain and pride of a witness to the events themselves.

Sitting in his comfortable Mobile living room surrounded by his family pictures, ninety-two-year-old Walter Samples told a story stretching back to his maternal grandmother, who was born a slave in 1835. His mother, a domestic servant in Mobile, and father, a factory worker for the Armour meatpacking house there, raised seven children in the town of Whistler that now adjoins Mobile. Five of their children, including Walter, graduated from college. But the main topic of my history lesson from Walter Samples was the U.S. Postal Service in Mobile. For the forty-one years, six months, and twenty days that Samples worked for the postal service, he fought for the rights of African-American workers there to be treated fairly and to be paid equally. In Mobile, Samples helped to make history. His story and the larger struggle for civil rights in Mobile is more fully revealed in Wilson's accompanying text.

STRUCTURES

After I began to photograph in and around Mobile, I sent Wilson a book my wife and I had edited years earlier about the remote Mayan tribes of Chiapas, Mexico. In a phone call, Wilson remarked on the distinctive styles of dress and ceremonial costumes worn by each tribe. He said something to me that at the time seemed far-fetched but became clear once I'd spent time in Mobile. He said, "You know, Mobile itself is a kind of a tribal place, isolated for centuries, where people still belong to their particular groups." After our conversation, I began to look with my camera for traditional activities, customs, and rituals. I wondered if I could show in a photograph the way people still think about themselves in Mobile, and reveal the structures of a society that endure.

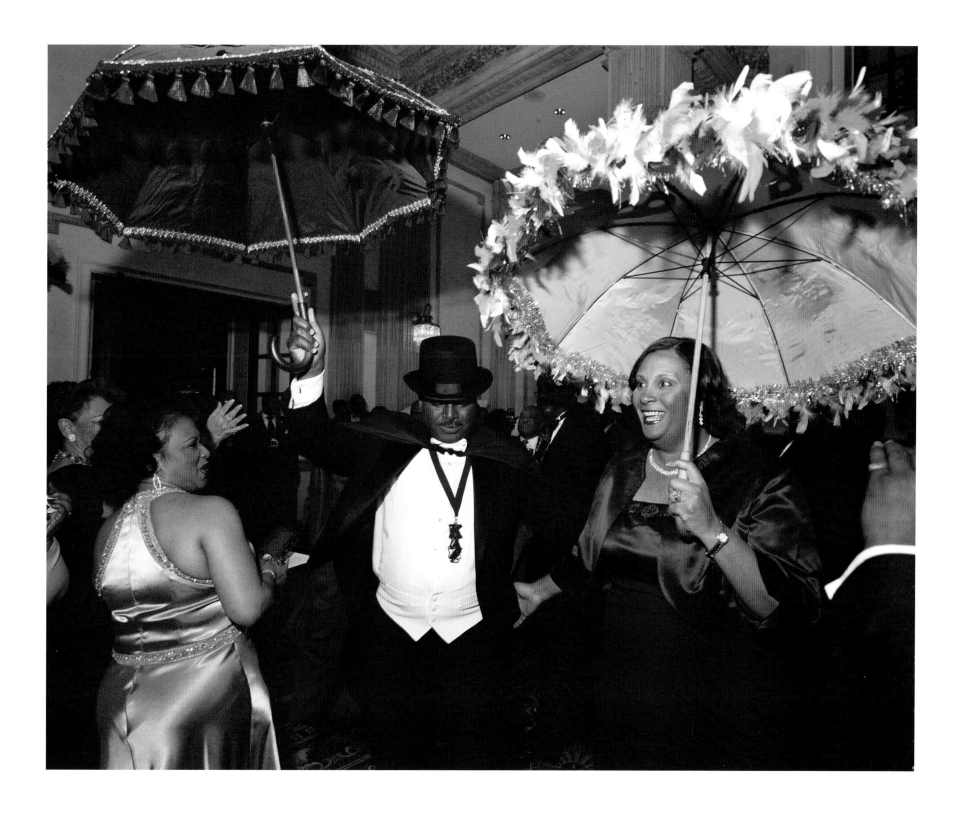

GRAND MARSHAL'S RECEPTION, BATTLE HOUSE RENAISSANCE HOTEL, MOBILE

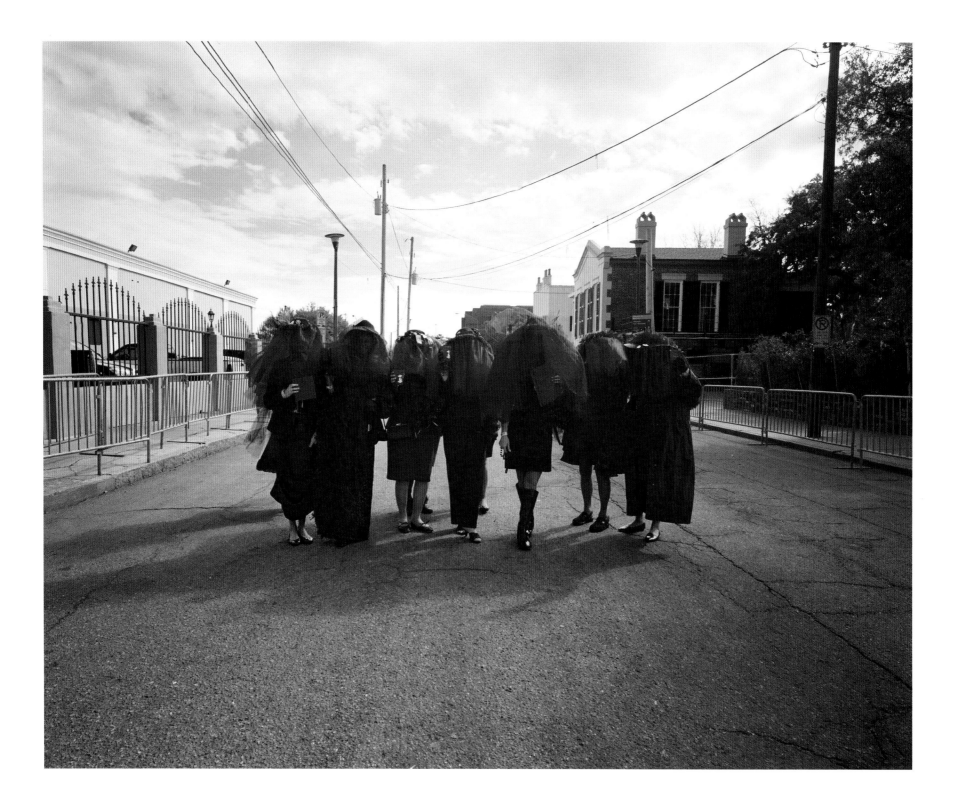

MISTRESSES OF JOE CAIN, MARDI GRAS, MOBILE

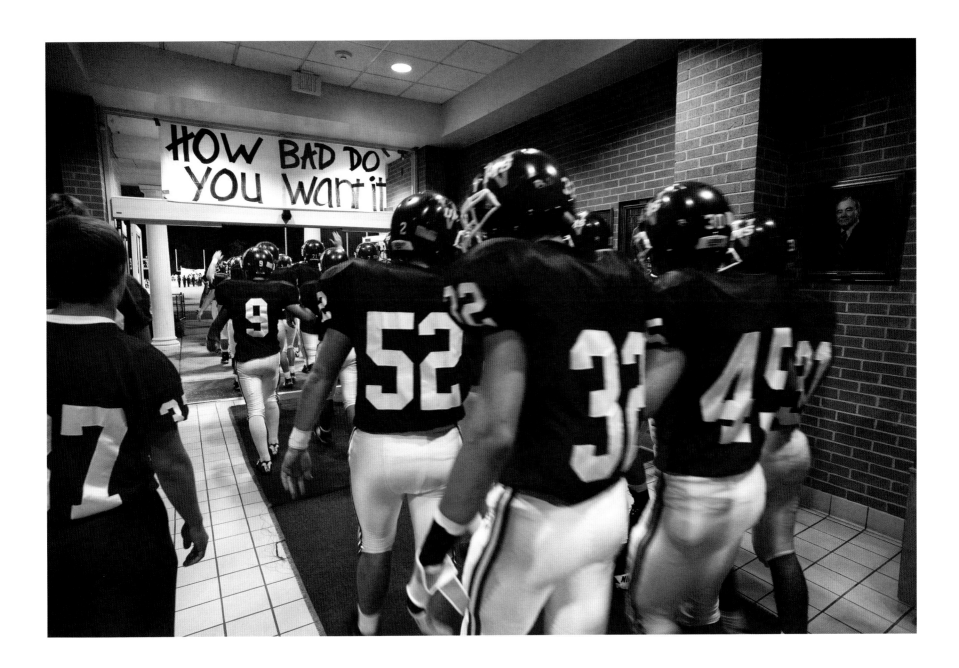

UMS-WRIGHT BULLDOGS ENTERING COOPER STADIUM FOR SECOND HALF AGAINST THE THOMASVILLE TIGERS

MURPHY HIGH SCHOOL TROPHY ROOM AND AUXILIARY LIBRARY, MOBILE

BRAVERY AND BEAUTY MINT JULEP PARTY, OAKLEIGH HOUSE, MOBILE

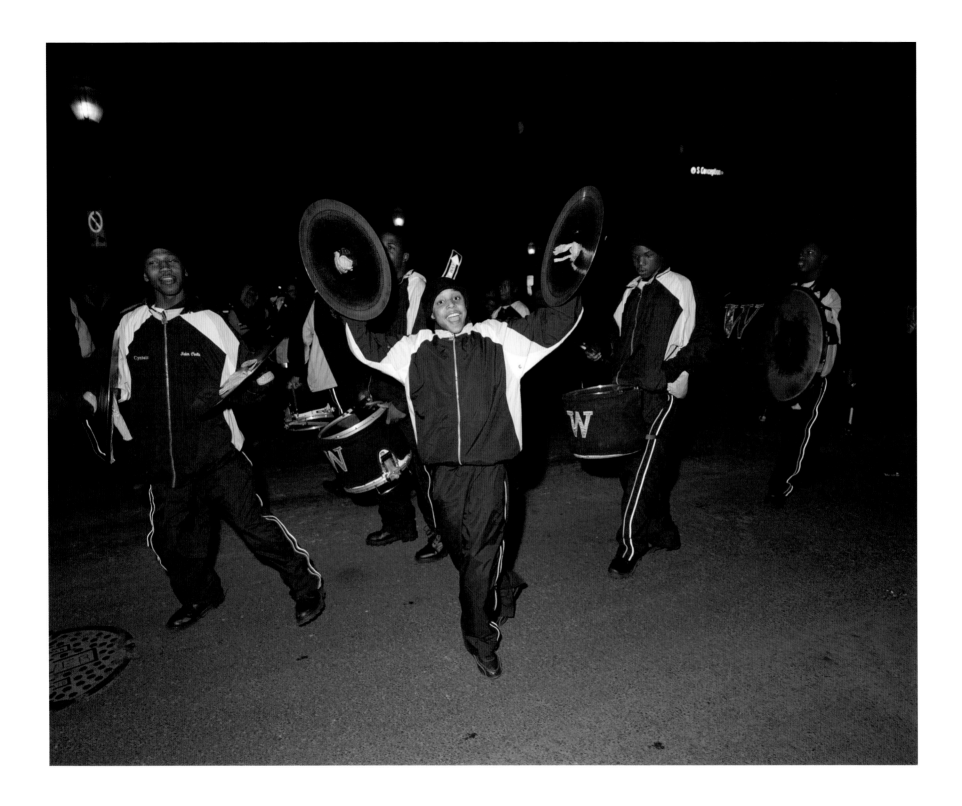

ORDER OF BUTTERFLY MAIDENS PARADE, MOBILE

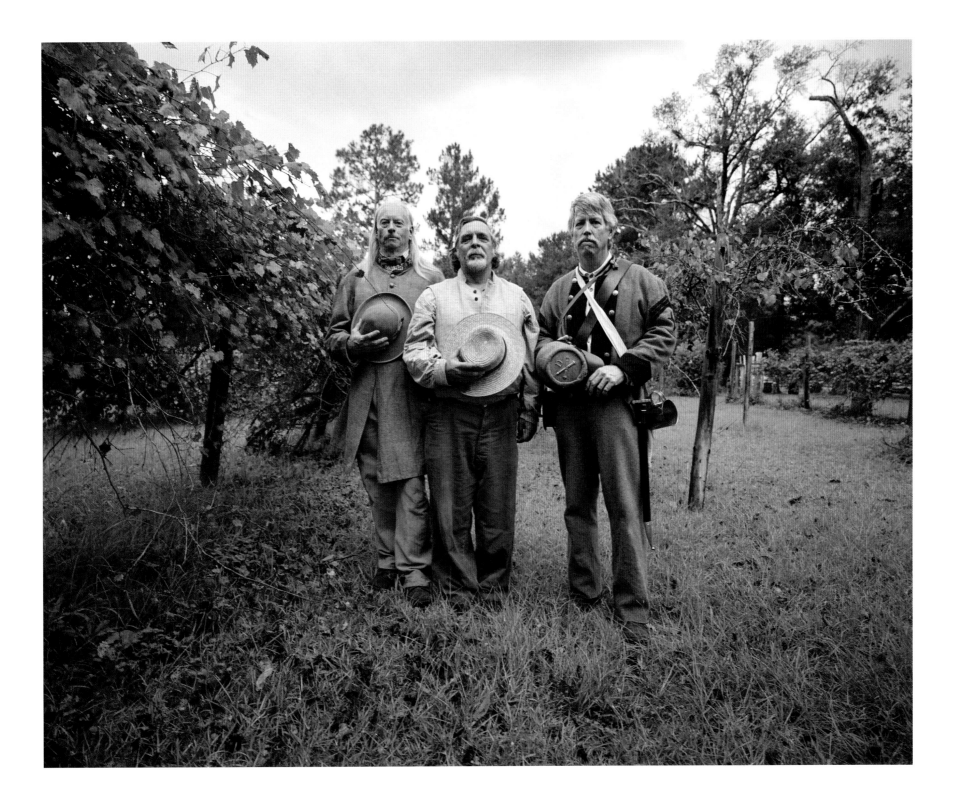

KEN McGHEE, BEETLE BAILEY, AND STEPHEN ELLISON, MAGEE FARM, KUSHLA

MURPHY HIGH SCHOOL PANTHERS WITH COACH RONN LEE

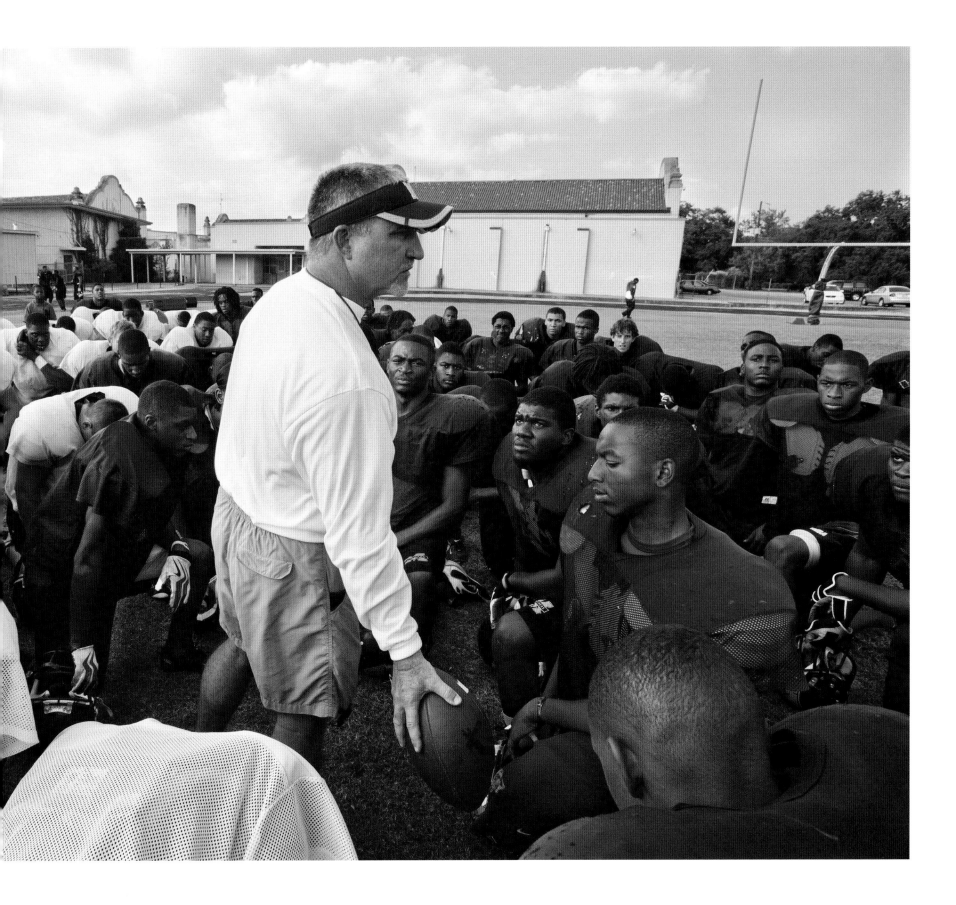

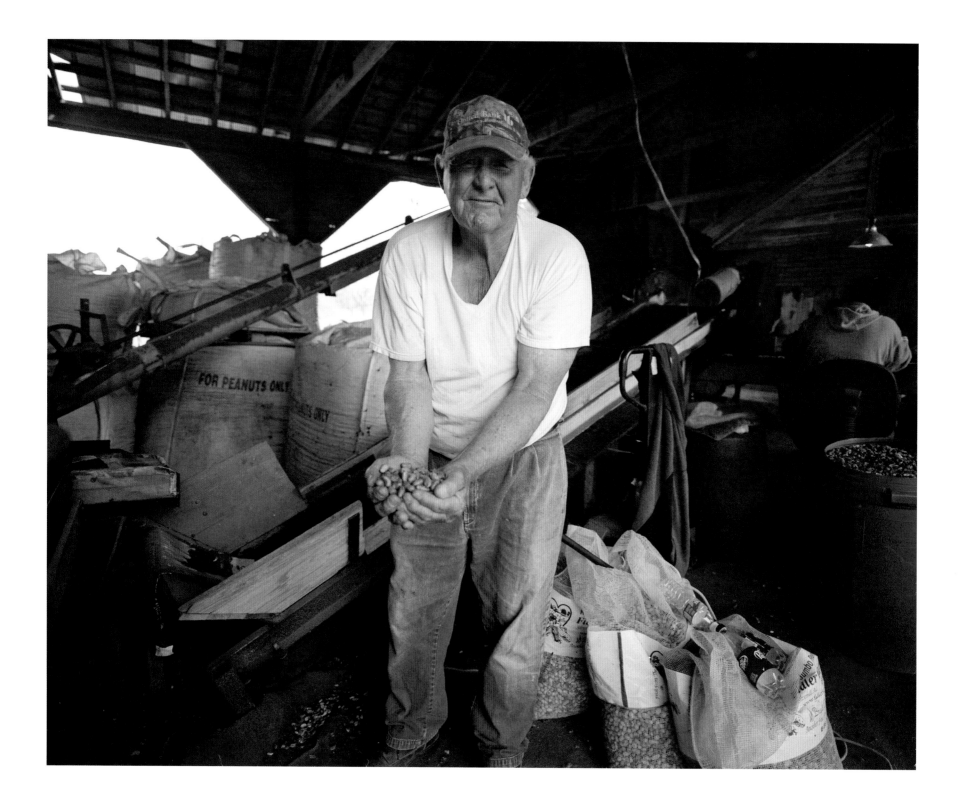

JIMMY FIDLER, PEANUT FARMER, FAIRHOPE

WEIGHING-IN OF WILD TURKEYS, CHOCTAW BLUFF HUNTING CLUB, CLARKE COUNTY

MURPHY HIGH SCHOOL MARCHING BAND BEFORE THE MURPHY-CITRONELLE GAME, LADD PEEBLES STADIUM, MOBILE

BIRTHDAY GIRLS, STEWART MEMORIAL CHRISTIAN METHODIST CHURCH, MOBILE

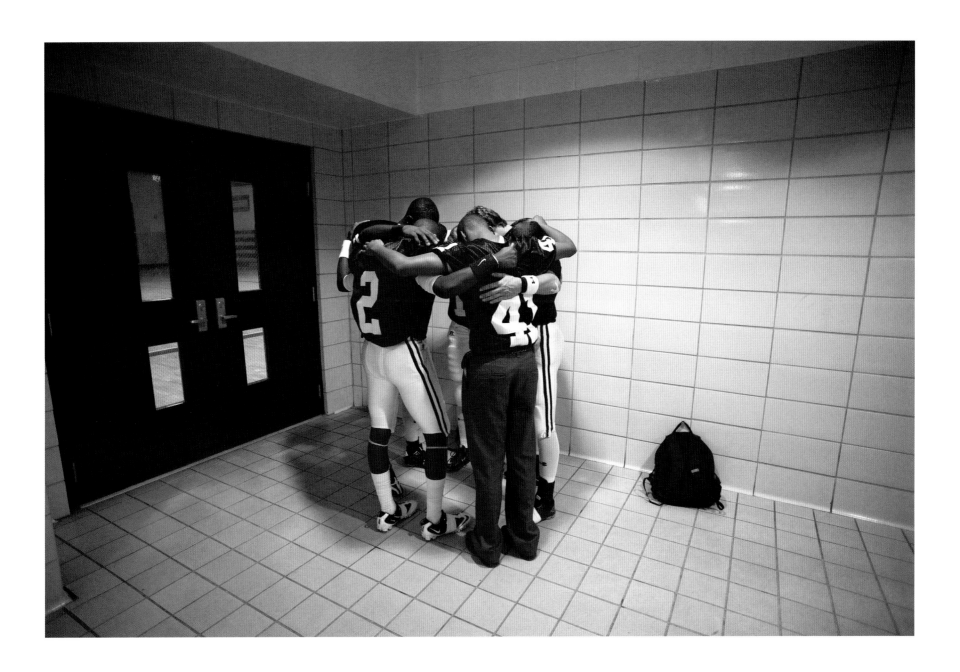

UMS-WRIGHT BULLDOGS PRAYING BEFORE THE GAME, MOBILE

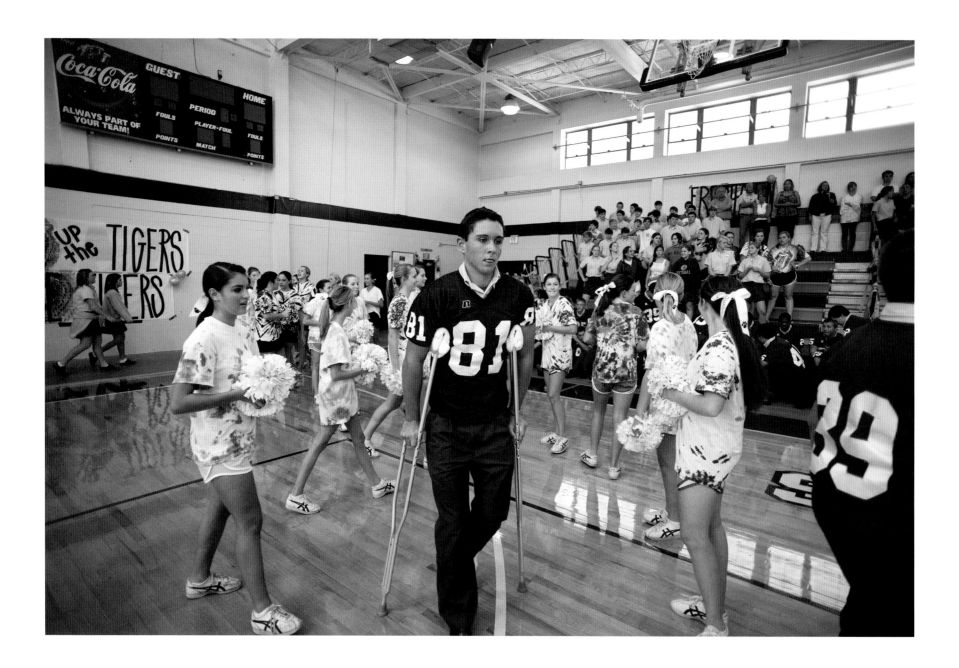

UMS-WRIGHT PEP RALLY, MOBILE

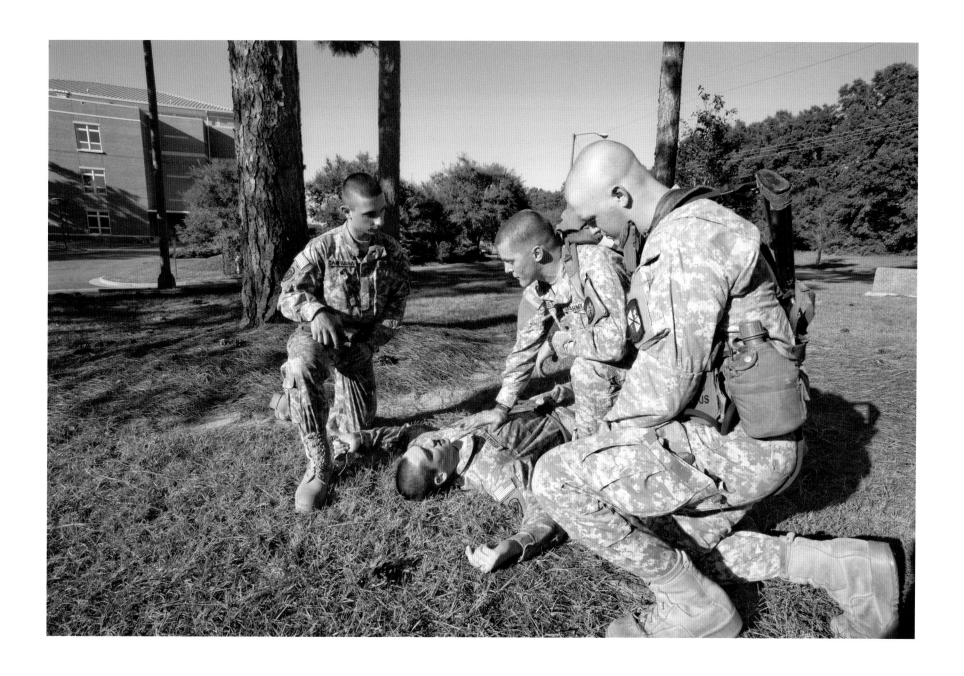

ROTC RANGER CHALLENGE TRAINING, UNIVERSITY OF SOUTH ALABAMA

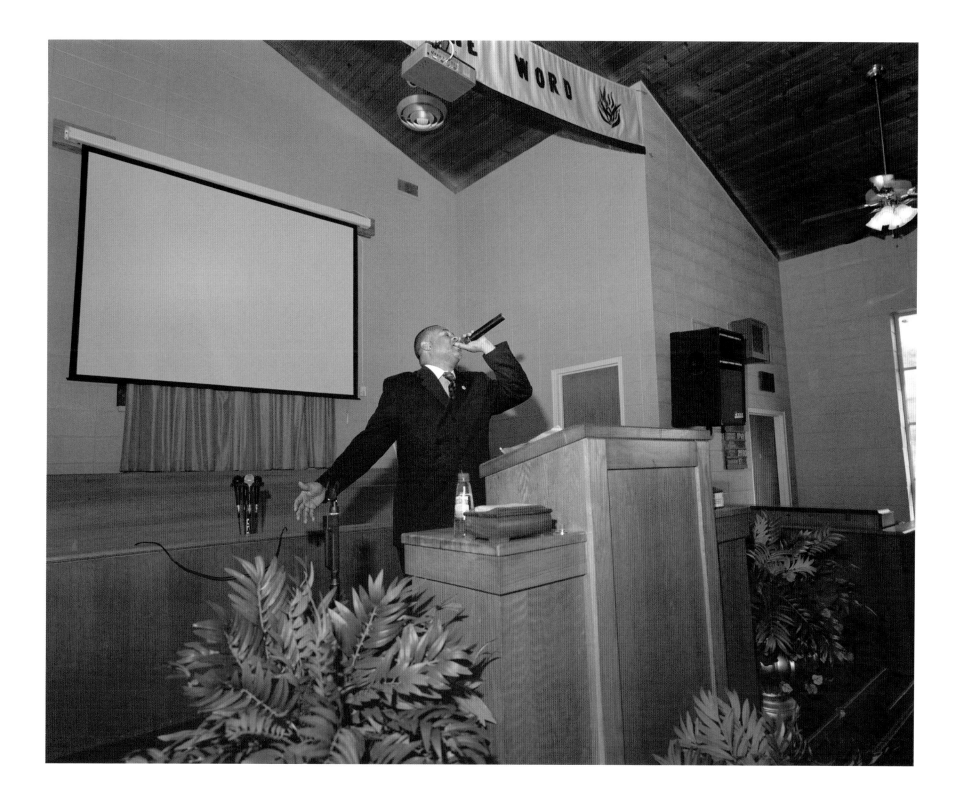

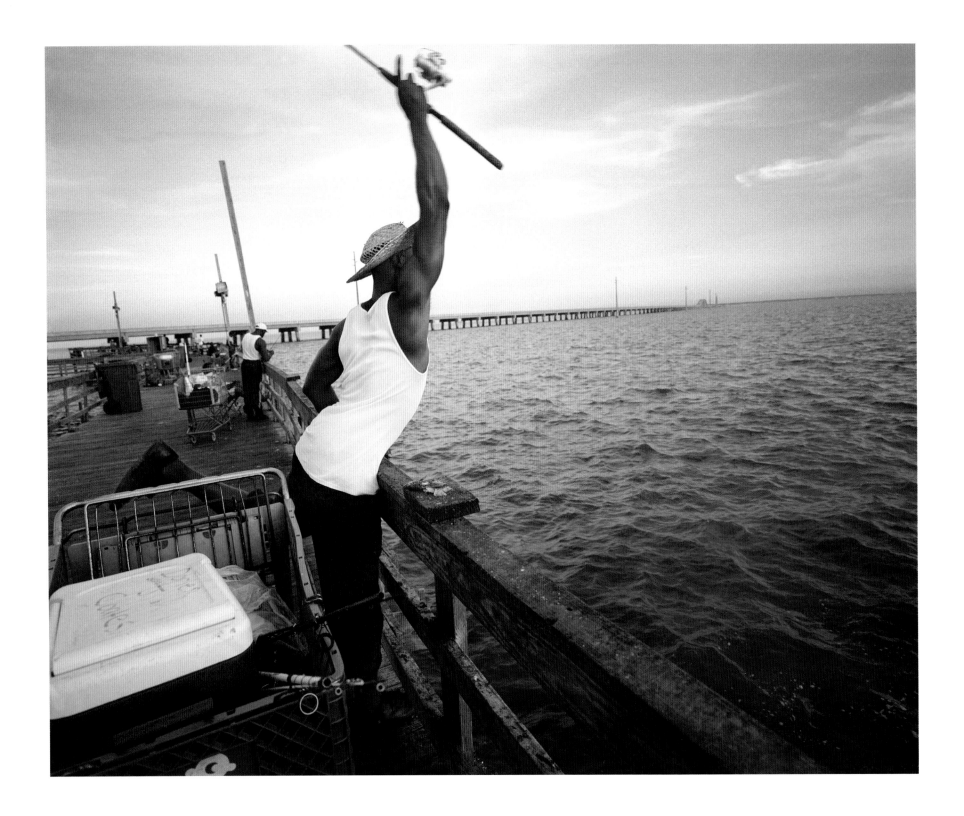

BEN DAVIS, CEDAR POINT PIER, SOUTH MOBILE COUNTY

BIOPHILIA

One evening in Mobile, reading Wilson's book *Consilience*, I was struck by this quote, which appears as the epigraph to this book:

> People must belong to a tribe; they yearn to have a purpose larger
> than themselves. We are obliged by the deepest drives of the human
> spirit to make ourselves more than animated dust, and we must have
> a story to tell about where we came from, and why we are here.

Why We Are Here became not only the title of our book but also a kind of mantra I repeated to myself as I took pictures. With this quote in mind, I saw that my photographs could be about a particular people and a unique American city and its landscapes, while at the same time portraying something larger: the deeply human impulse to tell a story with our lives, a story connected to place.

As a young man, I had learned about the power of place thousands of miles from Mobile when I was photographing on the southern Bering Sea coast of Alaska. One very cold, clear afternoon, I was in the Inuit village of Tununak, having a meal with two native men I'd been hunting with earlier in the day. One of the men, Billy Flynn, a visitor from the nearby village of Newtok, told me he was homesick. I was a little homesick myself and asked Billy, "Why?" Looking out the window at what to me was an absolutely flat, featureless, snow-covered expanse, Billy pointed to a tiny bump on the horizon and said, "Here, there are too many hills!" Perhaps, like Billy Flynn, we are all imprinted on the important places in our lives, connected to the nuances of our own landscapes.

Now in Mobile I wanted to use my camera to explore the connection between people and place. So, when I set out late one fall afternoon to photograph fishermen on Cedar Point Pier, I was thinking that people have probably fished the tidal waters at this southernmost tip of the Mobile Bay for hundreds, even thousands of years. I mingled and talked with several fishermen, but was especially drawn to one friendly young man in a straw hat named Ben Davis. While Ben cut up a small red snapper for bait, he told

me he hadn't had much luck yet. He was waiting for the underwater lights to come on next to the pier, which would draw the bigger fish to the surface.

I picked up my camera and began to focus on Ben in the last red light of the day. Just at the top arc of his cast, with his right arm stretched high and his left foot kicked back, I clicked the shutter. Behind Ben in my picture you can see other people fishing all the way down the wooden pier, then the long, concrete expanse of the Dauphin Island Bridge, and, just visible on the right of the horizon, the thin blue edge of the island itself.

After reading *Consilience*, I turned to several of Wilson's other books, particularly as they relate to his formative years in Mobile, to human nature, and to ecology. Finishing *Naturalist* showed me how Wilson's youth in Mobile and on the Gulf Coast helped to shape his future life and work. If young Ed experienced a sense of awe and wonder studying insects, exploring the mouth of the Mobile-Tensaw Delta, or rambling through a longleaf pine forest, I would try to infuse that child's sense of awe and wonder into my pictures. From characters, events, themes, and places in his novel, *Anthill*, I made a list of things to photograph, subjects that resonated with Wilson's stories and with our conversations: longleaf pine savanna, evangelical religion, ancestral homes, strip malls, real estate development, hunting, guns, football, race, and family.

Many of the stories Wilson told me about growing up in Mobile appear in his text in this book. One, in particular, describes a carnivorous pitcher plant bog he discovered as a teenager on the Dog River, though at that time he didn't realize its ecological significance. Together, Wilson and I visited the Splinter Hill Bog north of Mobile with Bill Finch, an expert on the flora and fauna of the Alabama coastal region, who directs the Mobile Botanical Gardens. Previously, I had traveled with Finch by boat up the Mobile-Tensaw Delta to the site of the early Mississippian native settlement at Bottle Creek and on foot into the marshes of Grand Bay. I knew he could recite the Latin name of practically any plant and describe its relationship to other plants nearby as well as to the overall local ecosystem. Watching Finch and Wilson wander through Splinter Hill Bog and hearing them talk about the plants they encountered was like observing two great jazz guitarists riffing with each other before the ideal audience in the perfect nightclub. As I listened

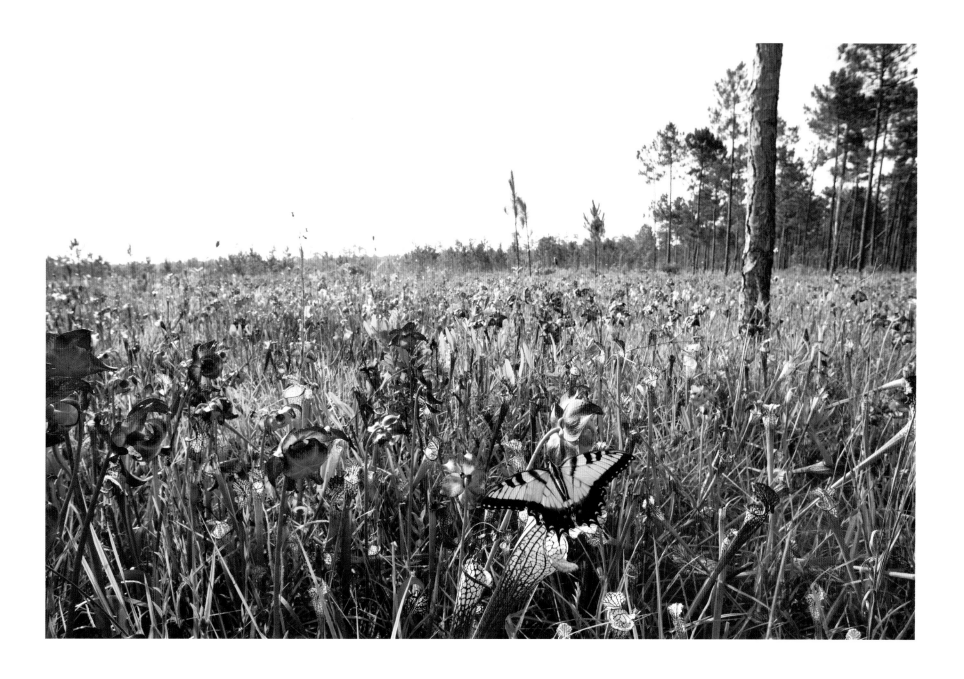

EASTERN TIGER SWALLOWTAIL AND PITCHER PLANTS, SPLINTER HILL BOG, BALDWIN COUNTY

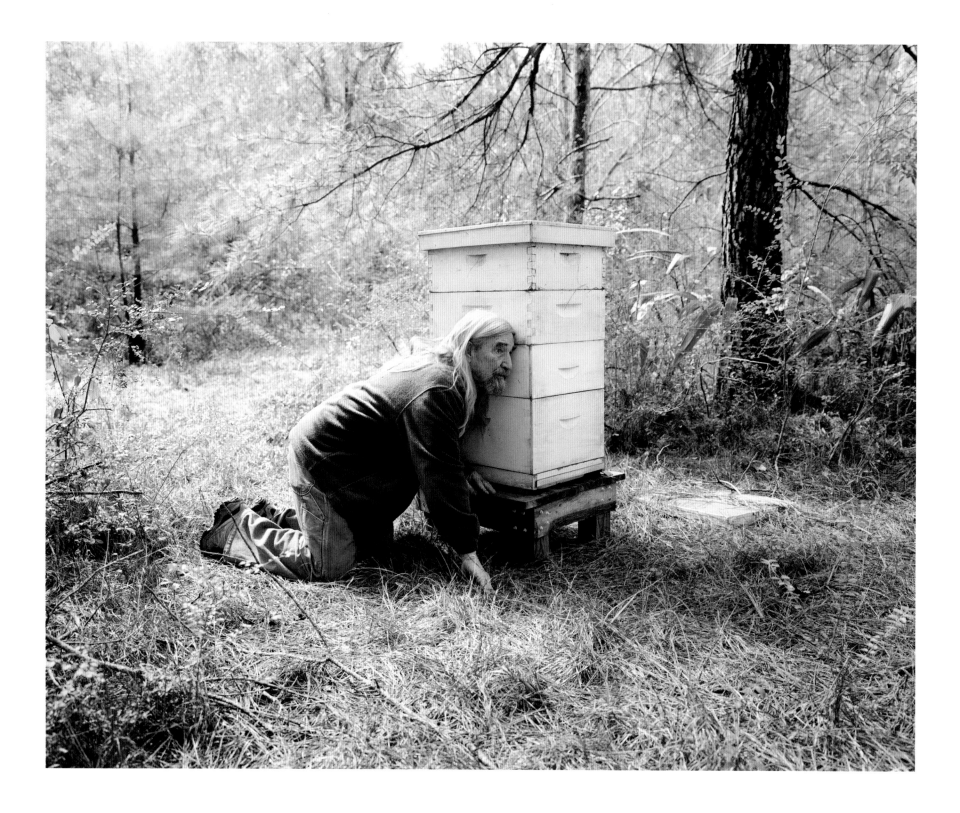

ROY HYDE, FAIRHOPE

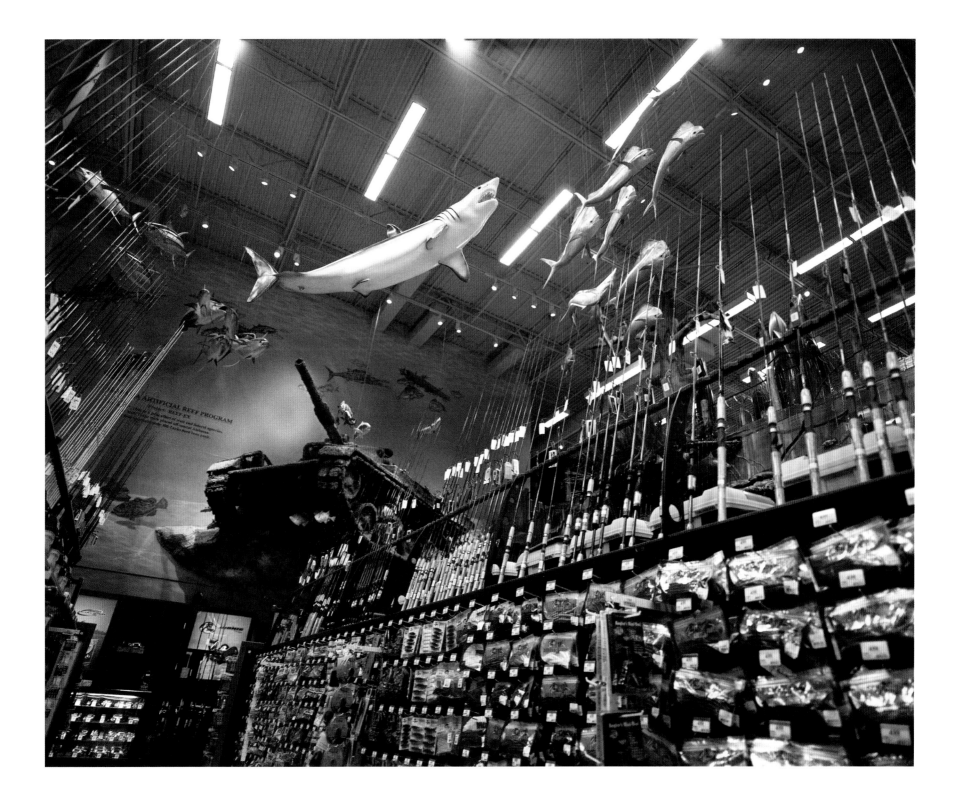

BASS PRO OUTDOOR WORLD, SPANISH FORT

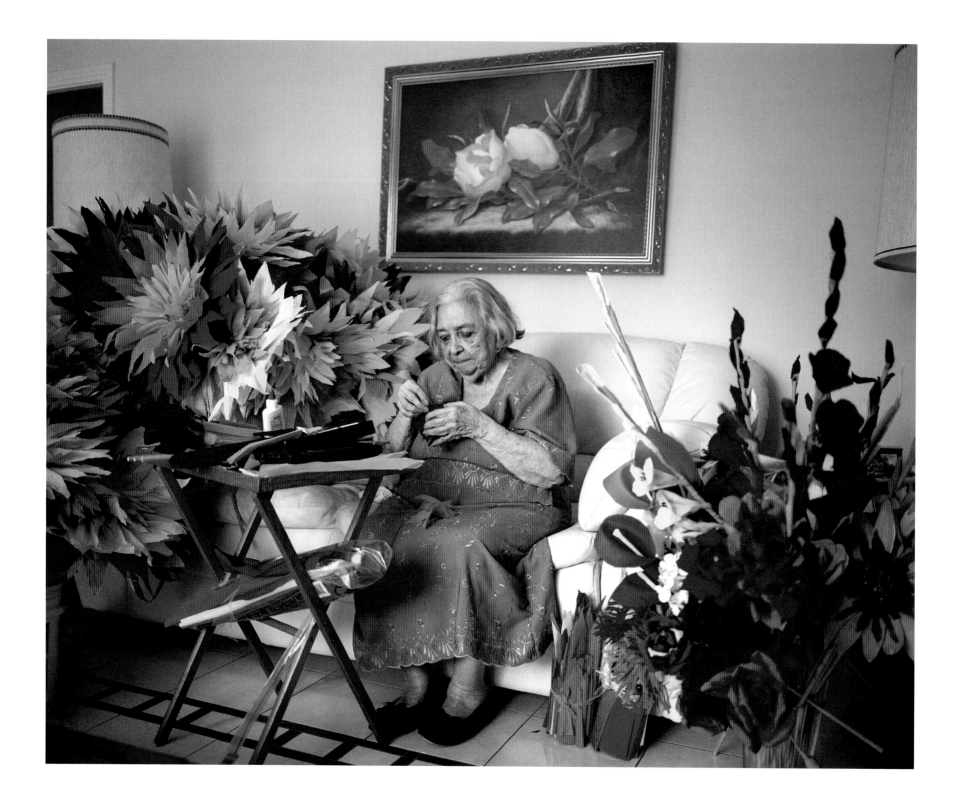

ROSA BARAHONA, MOBILE

to this extraordinary performance, I was chasing butterflies through a flowering primeval bog.

Reading Wilson's *The Creation* introduced me to biophilia, a hypothesis he coined in 1984 to describe the way human beings evolved to be connected to nature, to love nature and living things as an essential part of who we are as a species. Wasn't I expressing my own biophilia in my photographs that day in Splinter Hill or in my picture of atamasco lilies blooming at dawn near Choctaw Bluff? I know I was thinking of biophilia when I accompanied Roy Hyde one cold February morning and photographed him on his knees, pressing an ear to his stack of white wooden hives to see if the bees were stirring.

But what really stood out for me was another way of expressing biophilia. I saw people in and around Mobile—away from the swamps and pine savannas and creatures of the forest—surrounding themselves with images or replicas of nature: in the lifelike schools of papier mâché fish swimming above shoppers in the Outdoor World store in Spanish Fort; on Lenora Ash's shower curtain depicting horses trotting through a sun-dappled forest in an idyllic stream; or on so many Mardi Gras floats of birds, flowers, and plants.

I saw living proof of our hardwired love of nature when I took a photograph of Rosa Barahona, an immigrant to Mobile from El Salvador. Though she is practically deaf and blind, Rosa spends her time making vibrant paper flowers in her house, which is filled with her floral creations. Rosa's daughter told me she was making these flowers for the annual Mobile International Festival, where crafts from indigenous groups of many countries are displayed, yet I would argue that Rosa's impulse to create beautiful copies of the natural world has little to do with her country of origin or her race.

PALE PITCHER PLANTS AND LONGLEAF PINES, GRAND BAY SAVANNA

JAPANESE CAMELLIA, FAIRHOPE

CHOCTAW BLUFF HUNTING CLUB, CLARKE COUNTY

COLE BROS. CIRCUS, MOBILE

BELLINGRATH GARDENS GIFT SHOP, MOBILE

EL CAMINO CHICKEN, U.S. 90 AND PADGETT SWITCH ROAD, IRVINGTON

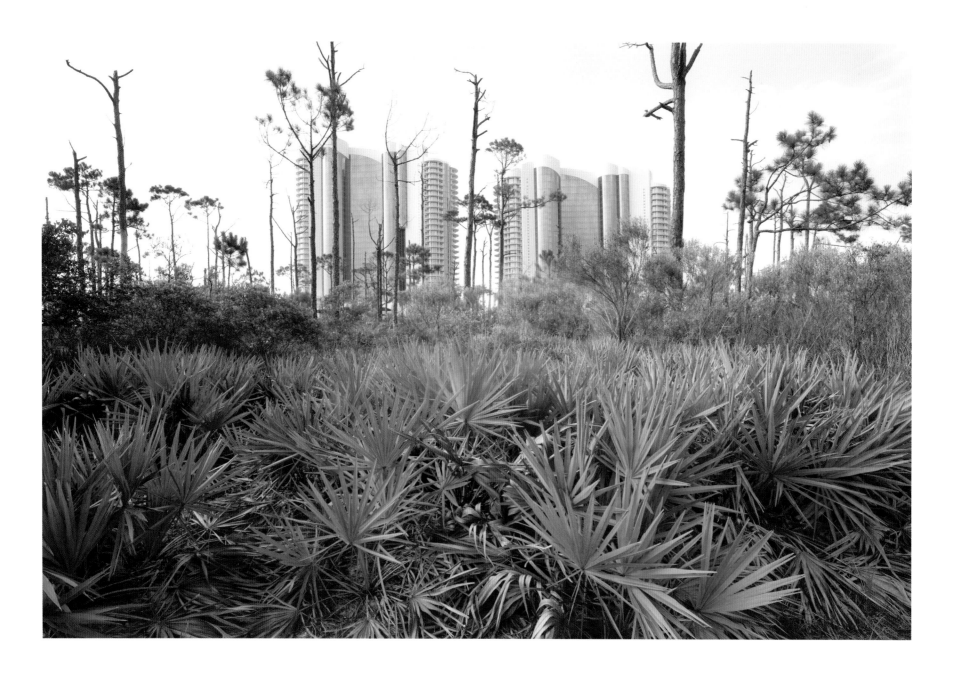

ORANGE BEACH

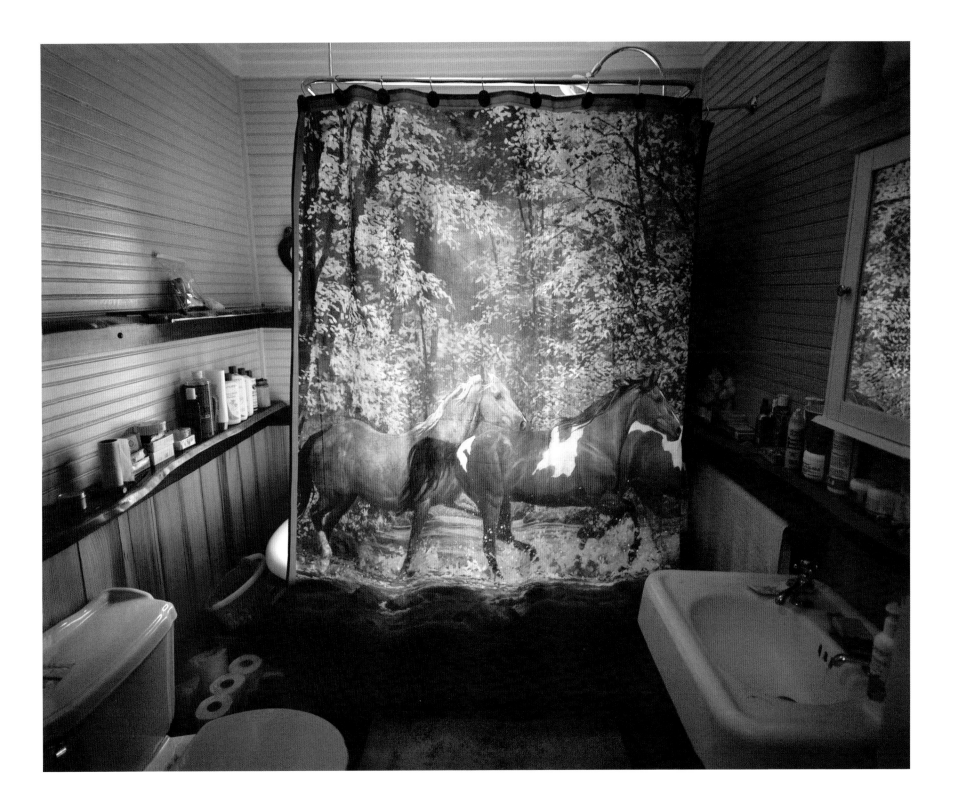

LENORA ASH'S HOUSE, FAIRHOPE

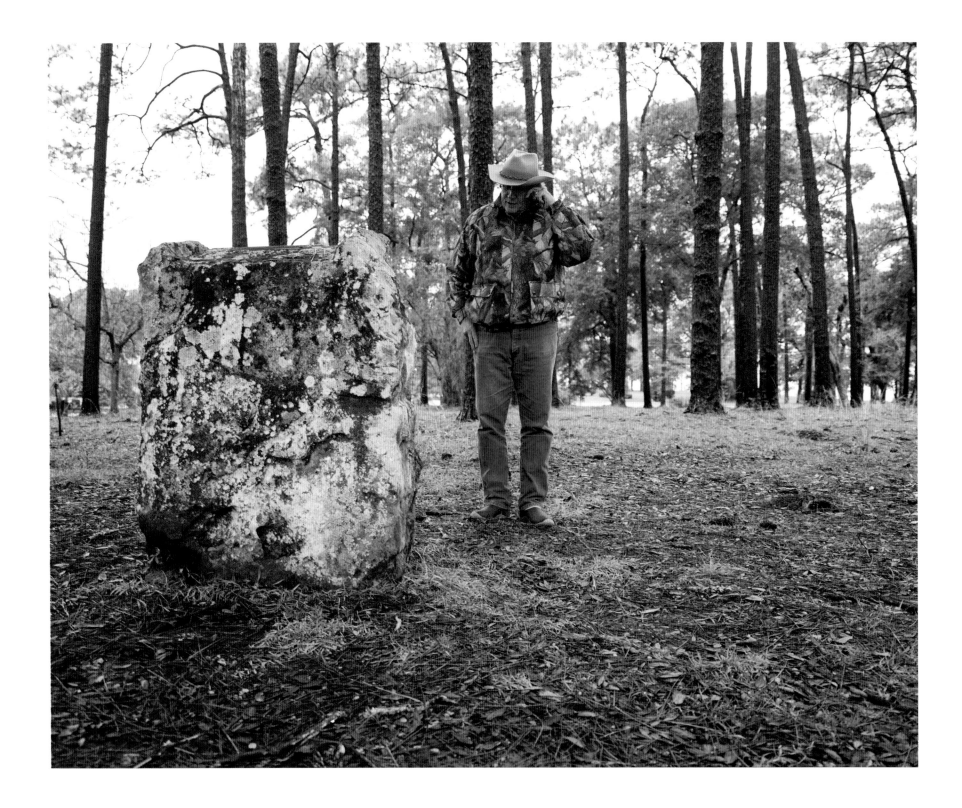

MARTIN LANAUX, KNOLL PARK, FAIRHOPE

GULF SHORES

KUDZU AND ARTIFICIAL PALM TREE, MOBILE

LOBLOLLY PINE NURSERY, SEMMES

INDIAN MOUND STATE PARK, DAUPHIN ISLAND

DUCKBLIND CANE, OSPREY NEST ON A DEAD CYPRESS, MOBILE DELTA

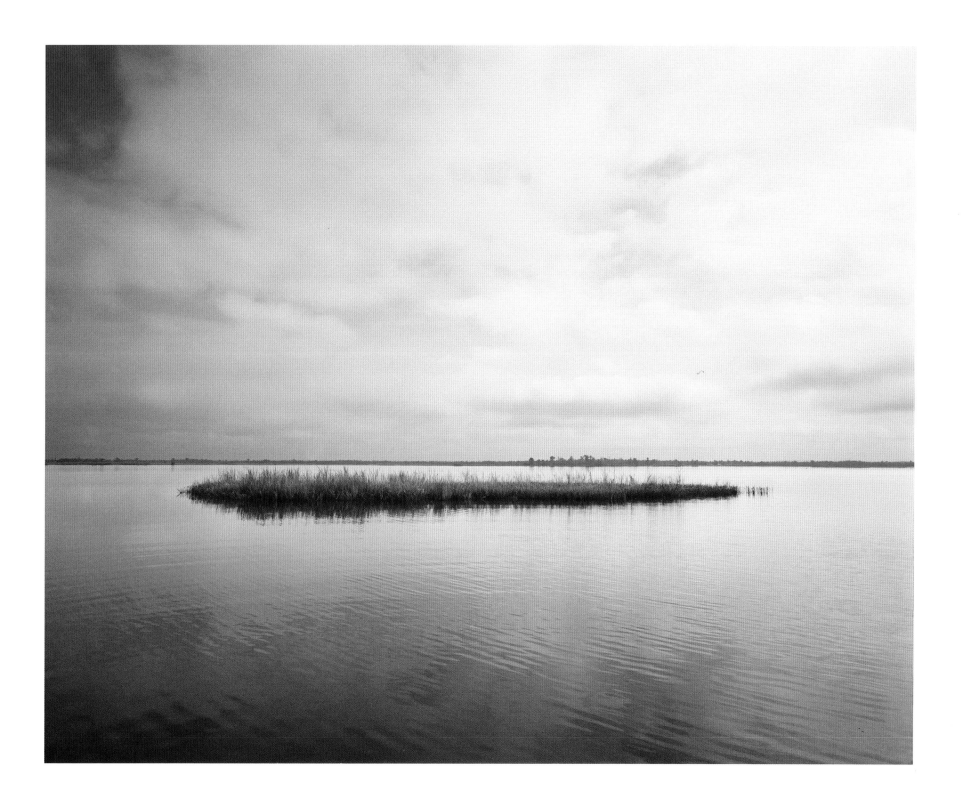

LEWIS ISLAND, CHUCKFEE BAY, MOBILE DELTA

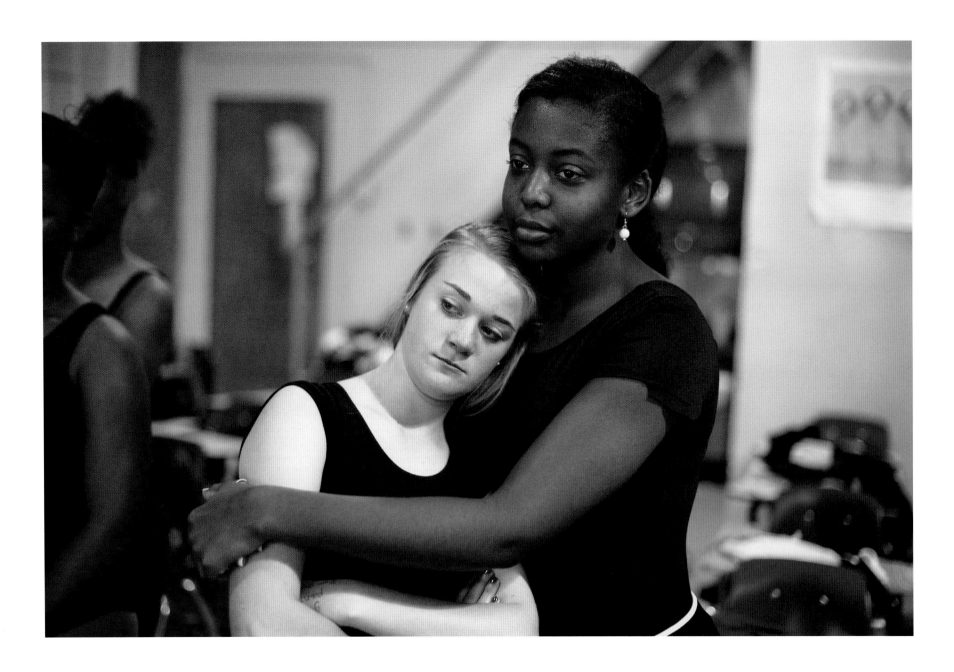

MODERN DANCE CLASS, MURPHY HIGH SCHOOL, MOBILE

In his text to this book, Ed Wilson writes frankly about the racial attitudes he encountered as a boy living in segregated Mobile and later in his sophomore year of 1944, attending Mobile's all-white Murphy High School. Wilson shows us this not so distant time in the context of the tragic attitudes about race persisting from the institution of slavery early in eighteenth-century Mobile through the Civil War, then slowly evolving through Reconstruction, Jim Crow, the civil rights era, and into the present day.

As a photographer, I had a chance to observe and take pictures of the new generation of blacks and whites growing up in Mobile. I spent a week at Murphy High with the idea of photographing the Murphy Panthers football team. At Murphy I couldn't help noticing how at ease black and white students are with one another. My pictures reveal some of their obvious gestures of friendship and affection. Other signs are more subtle. I am thinking in particular of a photograph I made of a young woman dancing in a modern dance class. There is nothing remarkable about this situation other than the fact that it is not remarkable. This is a young black woman dancing with absolute poise and grace in a completely integrated Murphy classroom surrounded by whites, Hispanics, other blacks, and students from several countries.

I had a similar response to photographing another kind of dance, though this one was segregated. When I was invited to attend the Mobile Area Mardi Gras Association (MAMGA) Grand Marshal's Ball, I expected my pictures to show the separate Mardi Gras societies that exist for both whites and blacks in the city. MAMGA, as it turns out, is the black organization. And, true to my assumptions, no whites appear in my photos from that evening.

But, in one of those pictures, a group of elegantly dressed MAMGA partygoers is shown in the ornate setting of the ballroom of the Battle House Hotel. They are drinking, talking, and dancing. In capturing their evident sense of comfort in this place in the heart of old Mobile, the picture speaks in its own way to changes in Mobile's history, to an event and an attitude that would have been unimaginable in Wilson's youth.

Behind the MAMGA revelers is a tapestry depicting another gathering of elegantly dressed Mobilians from an earlier century. A multiethnic group of four bewigged men appears to be reading a proclamation. Or, perhaps,

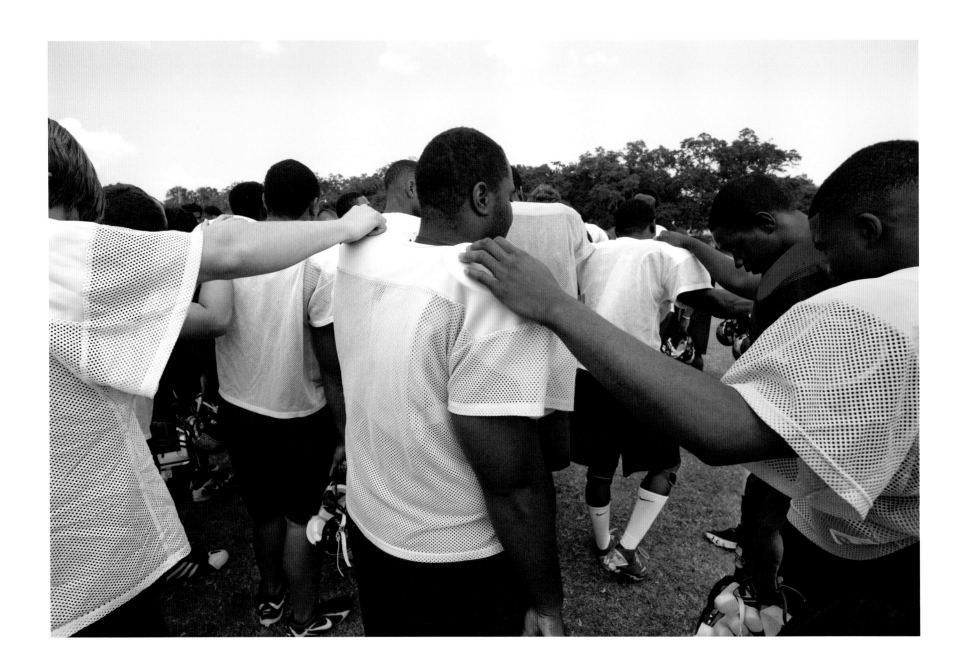

MURPHY PANTHERS FOOTBALL PRACTICE, MOBILE

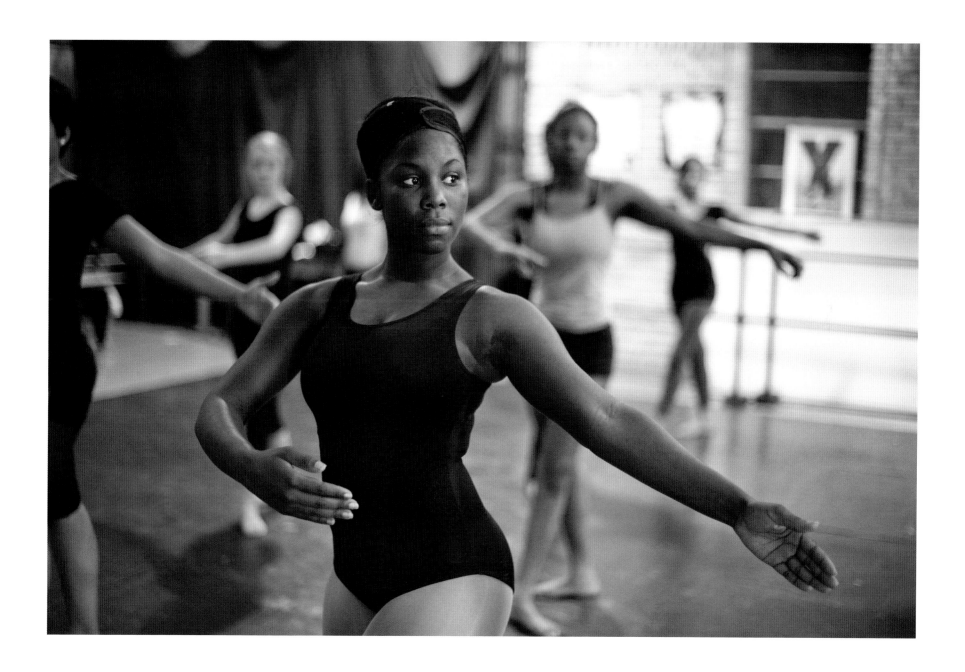

MODERN DANCE CLASS, MURPHY HIGH SCHOOL, MOBILE

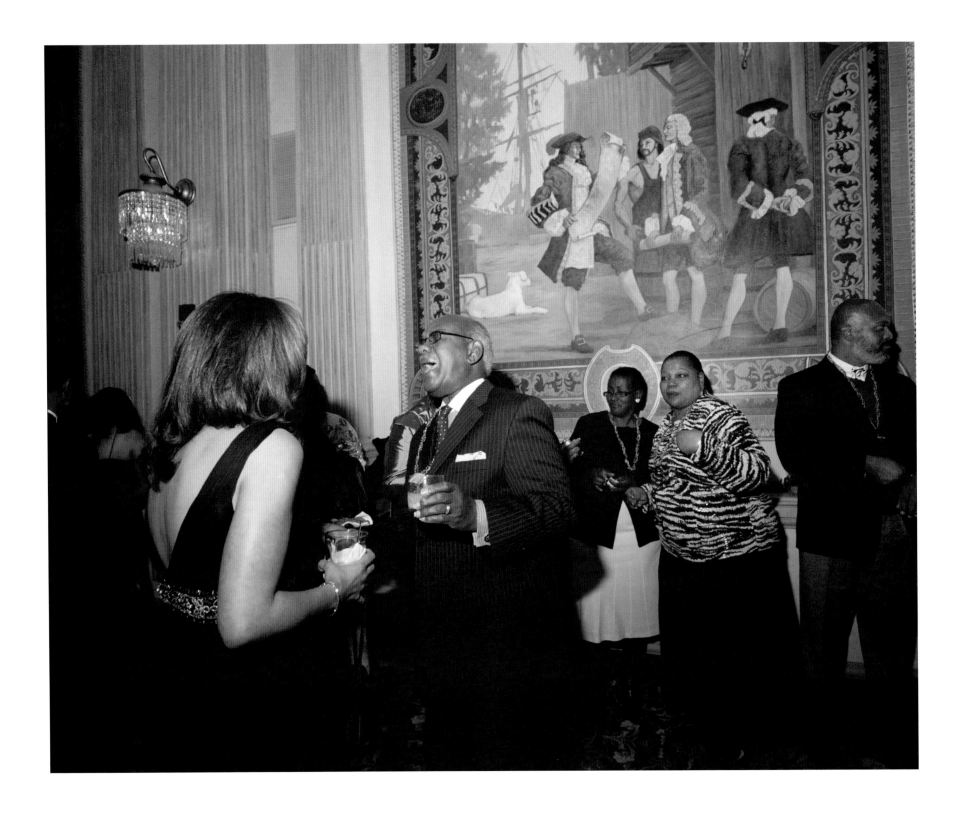

GRAND MARSHAL'S BALL, BATTLE HOUSE HOTEL, MOBILE

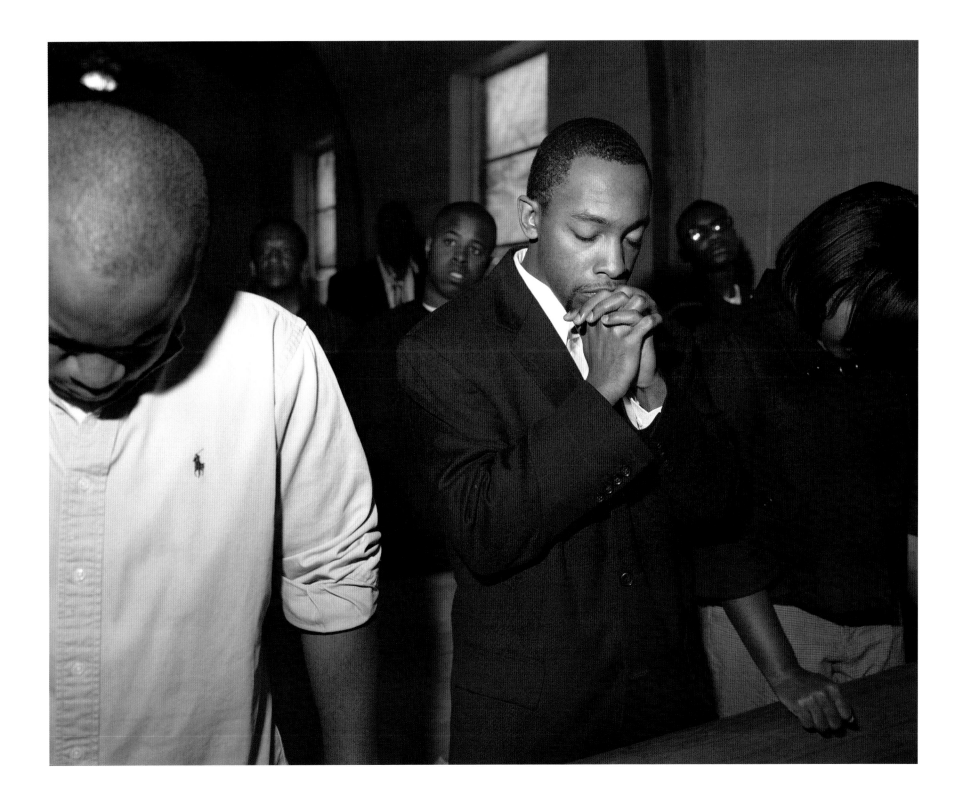

WORD OF LIFE COMMUNITY CHURCH, SOUTH ATMORE AVENUE, MOBILE

that scrolled sheet is a bill of lading for goods being unloaded from the ship docked in the harbor behind them. Without setting out to do so, I had illustrated one of the main themes of Wilson's text to this book. The photograph shows Mobile as a port city that has always been a polyglot society where different languages are spoken, enriched by citizens from many nations.

One Sunday morning in the Word of Life Community Church I got a double lesson on the meaning of polyglot in Mobile when I photographed a group of African-Americans speaking in tongues and a few minutes later praying in English to the words and sounds of gospel music.

Almost a week later, on the outskirts of Mobile, I heard yet another tongue spoken as I made pictures of the same prayerful gestures from church but now in a very different setting. I was invited to a *Hoji*, or Buddhist memorial service, in the Irvington home of Mrs. Heak Hong, whose husband had died one year earlier. Two red-robed Cambodian monks sat cross-legged at her kitchen table. Mrs. Hong and a group of her Cambodian immigrant neighbors had created a traditional feast for the occasion. As I snapped the shutter, the group offered a prayer over the food we would all share—dishes intended first for the monks, who consume only one meal a day and must eat before noon.

I also visited Truat Nguyen, a former South Vietnamese pilot who fled to the United States with his family after the fall of Saigon in 1975. He and his wife were stringing colorful flags outside their modest brick home to commemorate the Vietnamese New Year. The next afternoon, I visited again and made a portrait of Truat in his dark blue City of Mobile public works uniform, participating in a much more familiar ceremony. Seated below him, his goddaughter, Brittany, is doing her homework at the dining-room table where Truat helps her every schoolday afternoon. Truat Nguyen's story of preserving traditional practices while assimilating into a new society has played out countless times in the history of Mobile.

Though I made all of my photographs of Mobile in a two-year period, some of my pictures project a longer span of history. I was introduced to a hardworking charter boat captain named Brent Shaver and his wife Pam, a former postmaster, in their Orange Beach home. In my portrait, Pam's arms rest on Brent's shoulders. You can see their affection and bond. But, if you look more closely, Brent's expression and demeanor are ambiguous.

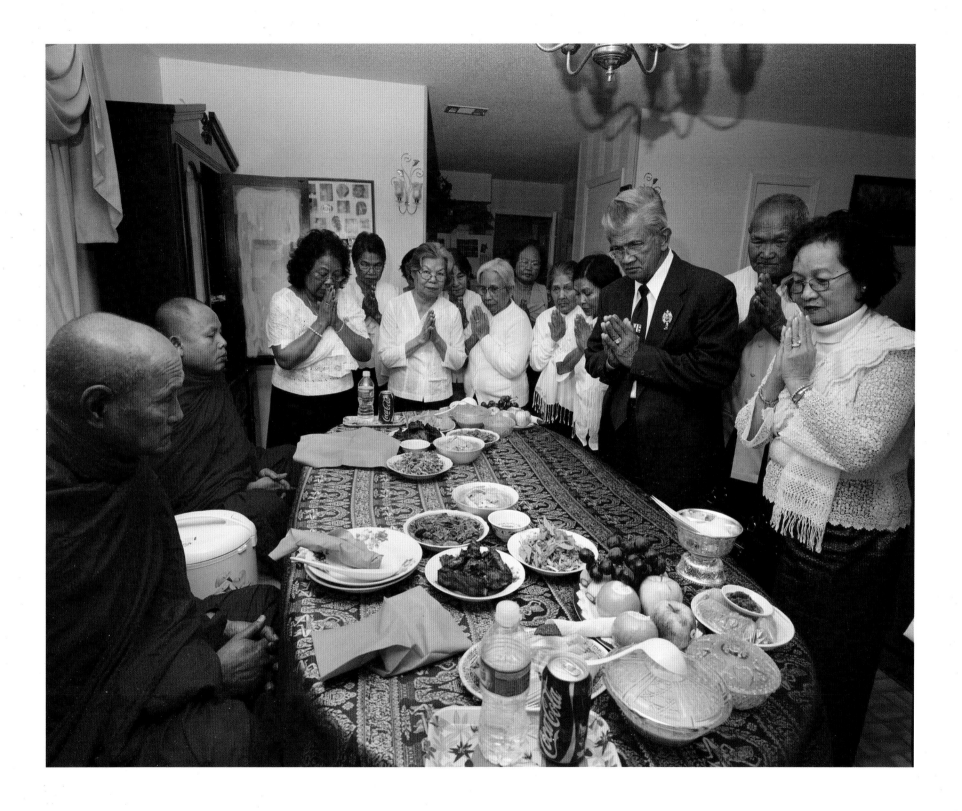

HOJI (A BUDDHIST MEMORIAL SERVICE FOR THE DECEASED), MRS. HEAK HONG'S HOME, IRVINGTON

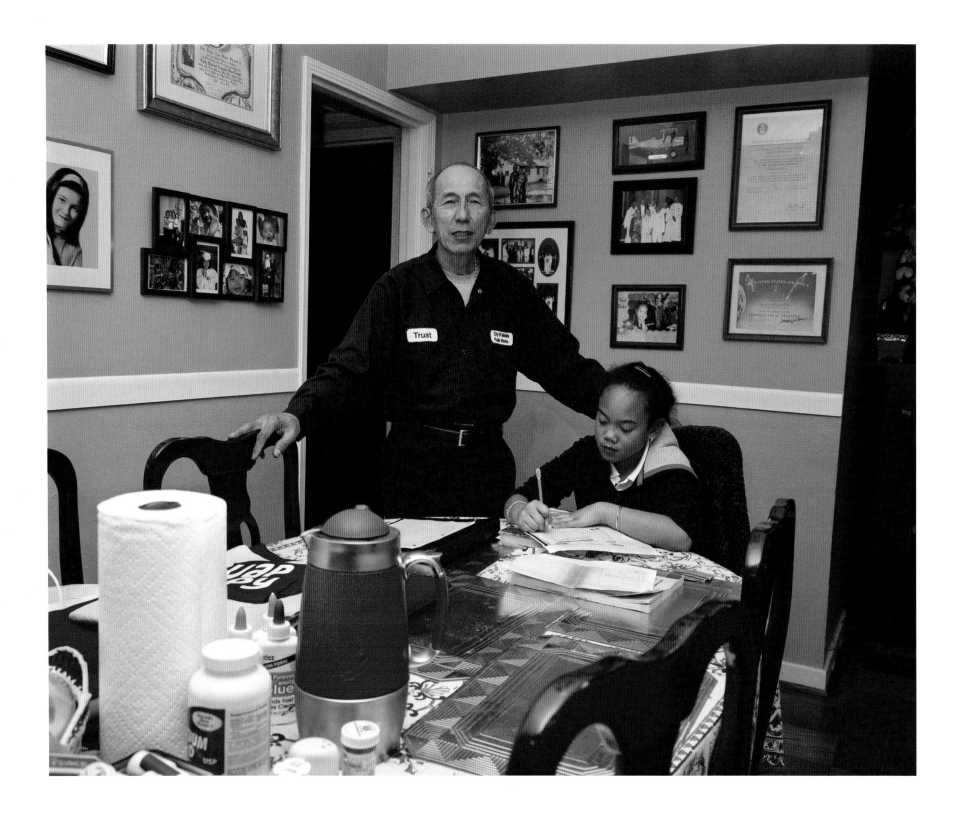

TRUAT V. NGUYEN AND HIS GODDAUGHTER, BRITTANY NGUYEN, SOUTH MOBILE

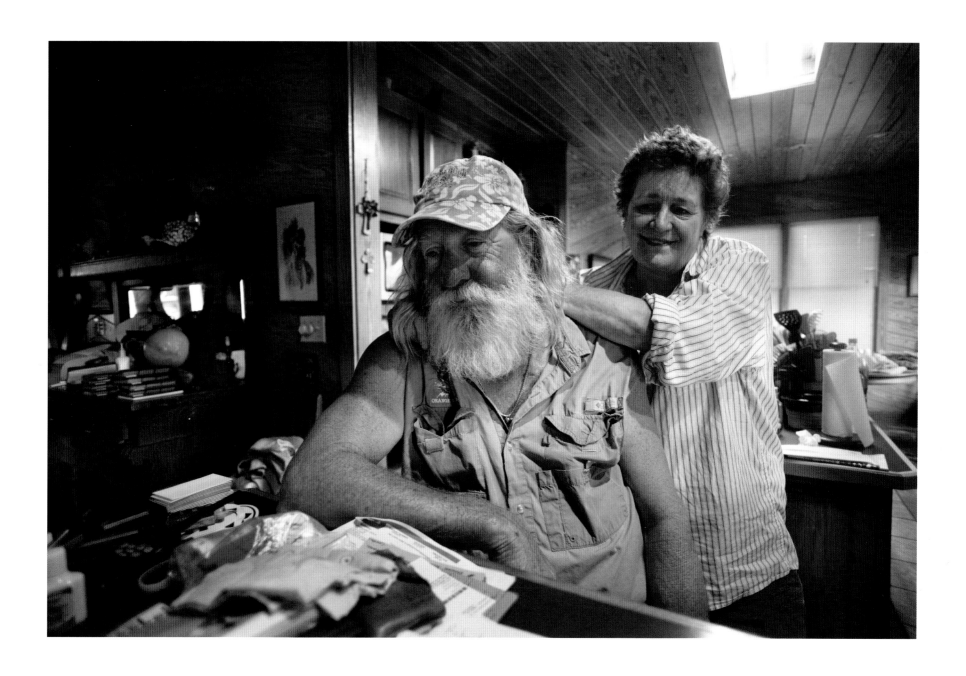

CAPTAIN BRENT AND PAM SHAVER, ORANGE BEACH

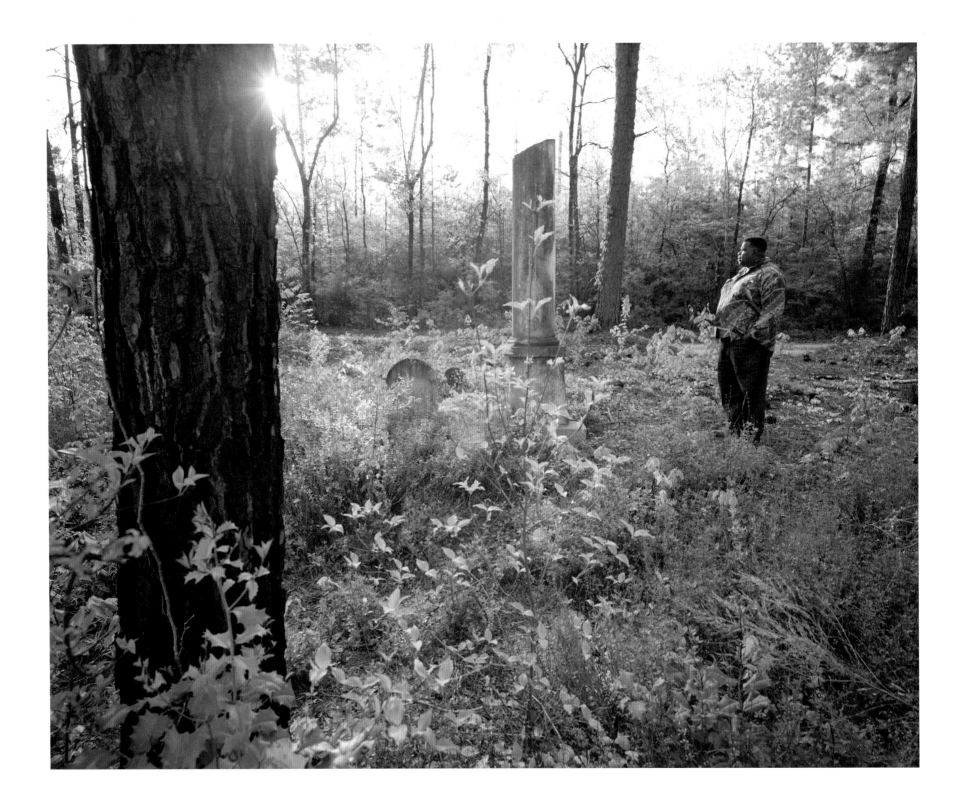

FRANK MITCHELL, JAMES CEMETERY, CHOCTAW BLUFF, CLARKE COUNTY

It was late afternoon when I took this picture, and Brent had been on his boat on the Gulf with his crew since 6 A.M. Perhaps he is just tired. Or he could be thinking about his temporary job with British Petroleum searching for injured birds and sick marine mammals following the Gulf Horizon oil spill. Or maybe Brent is pondering the ban on fishing in the Gulf while BP oil spews into the waters he's known for decades.

Other portraits are equally bittersweet. One fall morning, Frank Mitchell was showing me where to look for wild turkeys nesting in the pine forest near Choctaw Bluff when he pulled his truck over to point out gravestones of James Cemetery scattered amidst the bushes and slash pine. Frank's father is buried here. His extended family has lived and farmed these hills for generations. In fact, this is the graveyard his ancestors established for African-Americans prior to the Civil War. In my portrait, Frank Mitchell stands on the edge of the graveyard staring off into the distance of memory and time.

TAKE THAT, SOCIETY

If you were to take a walk with Wilson and me near Mobile, I'd suggest not just any stroll but a walk on the E. O. Wilson Boardwalk. Imagine you are strolling with us along that nature trail on the grounds of the same Fort Blakely that Wilson describes in his accompanying text as the site of his great-grandfather James Eli Joyner's participation in the last major battle of the Civil War.

And, as you stride next to Wilson, you are looking at a bald cypress in the Tensaw River, passing by cattails, wild rice, and giant cutgrass. Wilson describes the different insects you encounter along the way, like the huge nephila silk spider whose webs can get up to six feet wide and twenty feet high. He peers into one of those webs and points to another tiny spider, the dewdrop, that lives in the nephila's web, steals bits of its food, and makes its own web within that web for its cache. And you are beginning to get this sense of other extraordinary worlds-within-worlds, parallel universes, right here in this place, going on around you, that you hadn't been aware of.

E. O. WILSON BOARDWALK, FORT BLAKELY

You are moving through time and space with a new awareness, a heightened sensibility. Then on the railing you see a huge insect that Wilson identifies as an Eastern Lubber grasshopper. But don't touch. Its bright colors and lazy manner indicate it is poisonous to predators and can produce an irritating spray.

Next you encounter a couple who have been walking in our direction. They live nearby, in Daphne. He sports a crimson University of Alabama cap and carries two fishing poles and a net. She is pulling and holding enough supplies for a long day on the Tensaw River. Different species of dragonflies have been buzzing by all morning, and now a green one with a huge head, white spots on its body, and characteristic double wings lands briefly on the railing next to Wilson before flying off.

In what must be one of the most ironic moments in the history of entomology, the man begins to teach Edward Wilson how to hypnotize a dragonfly. When his sons were young and seemed to be getting bored in the woods, the man always tried this trick. He would find a dragonfly, extend his finger, and move his hand just like this: in a circular motion, getting closer and closer to the legs of the insect until it steps on board.

And what strikes you, after the couple has walked away, is something Wilson tells you. "You know, I wake up every day, and I feel like I'm just getting started. I want to study dragonflies now. That's my next project in Mobile."

If you are a photographer working on a book with Wilson, you understand you didn't really need to go looking with your camera for the Mobile of his childhood. In his eighties, he has the same sense of awe and wonder at the natural world that he had as a young boy, and many of the aspects of the city that attracted him then are still present in and around Mobile.

At the end of the boardwalk, surrounded by a forest of cypress and tupelo, and set in a floodplain of bluestem palmettos, is a little gazebo with a bench. On that bench someone has taken a sharp knife and cut out these words in large capital letters: I JUST CARVED ON THE BENCH. TAKE THAT SOCIETY. Since the letters haven't weathered, this exclamation must have been carved recently, during the time Wilson and I worked on this book.

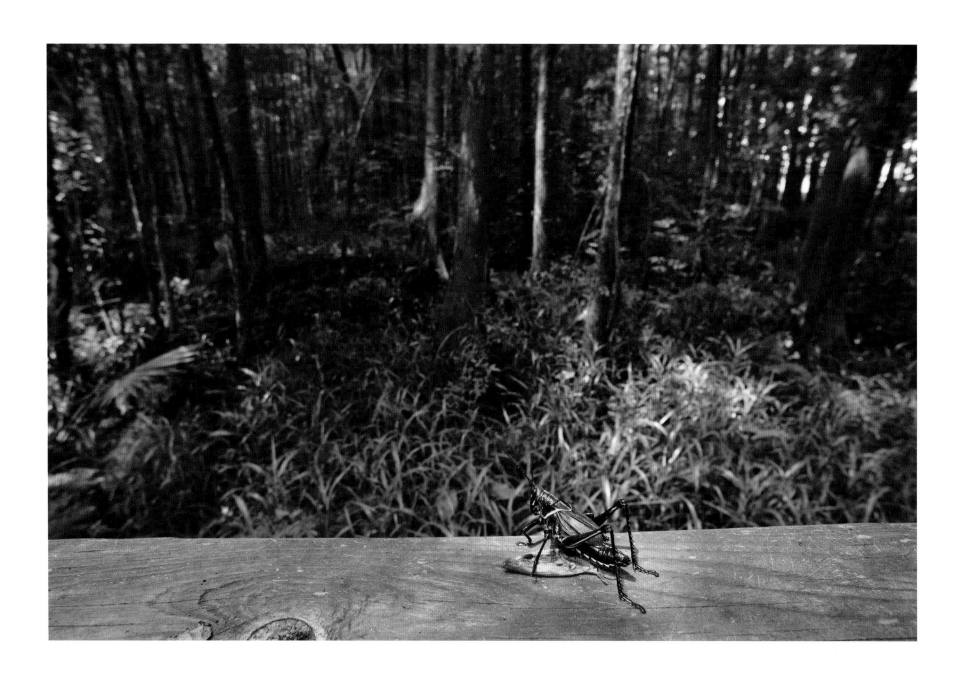

EASTERN LUBBER GRASSHOPPER, E. O. WILSON BOARDWALK, FORT BLAKELY

E. O. WILSON BOARDWALK, FORT BLAKELY

So the idea that comes to mind, standing next to Wilson at the end of the E. O. Wilson Boardwalk, is that he has spent a lifetime carving on the bench of society, following his instincts and his intellect without stopping to worry about what society thinks.

And with me he's carving on that bench again here in his hometown of Mobile. With this book, Wilson is working in the same way he worked for so many years on his groundbreaking research with ants. And I'm working as I did in that tiny village in northern New Mexico. To use a photographer's metaphor, together we are focusing on one small place and in such depth, in hopes of seeing the big picture. As those words weather on the bench and become indistinguishable from their wooden palette, I hope this story, our history of Mobile, will not only ring true for Mobilians in the years to come but also resonate with other Alabamians, Southerners, and all who care about the places in their lives.

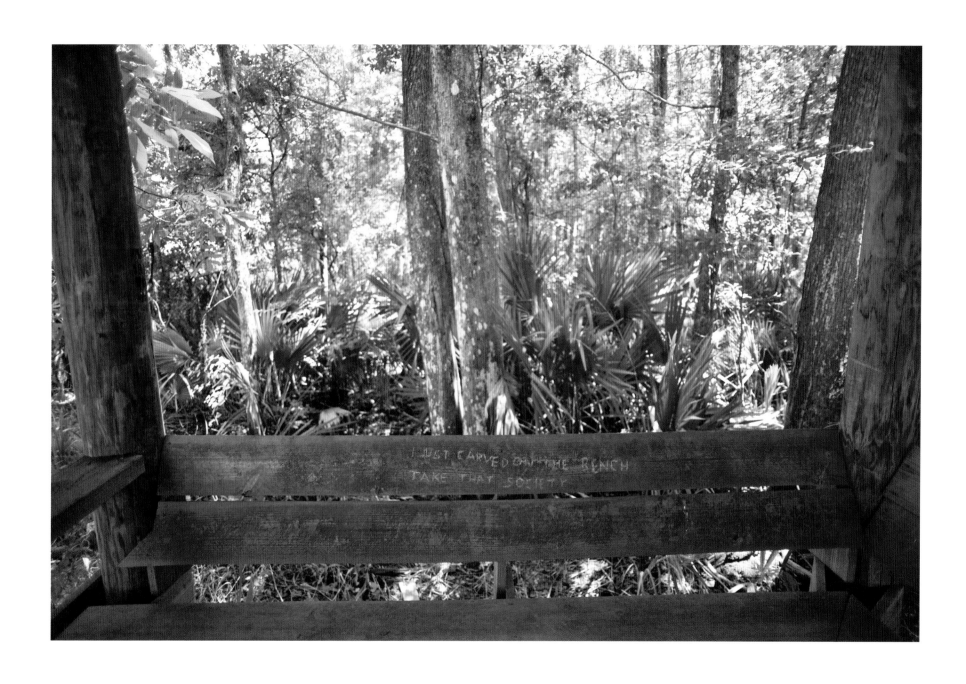

E. O. WILSON BOARDWALK, FORT BLAKELY

Why We
Are Here

BY EDWARD O. WILSON

KYLE TUCKER, CAPTAIN FOR CRESCENT TOWING, ON THE TUGBOAT *NOON WEDNESDAY*, MOBILE HARBOR

A place exists in the mind and heart as much as in its physical location. Its written history, if it is to be completely true, must be part recorded fact, part memory, and part metaphor.

The city of Mobile, pronounced Moe-*beel*, is inhabited by people who call themselves Alabamians. If you mistakenly say Mo-*bill* or Alabamans, you will be recognized as an outlander. Mobile is moderately prosperous as middle-sized American cities go, but more relaxed. There is no aura of hustle and wealth as in Houston down the Gulf Coast, no rococo commercial entertainment for tourists as in New Orleans. The city has not suffered the creeping debility of Sunbelt leisure that afflicts Tampa–St. Petersburg. Seen from Mobile Bay, the few tall buildings of its skyline do not plead for attention. Anyway, what would be the point? The profile is seen mostly by tugboat captains and fishermen.

Mobilians know who they are. They have a rare tribal unity and pride. More than in most other municipalities of comparable size, they do not merely live in and around the city; they belong there. They take pleasure in their separateness. They trace their ancestry as far back as they can and in detail. If you are a fellow native, they want to know about your forebears. Who are your people? they ask. They rejoice if you share a cousin, however far removed. They like guns. They prefer honor to laws. Religion yes, priests no. They don't like being told what to do. They have a congenital dislike

of the federal government. Unlike most of urban and suburban America, Mobile has a soul.

Who am I to speak for Mobile? That is fair to ask, given that I've spent almost all of my adult life away from there. Often the best histories are written by expatriates, with eroding memories but with the advantage of perspective. I do not think of myself as a Harvard professor who was born and grew up in the South. I am a Southerner, and Alabamian to boot, and native Mobilian on top of all that, who went north to find work. I feel I am qualified to write about this city.

So, Moe-*beel*, Alabama, by the grace of God. For the casual visitor a warm welcome awaits and the iconic images are duly laid out: Bellingrath Gardens and the Azalea Trail, magnolia and live oak everywhere, and Spanish moss and mistletoe also, Carnival and pecan pralines and America's Junior Miss Pageant, blue crabs and bottom fish scrambling toward shore during the Mobile Bay Jubilee. And more—the battleship USS *Alabama* resting at the top of the bay, Fort Condé and Fort Gaines and Fort Morgan; the battles of Mauvila, of Mobile Bay, of Spanish Fort, and of Fort Blakely; the twin Mobile and Tensaw rivers and the delta swamp wilderness in between; King Cotton and the shipyard and bay pilots and bar pilots; William Bartram and Raphael Semmes and David Farragut and Hank Aaron. And less often talked about but not hidden: at Mobile arrived the first African slaves of the Gulf Coast, in 1702, and the last (illegal) slave ship to reach America, in 1859.

But the gestalt and spirit of Mobile are no more than hinted by this list. Its history, seldom told, has been sometimes heroic, sometimes dark and violent, as it unfolded across three centuries in a beautiful land under five successive flags: French, English, Spanish, Confederate, and American (twice).

As a Mobilian, I take pride in this story and will make no apology for any of it. Of course I am biased. I never thought about it much at the time, but when I was growing up I had a Mobile-centric view of the cosmos. It was, I assumed, the gold standard for the cities of America. Other places were either deviants or lesser copies. I accepted as normal and eternal Mobile's oddities and contradictions. They were just there, to be pondered if you wished, like the mysteries of holy scripture. How else, for example, could I be a devout Christian but also, as equally expected of me, a dedicated racist?

Many years later, the wife of a fellow professor ventured to me at a Harvard cocktail party, "It must have been terrible to grow up in such a racist society." I replied, "You don't understand. I was a racist myself. We were all racists." I would have been ridiculed and ostracized by the boys I ran around with if I deviated. Adults would have thought me a bit deranged: "What the hell is the matter with you, boy?" Two generations later, we have come out of the nightmare of racial injustice, not completely but a lot, and moving in the right direction, much the same as for Americans elsewhere.

I am disinclined to speak ill of my personal forebears, who since Alabama's birth helped build the state into what it became and had a hard enough time doing it. All of them alive at the outset of the Civil War resided somewhere in Alabama. Two of my great-grandfathers wore gray wool during that conflict, and a third was a blockade-runner who hustled supplies into Mobile right past Farragut's flagship in a swift pilot cutter. A fourth great-grandfather, who lived up in northern Alabama, just kept on farming. All of the families of their generation are descended in part from lines that go back in Alabama from before 1819, when it was carved out as a state from the eastern sector of the Mississippi Territory.

Now that I've started in on my pedigree, let me go back one more generation and tell you about my great-great grandfather, Henry J. Hawkins, who came to Mobile from Providence, Rhode Island, in the 1840s. When the Civil War broke out—I hope I'm not expected to call it the War Between the States or War for Southern Independence in die-hard loyalist style—Henry renounced his United States citizenship and pledged allegiance to the Confederate States of America. His own father, still back in Providence, went the other way and commanded the Hawkins Company of infantry to fight against the Confederacy. So I had ancestors on opposite sides of this conflict, which a few Southerners still elliptically refer to simply as "The War."

As I learned as a boy, Henry J. Hawkins was a naval engineer who was prosperous enough to build the house where I lived a large part of my childhood. It was a short walk to Bienville Square in the heart of the old city, and the first residence built on Charleston Street. Big enough to hold three families, it was filled to just that capacity in the early years of the Great Depression. In 1932, my father, Edward Osborne Wilson, Sr., brought my mother and me to live there a while to get through temporary financial straits. We

joined Uncle Harry and his small family, who had arrived under similar circumstances. We all did tolerably well in small apartments staked out on the first floor.

There was a meticulously kept parlor in the house just inside and to the right of the front door, containing the family Bible, and a little clasped album with Civil War era daguerreotypes of family members and friends, unfortunately unlabeled (you were supposed to know who they were, at least if you opened it during the nineteenth century). Representing literature and standing alone in a closed glass case was one copy of Owen Wister's *The Virginian*. This I read hungrily.

There were several other bedrooms; one on the first floor was occupied by Uncle Herbert, a disabled veteran of World War I and in the 1930s a security guard at the Mobile Docks. Among my earliest memories are his reading the Alley Oop comic strip to me each day from the *Mobile Press Register*. On the second floor, which I never was allowed to visit, were the bedrooms of my grandmother, Mary Joyner Wilson, and two elderly, notoriously querulous maiden great-aunts. When I was an infant, my mother later told me, one of the aunts (not Aunt Georgia, the other one whose name I've forgotten) fought with her over who would hold me on her lap. She asked to do that frequently and more than once broke into hysterical weeping when denied the honor. (This was probably the same one who earned local infamy and family shame by throwing a brick through the stained-glass window of a nearby Catholic church.)

During my early teens, after emigration and deaths had nearly emptied the house, I was handed all the chores thought appropriate for a boy. The most important was the daily cleaning of the antique coal-burning stove in the kitchen. I carried the ashes out of the house in a bucket and dumped them in a narrow space between the garage and back fence. The midden formed there over generations was used by my father—when he was a boy—and his three brothers as a backstop for target shooting. Countless .22 cartridges were still buried there in my time, like the bones and wrecked ordnance of some forgotten wartime skirmish.

A much more interesting job was to inspect the exposed plumbing under the Charleston Street house whenever a serious freeze was forecast. In earlier times, Mobilians often built their houses off the ground, presumably to

get easy access to the plumbing and also to help cool the interior during the long hot summers. My job was to explore the crawlspace on hands and knees in order to check the cloth wrappings kept tied in place as insulation for the exposed pipes. This squashed space, dirt-floored and cobweb-hung, was my territory. I found it a good place to hide things I didn't want my parents to see.

The people of South Alabama, living on the fringe of the subtropics, have never fully accepted the concept of winter. Oranges and satsumas had been grown in the vicinity of Mobile as early as 1878. In 1915, entrepreneurs named a satellite town Satsuma in the belief that the region could support a citrus-growing industry. In the 1920s, unfortunately, outbreaks of a bacterial disease called citrus canker, combined with a few prolonged hard freezes, ended the dream.

Seafood, on the other hand, was abundant and cheap. On weekends during the impoverished 1930s my father and two of his brothers used to sit on the back steps of the Charleston house to talk, drink what I presume was newly legal beer, and shuck fresh oysters out of a croaker sack. I don't know what they paid for the oysters, but I'll bet it was under a dollar. Once, when I was four, they handed me an oyster and showed me how to slurp it raw off the half-shell. It tasted terrible. When they offered a second one, I asked if the first had been a boy or a girl. Uncle Harry said it was a boy. I asked if I could try a girl oyster. This second one they handed me tasted awful too. (Actually, you can't tell gender from the shell alone, and, unknown at the time, individual oysters can switch their genders.) Ever since, I've eaten oysters only if fried, if you wish to know, preferably served with balls of seasoned corn meal called hush puppies, also fried.

The back steps led inside to a large screened-in porch with an icebox and garden tools, together with three zinc tubs and a scrub board for use on laundry day, which was each Wednesday. Next to the door was a table temporarily reserved for my black widow spiders. I should confess that, by the age of twelve, I had become fascinated with insects and other creepy-crawlies and decided with complete certitude that, upon growing up, I would be an entomologist. The poisonous black widows were kept in large jars with holes punched in the lids to let in air. All were adult females and territorial, so I could put no more than one in each jar.

BILLY RICE AT AUTREY'S FISH CAMP, MOBILE CAUSEWAY

No one in the family or around the neighborhood questioned my menacing little collection. People thereabouts were generally unconcerned about such things, so long as it did not place their persons in imminent danger. By unspoken understanding, what you did was your own business. I also benefited from the wide latitude generally given eccentrics in the Deep South. There was moreover a generous tolerance for firearms. You could still fire guns within the city limits of Mobile at that time, even in residential areas near the center of the city—providing you had not previously come to the attention of the police for noisy domestic dispute or threats to your neighbors. Each Fourth of July my father, with no evident thought that it was unusual, discharged his shotgun out the back door and into the ground, with two blasts as fast as he could, *bang! bang!* Shotguns, he said, were better than firecrackers, of which all kinds were also still allowed (my favorite were cherry bombs, containing tiny amounts of powder that exploded on contact with a hard surface).

So who was to say a boy entomologist couldn't keep black widow spiders in his home? These spectacular poisonous creatures, dwellers of hidden spaces, hanging upside down in tangled webs, their large glistening ebony bodies decorated with bright red hourglass patches on their undersides, these scourges of country people who still used outhouses with a hole in the bench, were abundant in vacant lots around the neighborhood under discarded whiskey bottles, pieces of broken lumber, and other such detritus. I scooped them up in bottles and watched them spin their webs. I fed them live insects collected at night around the back-porch light.

Black widows, along with the dozens of species of butterflies in South Alabama I collected and pinned, and fire ants, whose nests I kicked open to watch the inhabitants swarm out, were my private version of wildlife. I never took much interest in birds. The bear and alligators I might have seen when cycling along the nearby Mobile Bay Causeway had long ago been shot out. It was a time when virtually every adult male owned a rifle or pistol of some kind or another, and it was considered good sport by many—my father, sad to report, included—to go out in the country and shoot at anything that moved. That is, so long as it was not domestic stock or near a building occupied by people.

WEEKS BAY RESERVE, FAIRHOPE

While I was in the seventh grade in Barton Academy on Government Street, at that time a public school, I was one of the students invited by the Mobile Chamber of Commerce to come to one of their luncheons and talk about our special projects. I brought along a bottled black widow and gave a five-minute lecture, in what must have been a reedy soprano, on the habits of *Latrodectus mactans*. At the conclusion, I received polite applause from the otherwise deadpan businessmen. Their secretary sent a note to my parents afterward saying what a bright boy I was.

Two years later, my interests had turned to snakes. I became what might have been the only herpetologist active in Mobile at that time, which I admit was not a distinction worth boasting about. There were some forty species teeming in abundance around Mobile. As a reward for my odd interests and perhaps with some credit due the black widows, I was invited to be the nature counselor at Camp Pushmataha, the Boy Scout summer camp in nearby Citronelle. At fourteen years of age, one hundred pounds, and with a still squeaky voice, I made my living that summer mostly by catching and lecturing on snakes. My fellow Scouts responded enthusiastically when I put them on a perpetual snake hunt in the woods around Pushmataha. Whenever one was found, a shout was relayed from boy to boy, *Snake! Snake! Snake!*, and I and every other Scout within earshot came running. We didn't kill any of the ones we found, which was an act of mercy contrary to one of the two absolute dictums of Alabama country folk. (The other one was to shoot all broad-winged hawks, generically classified as "chicken hawks" and wrongly believed to be deadly enemies of poultry.) Instead, we kept some of the most interesting specimens in screened cages and released the rest. I ran this enterprise nonstop day and night through the summer, except for one week spent back on Charleston Street recovering from the bite of a pygmy rattlesnake.

At the end of the summer, I was voted the second most popular staffer, topped only by the senior counselor. My niche in life was now chosen. Pushmataha-programmed, I was to follow a life as a naturalist and teacher.

I have since lived in other towns and cities, traveled over much of the world, worked almost all of my adult life at Harvard University, and learned to speak with a television newscaster accent for greater speed. But as the years passed I came to realize that I always was, and will remain in the years

BASS PRO OUTDOOR WORLD, SPANISH FORT

BOYKIN LODGE, McINTOSH

INDIAN MOUND STATE PARK, DAUPHIN ISLAND

left to me, a Mobilian. There my spirit chose to live. Rational ambition could never persuade it to leave.

It has grown apparent to me that the character of Mobile is due in part to the isolating effect of its geography. To the south is the Gulf of Mexico and a string of barrier islands. Immediate to the east is Mobile Bay, a broad body of layered fresh-and-brackish water almost completely landlocked by Fort Morgan Peninsula and entered from the Gulf only through a strait of shallow water crisscrossed by shifting sandbars. Ninety miles farther east on the coast is Pensacola, a thriving little port city at the tip of the Florida panhandle. Beyond Pensacola stretches the main part of the panhandle itself, the "Other Florida," whose forests and wetlands have remained relatively undeveloped even into the twenty-first century.

Some of my forebears knew of these barriers to travel out of Mobile firsthand. My great-grandfather William Christopher Wilson—"Black Bill" to his friends—was a bar pilot who, in the 1840s and 1850s, guided ships back and forth across the sand drifts at the bay's entrance. He and his family lived in Pilottown, near the tip of Fort Morgan Peninsula, directly on the shore of the Gulf and in first sight of arriving ships as their sails broke the horizon. When war broke out in 1861 and Admiral Farragut's fleet closed entrance to the bay, Black Bill switched to blockade-running on his pilot cutter. He was captured by the Union fleet on one of the runs from Havana, Cuba, laden with supplies for Mobile.

Farragut badly needed a pilot for the breakthrough into Mobile Bay. The idea in seizing the bay was to put the city under cannonfire and create a pincer on the defenders while Union troops approached from the northwest and east. He could not afford to have his ships run aground on the sandbars and receive fire from the forts on either side. The mines ("torpedoes") Confederates had planted in the channel would be bad enough, but he knew the fleet could absorb the damage they would inflict if it moved quickly. When, in fact, one ship did hit a mine, Farragut shouted his immortal order: "Damn the torpedoes, full speed ahead."

But, before he could do anything at all, the great Union admiral had to have a bar pilot. When Black Bill was brought before him, Farragut offered a substantial sum of money, passage to a Northern city for him and his family,

a job there, and the Congressional Medal of Honor, at least if his performance deserved it. My great-grandfather's response was, "I'll see the whole Yankee fleet in hell before I betray my country." He was immediately sent off to prison as a common criminal, classified as such because he was not an officer in the Confederate Navy and therefore simply a civilian who had broken federal civil law. He ended up in Fort Warren in Boston Harbor, at the high-security prison where naval officers and blockade-runners were kept. The special treatment, or perhaps more accurately mistreatment, was due to the high price the Union effort would pay if the blockades of the Confederate ports were compromised. When the war ended, Black Bill's sentence was extended for a year for "insubordination" (spitting on an officer, according to the story passed cheerfully down in the family). During part of this time, he shared prison quarters with Alexander H. Stephens, the newly captured vice president of the Confederacy.

Meanwhile, Farragut got his pilot in Martin Freeman, a Mississippian who had signed on to the Union Navy in Louisiana. Brought to the fleet outside Mobile for the job, he guided the Union ships into Mobile Bay with exceptional skill and bravery. In the eyes of other, still loyal Confederates, he became, I might add, the only person ever to receive the Congressional Medal of Honor for betraying his country.

Upon release, Black Bill Wilson was given passage by ship from Boston south to the Florida Keys and then north along the Gulf Coast to Tampa. Dumped there, he had to travel flat broke and shank's mare the rest of the way home. He walked half the length of the Florida Peninsula and then, coming onto the Old Spanish Trail, he turned westward, walking the entire length of the panhandle to the Alabama border. Along the route he had to talk his way onto ferry rides across all of the rivers that flow south out of their own watersheds across the panhandle. Florida was mostly lawless and in places dangerous at that time, just as John Muir found it when at the same time he trekked across the state, later described in *A Thousand-Mile Walk to the Gulf*.

Mobile has always been isolated by the parallel rivers of the kind encountered by Black Bill. One after another they run south across the coastal plain, from the Pascagoula near the Mississippi state line to the Perdido on the Florida border, and then on to the Escambia, Coldwater,

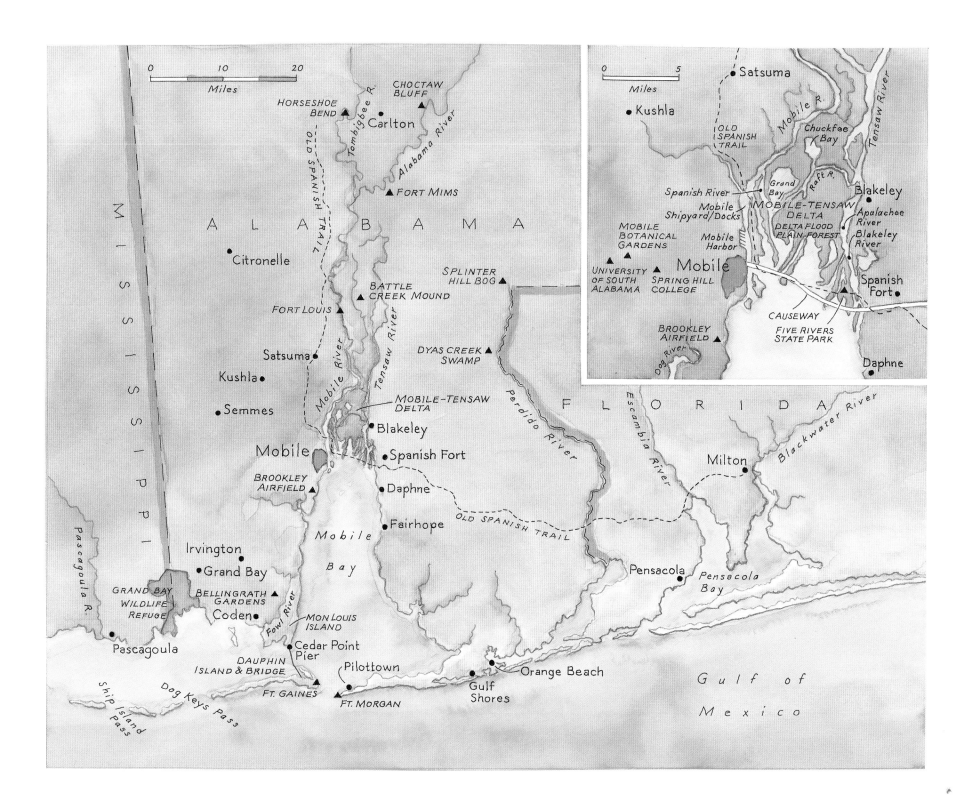

Main map labels:

MISSISSIPPI

ALABAMA

FLORIDA

CHOCTAW BLUFF ▲

HORSESHOE BEND ▲

Carlton

OLD SPANISH TRAIL

Tombigbee R.

Alabama River

FORT MIMS ▲

Citronelle

BATTLE CREEK MOUND ▲

SPLINTER HILL BOG ▲

FORT LOUIS ▲

Tensaw River

Mobile River

Satsuma

DYAS CREEK SWAMP ▲

Kushla

Perdido River

Semmes

MOBILE-TENSAW DELTA

Blakeley

Escambia River

Blackwater River

Mobile

Spanish Fort

BROOKLEY AIRFIELD ▲

Daphne

Milton

Fairhope

OLD SPANISH TRAIL

Pascagoula R.

Mobile Bay

Pensacola

Pensacola Bay

Irvington

Grand Bay

GRAND BAY WILDLIFE REFUGE

BELLINGRATH GARDENS ▲

Fowl River

Coden

MON LOUIS ISLAND

Pascagoula

Cedar Point Pier

DAUPHIN ISLAND & BRIDGE

Pilottown

Orange Beach

Ship Island Pass

Dog Keys Pass

FT. GAINES ▲

FT. MORGAN ▲

Gulf Shores

Gulf of Mexico

Inset map labels:

Satsuma

Kushla

OLD SPANISH TRAIL

Mobile R.

Tensaw River

Chuckfee Bay

Spanish River

Grand Bay

Raft R.

Blakeley

MOBILE-TENSAW DELTA

Mobile Shipyard/Docks

Apalachee River

MOBILE BOTANICAL GARDENS

Mobile Harbor

DELTA FLOOD PLAIN FOREST

Blakeley River

UNIVERSITY OF SOUTH ALABAMA ▲

SPRING HILL COLLEGE ▲

Mobile

Spanish Fort ▲

CAUSEWAY

FIVE RIVERS STATE PARK

BROOKLEY AIRFIELD ▲

Dog River

Daphne

0 5 Miles

Blackwater, Choctawhatchee, Apalachicola, Ochlocknee, Auchilla, Ecoph-ina, and Suwannee. Flanked by dense floodplain forests and ending in del-taic swamps, they dissect the flatland into neat geographic segments.

Unless Mobilians wanted more wilderness, of which they already had plenty, there was little of immediate value east of Pensacola. Black Bill and, later, his son (my grandfather, Harry Maury Wilson), an engineer on a train between Mobile and Pensacola in the 1890s and early 1900s, thought ill of the Florida panhandle. It had few respectable harbors, a lot of yellow fever and malaria, and its people were still struggling up from neglect suffered during its Spanish colonial past. When, half a century later, I was nature counselor at a Boy Scout camp near Pensacola (continuing my career the year after Pushmataha), I went searching for the Old Spanish Trail. This relict is a red-brick road, although now mostly converted to asphalt, that still runs along the panhandle from Tallahassee west to the little town of Milton, just outside Pensacola. I found an abandoned segment, partly covered with windblown white sand, in woodland on the west banks of the Blackwater River. As I walked along, I thought of Black Bill, homeward bound on these same bricks, tired but happy that the terrible war was over and he was alive and, thank the Good Lord, Mobile only three days' journey away.

To the northeast of Mobile, looking the same today as it did when the first French colonists arrived in 1702, is another barrier to the city—the floodplain forest, bounded on the west by the Mobile River and on the east by the Apalachee and other terminal branches of the Tensaw River. This delta, 500 square miles in extent, is covered by a lacework of tributary creeks, streams, and hidden oxbow lakes. There are earthen rises here and there on which habitable structures might be built, but the environment as a whole is half land, half water, with most of the land periodically flooded. It is almost an impenetrable jungle on foot. An elevated highway has been built across its northern sector, but anyone wanting to reach Florida from Mobile directly has to do so by boat or drive there by automobile over the eight-mile-long causeway bordering the northern edge of Mobile Bay.

Finally, to complete nature's enduring encirclement of Mobile, there is the Pascagoula River to the west, just over the border in Mississippi, one of the last completely free-running rivers in the continental United States, with

MOBILE DELTA

no dams yet to impound it. Like the coastal rivers to the east, the Pascagoula is bracketed by a floodplain swamp forest.

One of the consequences of the geographic isolation of Mobile is that its citizens have never had easy access to the beach. If you travel out of town in search of the Gulf of Mexico without leaving Alabama, you will end up at the mud banks of Cedar Point and Coden. Still ahead, across the western channel of Mobile Bay, lies Dauphin Island and, out of sight beyond, the Gulf of Mexico. Dauphin Island can be reached only by boat or a mile-long bridge. On the island are found modest vacation homes, Alabama's marine biological station, and, for the brief period in the spring when swarms of exhausted migratory songbirds make landfall from Yucatán, the site for bird-watching ranked one of the best ten in the world. At the western end is a long spit of land from which private fishing shacks are periodically swept away by hurricanes. At the opposite, eastern side is one of the two Civil War–era forts whose guns and mines forced Admiral Farragut to hurry his fleet through the strait during the Battle of Mobile. During the early French period, the island had a little bay of its own that served as the principal port of call for the larger Mobile Bay area.

Dauphin Island, while an exceptionally interesting place for its biology and history, also possesses a little beachfront of expected Gulf Coast quality. Few go all the way there, however, expressly to use this beach, even though the sand and seashells strewn along the surf would probably be found more than suitable if they were instead in New England—at least in July and August, when the brave and hardy finally find water warm enough to enter.

For fun and sun, Mobilians prefer to travel instead all the way over the Mobile Bay Causeway to reach Baldwin County, then another considerable distance south to reach Gulf Shores at the base of the Fort Morgan Peninsula. There, at last, one finds a long stretch of the sugar white sand and warm turquoise waters expected of the Gulf of Mexico. Once sparsely inhabited and called the Redneck Riviera, it is now at risk of being swallowed up by condos in what real estate developers further east like to call the Emerald Coast. At Gulf Shores, however, you are at least, mercifully, still in Alabama. I say mercifully, because Mobile and the south coast of Alabama, consisting mostly of the Fort Morgan Peninsula and Dauphin Island, have been at least partly sheltered from the debilitating emanations coming out of Florida.

GULF SHORES

GULF SHORES

For beach and surf of expected quality, there is also the Mississippi coast beyond the Pascagoula delta. A magnet for Mobilians, even if on foreign soil, it is, however, notoriously crowded and unstable. In intervals between major hurricanes that roar through the wide Ship Island Pass and Dog Keys Pass and wipe everything clean, the beaches are built up with resorts, casinos, and private homes. The whole is not as alien a shoreline as Florida, but it is still non-Alabamian.

I admit that I nevertheless love this little strip of Mississippi. When I was seven years old, I was taken there to enter the Gulf Coast Military Academy (GCMA), located between Biloxi and Gulfport. (More precisely, I was parked there for six months while my parents were being divorced.) It was an introduction to the powerful militaristic culture of the Old South as shocking for a boy as a Southern Baptist full-body dunk in a tank of water (that was to come later). I hated the GCMA most of the time I was there as a junior cadet, but I got used to it toward the end and in time, after I left, came to respect deeply the impression it made on me. GCMA, with its gray uniforms and weekly polished brass buckles, is gone now, closed in 1976, but it was tough and disciplined enough during the 1930s to be nationally ranked each year as a West Point Honors Academy, which meant that its honors graduates were automatically admitted to their choice of West Point or Annapolis. GCMA's graduates include generals, admirals, and many officers who won America's highest military honors in World War II, Korea, and Vietnam. I wrote accurately and admiringly of the Gulf Coast Military Academy in my 1994 memoir, *Naturalist*, and was immensely pleased to learn that the alumni took to reading out loud the passages I had written at each of their annual meetings. They also made me an Honorary Junior Cadet, the first and only one ever.

THE BEGINNING

You cannot understand the uniqueness of present-day Mobile unless you know its history as an inspirational and flawed epic played out over five centuries.*

*The colonial history of Mobile recounted here has been based substantially on Jay Higginbotham, "Discovery, Exploration, and Colonization of Mobile Bay," pp. 3–28, and Richmond F. Brown, "Colonial Mobile, 1712–1813," pp. 29–63, both in Michael V. R. Thomason, ed., *Mobile: The New History of Alabama's First City* (Tuscaloosa: University of Alabama Press, 2011); and further, Richmond F. Brown, *Coastal Encounters: The Transformation of the Gulf South in the Eighteenth Century* (Lincoln: University of Nebraska Press, 2007).

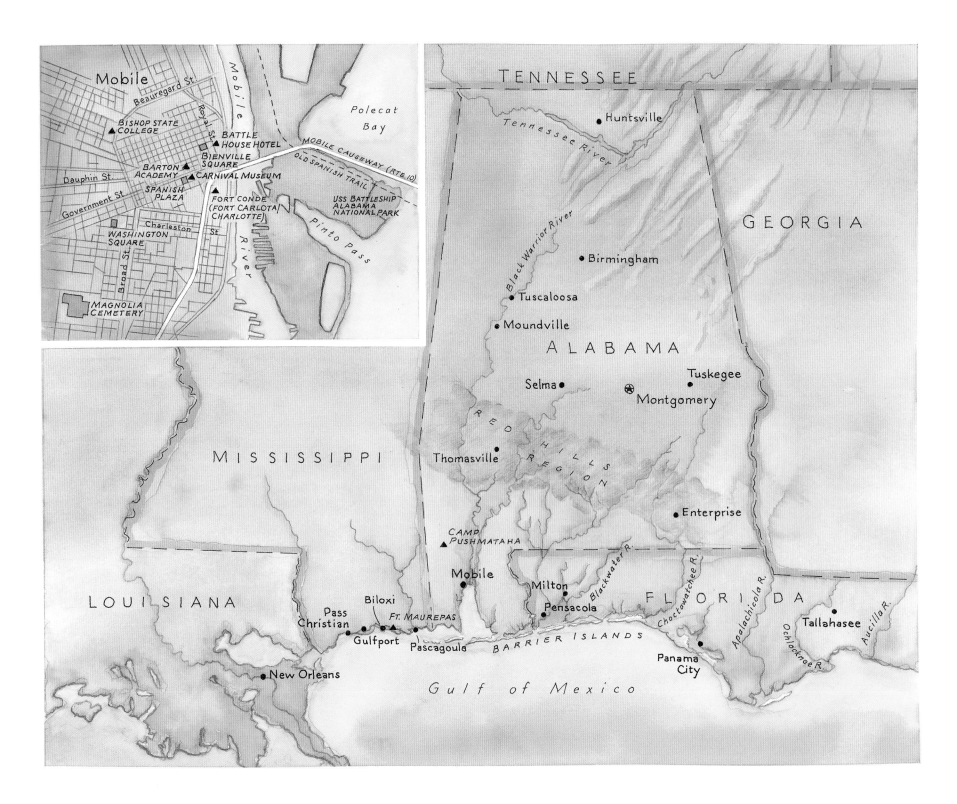

Mobile

Beauregard St.

BISHOP STATE COLLEGE

BATTLE HOUSE HOTEL

Royal St.

BIENVILLE SQUARE

BARTON ACADEMY

CARNIVAL MUSEUM

Dauphin St.

SPANISH PLAZA

Government St.

FORT CONDE (FORT CARLOTA/CHARLOTTE)

Charleston St.

Broad St.

WASHINGTON SQUARE

MAGNOLIA CEMETERY

Mobile River

Polecat Bay

MOBILE CAUSEWAY (RTE.10)

OLD SPANISH TRAIL

USS BATTLESHIP ALABAMA NATIONAL PARK

Pinto Pass

River

TENNESSEE

GEORGIA

ALABAMA

Tennessee River

Huntsville

Black Warrior River

Birmingham

Tuscaloosa

Moundville

Selma

Tuskegee

Montgomery

RED HILLS REGION

Thomasville

Enterprise

MISSISSIPPI

CAMP PUSHMATAHA

Mobile

LOUISIANA

Biloxi

Pass Christian

Ft. MAUREPAS

Gulfport

Pascagoula

Milton

Pensacola

Blackwater R.

FLORIDA

Choctawatchee R.

Apalachicola R.

Ochlocknee R.

Aucilla R.

Tallahasee

BARRIER ISLANDS

New Orleans

Panama City

Gulf of Mexico

The first written record of any place that can be called Mobile was the Indian village of Mauvila, located at a still unknown distance north of the present city. Mauvila was the principal home of the "petite nation" known in later years as the Mobilians, one among smaller tribes in the area that also included Biloxi, Pensacola, Pascagoula, Grand Tomeh, and Little Tomeh.

Mauvila was discovered by Hernando de Soto in 1540, and within hours he wiped it out. This "most decisive event," as some historians have called it, foreshadowed the relationship between the native peoples and European and American settlers for the next three centuries. The circumstances are not entirely clear after half a millennium, but what happened in essence is reliably recorded. De Soto, then governor and captain general of Cuba, was returning from the first extensive exploration into what is today the southeastern United States. He and his 600 conquistadors had been unsuccessful in their attempt to discover mines of precious metal and other treasures like those looted by their predecessors in Mexico and South America, and they were tired and discouraged. The little army, after departing from northern Georgia, had marched southwestward along river courses to the piedmont of west-central Alabama. There, Hernando de Soto met the region's paramount chief, Tascalusa. In the usual imperious Spanish manner, he demanded food, services, and women. Tascalusa, at first inclined to be friendly, quickly turned wary and apprehensive. Afraid to confront the Spanish directly, he temporized by suggesting that they proceed further downriver to Mauvila, in order there to fill out de Soto's list.

Tascalusa's response was likely that evinced by most native people around the world when confronted by an invading force from a radically different and well-armed culture. We can easily imagine that his impulses were conflicted. On the one hand, he would wish to take the measure of the Spanish as possible future trading partners and allies against his enemies. This has been the ultimately fatal strategy of indigenous people throughout the Americas. Yet he surely also recognized the peril of his situation. One wrong step too far toward either submission or confrontation could lead to disaster.

So, on arriving at Mauvila, Tascalusa decided to do nothing—at least for a while. He simply walked into one of the cabins and stayed there, with his guards posted outside, apparently hoping the conquistadors would tire of

waiting and leave the village. Instead, de Soto quickly grew impatient and sent three of his lieutenants to fetch the chief. Tascalusa's guards resisted, a scuffle ensued, and a guard was killed by a blow from one of the Spaniards. The murder triggered a wave of fighting that spread throughout the village. Somehow a fire was started, and soon all of Mauvila was ablaze. In the end, half of the 3,000 inhabitants lay dead. De Soto lost twenty men, and many of the others suffered crippling injuries. Lost also to the Spanish force were its women and children and a large part of its equipment and valuables. Thus ended Hernando de Soto's conquest of what was at that time called *La Florida*.

The Spanish could scarcely appreciate after the battle (or, more accurately put, the massacre) that Mauvila was not a mere savage encampment but a town at the edge of a civilization based on widespread trade and ruled by paramount chiefs. It was a satellite of the Mississippian mound-building culture that extended from the Mississippi River valley to northern Florida. Close to Mauvila, apparently unknown to the Spaniards, was a local center of the culture. It was located on Mound Island, a large, partly flooded tract in the upper reach of the Mobile-Tensaw Delta. It is today well hidden in dense floodplain forest, and the same was likely true in de Soto's time. The Bottle Creek site, as it is called by archaeologists, was occupied between AD 1250 and 1550 by people of the Pensacola variant of Mississippian mound-building culture. The location was clearly chosen for its strategic advantages. The settlement was, first of all, well protected by the swampy environment. It was close to the juncture of the major rivers leading to Mobile Bay. It had access to rich local resources and was within reach of trade routes among the villages of the region.

The Bottle Creek town, the inelegant name by which it is identified today, possessed the Pensacola variant of the Mississippian Mound Culture, characterized by the use of mollusk shells in the tempering of pottery. In both size and complexity of construction, it has been ranked by archaeologists as second only to the grand center at Moundville farther north near Tuscaloosa along the Black Warrior River. Before the coming of the Europeans, it was the cultural, social, and religious center of present-day southwestern Alabama.

TRAIL TO THE BOTTLE CREEK INDIAN MOUND, MOBILE DELTA

I became briefly aware of the larger mound culture to which Bottle Creek belonged, without understanding its significance, when as a fifteen-year-old I was serving as the nature counselor at Big Heart Boy Scout Summer Camp on the north shore of Pensacola Bay, the same from which I found the Old Spanish Trail. Down the beach a short distance away, my friends and I discovered the midden — essentially, a garbage dump — of a mound village. Its edge, extending across the narrow beach, was being slowly eroded away by the gentle bay surf. We enjoyed wading through the clear water in search of decorated pottery fragments. One of the gang came up with the sculpted clay figure of a human head of the kind also found, although unknown to us, at Bottle Creek.

Fifty years later, in the company of a ranger guide, I walked overland to Bottle Creek under the dense shade of the floodplain's forest canopy, easing around water-filled sloughs, fallen tree trunks, and saturated muck beds. A large water snake threatened us with open jaws as we worked past it, evoking no concern because we knew it was not venomous. An equally large cottonmouth moccasin, definitely venomous, turned and slid away as we approached. I cannot expect readers to share my emotion when I say I was thrilled to experience this swampworthy sample of wildlife.

Archaeologists come to Bottle Creek with their equipment and alertness to wildlife from another direction by a watery route, as described by Ian W. Brown in *Bottle Creek: A Pensacola Culture Site in South Alabama*. The whole operation he found to be "something just shy of a nightmare":

You launch your boat out into the Mobile [River] at Mt. Vernon Landing. Make sure you have plenty of life preservers, a paddle, and an extra tank of gas. An extra motor boat wouldn't hurt either, as you never know. Check to make sure you have your poncho, as you do know. Avoid barge by steering sharply to the right. Arrange man on bow to serve as sentry in crossing the river. Turn left into Tensaw River. Cruise at medium speed down this gently meandering river. Spot egrets, ospreys, and other forms of wildlife, but take care. If water is high, watch out for floating debris. If low, look for sawyers [loggers]. Continue on Tensaw River, avoiding Middle River to

your right. Less than a mile turn right at Bottle Creek, aptly named. There's a bottleneck at the headwaters, so if the water is low, steer well to the right (starboard, west, whatever, just do it). Proceed at rapid clip; everyone else does. There is not much traffic at this time of day, but look out for logs hanging from helicopter. Stop at high bank to the right and tie up to poison ivy vine–wrapped trees. Tie loosely as tidal waters sink boats, or so I've been told. Form a human chain and empty boat of equipment. Store boat accessories beneath palmettos. First check underside of palmettos for hornets' nests.

Rearrange backpack and don deerfly headgear. Have a crew member take the lead (advisable to choose a different person each day). Keep one hand free as you approach trail. Trail is recognizable as a thin stream, bordered by slightly higher land on either side. Watch out for water moccasins on slightly higher land. They will see you so not to worry. Note scuffmarks made by alligator tails on the ground and bear claw marks high on trees. Refrain from obvious curiosity and stay on trail. About a half mile into your walk stop abruptly at a mountain. This is Mound A. Note that you are standing on pottery, shell, and other debris.

I climbed up myself to the top of Mound A, forty-five feet high, to explore this principal construction of the Bottle Creek town. Upon it I knew rested, centuries ago, either the house of a chief or the principal ceremonial building. From one side below and near the base stretched the plaza of the town. All around, forming an ellipse a kilometer long, were arranged seventeen smaller mounds, presumably used as habitations by common people or for lesser functions. Beyond the western tip of the ellipse, turning north to approach the Tensaw River a kilometer away, is a channel once thought to be the canal by which the inhabitants paddled dugout canoes back and forth to the outside world but now considered to be a natural feature of the landscape. My feelings as I stood on Mound A were partly simple curiosity and partly spiritual. In this unlikely spot, swallowed by a still-existing Alabama wilderness, was the preserved home of a vanished civilization. It was already old when Hernando de Soto marched close by five centuries ago.

NEAR BOTTLE CREEK INDIAN MOUND, MOBILE DELTA

Its Neolithic lineage, extending back on the North American continent for 10,000 years, was as old as the Western lineage, also Neolithic, from which I had come. Its story very much belongs in the history of Alabama.

THE COLONIAL PERIOD

Hernando de Soto's misadventure at Mauvila in 1540 did not discourage the Spanish from further attempts to exploit the region. For the next century they held sway over the South Atlantic and Gulf coasts. But their attention was focused elsewhere, to the far greater riches their conquests had yielded in Mexico, Central America, and South America. They invested relatively little in *La Florida*, which had proven consistently disappointing.

In any case, the style of the Spanish did not suit colonization of the Gulf Coast or anywhere else, for that matter, at least during the critical early decades of European settlement of the Americas. Their preference was to discover populous kingdoms and paramount chiefdoms rich in gold and other treasure, conquer and rob them, and set up plantations serviced by slaves. These opportunities were absent on the coast of *La Florida*. One attempt to establish a permanent presence was led in 1559 by Tristán de Luna. More than 1,000 would-be colonists put ashore on the lower east side of Mobile Bay, but even with an abundant potential food supply the experiment soon ended with near starvation and the threat of mutiny, and the entire community returned to the colonial headquarters at Havana.

After the passage of another century, the growing threat of French colonization in the vicinity finally persuaded the Spanish crown to establish at least a fortification on the central Gulf Coast. The choice of location narrowed down to either Pensacola Bay or Mobile Bay. On the advice of the cartographer Carlos de Sigüenza y Góngera, in what was surely the first application of science to foreign policy in this part of the world, Pensacola won. In the 1690s, the redoubt was built.

This event proved to be decisive in the political future of the region. It helps to explain, among other things, a geographic anomaly in the map of the United States. Alabama awkwardly reaches the Gulf of Mexico solely through a narrow segment bracketing Mobile. The entire coastal plain to the

east, closing off the remainder of Alabama from the Gulf, is part of the state of Florida. The reason for the short-changing of Alabama is that, following the Louisiana Purchase by the United States from France in 1803, the status of Mobile, being close to the eastern fringe of the accession, remained ambiguous. President Madison decided that it should be American. A small Spanish garrison of 130 men occupied Fort Condé (called Fort Carlota at that time). They soon surrendered, in 1813, to an American command of eight hundred men and five gunboats. The Spanish force was evacuated to Pensacola, ninety miles to the east. When Alabama was admitted to the Union as a state in 1819, the panhandle, including Pensacola, was still in the hands of the irresolute Spanish. The United States purchased Florida from them the same year but did not admit the territory as a state until 1845. By that time it was too late, and the populations of South Alabama and the Florida panhandle were still too sparse, to make a change in geography compelling.

On occasion I've asked Alabamians why the state doesn't ask for the panhandle as simple geographic justice, so our state could have a decent amount of oceanfront—especially given that Florida has a superabundance of beaches elsewhere up and down its two coasts. I have invariably been met with a puzzled look. Two centuries of schoolchildren drawing a truncated map of Alabama, and the fear through the rest of America of raising the issue of states' rights again, obviously have had an enduring effect. Sadly, the still-uncomplaining Alabamians are forced to traverse part of Florida in order to get to what should be part of their beach.

From the beginning of the colonial era the near vacuum of Spanish activity on the Gulf Coast began to be filled by other European powers. During the early 1600s, the French, after establishing domain over the St. Lawrence River, in eastern Canada, began to explore southward along the Mississippi River. In 1682, following Cavelier de La Salle's historic voyage from the Great Lakes region to the mouth of the great river at present-day New Orleans, France claimed the entire Mississippi Valley. Within a short time, Versailles lay further claim to the greater part of the Gulf Coast, from Matagorda Bay in Texas all the way east to the Perdido River just east of Mobile. This intrusion by its chief colonial rival in North America spurred the Spanish crown to make its own strong countermove.

When an expedition led by Pierre Le Moyne d'Iberville under the auspices of the French crown came to Pensacola in 1698, they found the harbor at Pensacola securely in Spanish hands. Iberville began to search westward along the Gulf Coast for another base of comparable value. He soon encountered Dauphin Island, the principal barrier island of South Alabama. Naming it Massacre Island because of the many bones found in Indian ceremonial mounds there, he also explored the entrance of Mobile Bay itself but failed to grasp the extent and promise of this larger body of water and the two great rivers that empty into it. So Iberville, France's greatest naval hero and conqueror of Canada, sailed on and chose an inferior harbor immediately to the west, at present-day Biloxi. There he built Fort Maurepas and returned to France.

Two years later, in 1700, Charles Levasseur pushed on past Dauphin Island and recognized the full advantages of Mobile Bay. He immediately understood the potential of the Mobile and Tensaw rivers and the promise further north of the Alabama and Tombigbee rivers that feed the deltaic rivers. The advantages of the geography were obvious: Mobile Bay could protect a large fleet of ships gathered at single anchorage, and commerce could be safely conducted with Indian tribes around the bay and thence far into the interior. Moreover, these people— the Mobilians, Alabama, and Grand and Little Tomeh— seemed peaceable. Clearly, colonies could be established along the river courses. France understood better than Spain that no empire can hold for long the territories it claims unless the land is filled with its own citizens.

With demographic conquest in mind, Jean-Baptiste Le Moyne Bienville, Charles Levasseur, and Joseph Le Moyne de Sérigny sailed up the Mobile River to a settlement of the native Mobilians where, on January 13, 1702, they found a bluff rising to a safe height above the river waters. There, they decided a colony might be founded. Iberville, having returned to the Gulf Coast and recovering from an illness in Pensacola, ordered Bienville to proceed. Construct, he wrote, a wooden fort on the bluff, to be named in honor of the Sun King, Louis XIV. By the end of 1702, Fort Louis and the first houses and streets around it had been constructed and were receiving the first settlers.

Thus was born Old Mobile, more precisely French Mobile, the first European settlement of the bay area and the first in what was to become the state of Alabama. Just nine years later, however, following outbreaks of disease and flooding in the little village, Bienville ordered the settlement to be moved to its present site at the northwest corner of Mobile Bay. In 1723, the colonists began the construction of a new fort, made this time of brick and with a stone foundation. It was named Fort Condé, after Louis Henri, duc de Bourbon and prince de Condé.

For the remainder of its history, like Pensacola to the east, Mobile was to be governed under five flags in succession:

1702–63	France
1763–80	England
1780–13	Spain
1813–61	United States of America
1861–65	Confederate States of America
1865–	United States of America

During the eighteenth century, the European colonial powers established settlements along the Gulf of Mexico with the overriding motive of laying claim to the best harbors and the territory that could be reached inland through them. The colonists, they reasoned, would on their own find the best way to extract wealth from the land and its indigenous people. They understood from the start that little gold or treasure of any kind was in prospect and that wealth would at first have to be built by trade with the natives.

Yet intimacy with the Indian tribes carried a risk. Early on, it was clear to the French that bachelors among the immigrants would be inclined out of necessity to find wives in the populous Indian tribes surrounding them. If uncontrolled, such marriages would quickly dilute not only European blood but also allegiance to the mother country. So, at the very beginning of upriver Old Mobile, the French selected twenty-three young women, mostly from convents and orphanages in Paris, to be transported to the colony as marital prospects. The ones chosen for the honor were those "reared in virtue and piety" and "accustomed to labor and diligence." And indeed they proved up to the task. Upon arriving, they endured with remarkable courage

all the hardships of colonial life. The young women and the husbands they chose gave rise to what were eventually among the most prolific families of the colonial Gulf Coast, including the Rivards, Sauciers, Trépaniers, and Trudeaus.

French Louisiana, with Mobile as the first capital, was unfortunately not in any way a pleasant place to live. Antoine de la Mothe Cadillac, arriving as the new governor in 1713, could describe Mobile in less than glowing chamber of commerce terms.

Here there is nothing more than the piled up dregs of Canada, jailbirds who escaped the rope, without any subordination to Religion or the Government, steeped in vice, principally in their concubinage with savage women, whom they prefer to French girls.

The population of Old Mobile grew slowly. By 1726 it was 547, of which 261 were unencumbered French citizens, in particular 93 men, 72 women, and 96 children. There were 144 African slaves and 30 Indian slaves; also present were 7 indentured servants and 85 soldiers. The colony suffered a crisis in 1733, when it was struck by both a major hurricane and a smallpox epidemic. Help from the mother country was negligible, and available supplies ran severely short. In desperation, the Mobile commander, Dartaguiette d'Iron, wrote to the colonial sponsors: "Our planters and merchants here are dying of hunger. Some are clamoring to return to France; others secretly run away to the Spaniards at Pensacola. The colony is on the verge of being depopulated."

No growth ensued in the decades to follow. When, in 1763, possession of Mobile passed to the British by the Treaty of Paris, as part of the concessions that ended the Seven Years' War, there were still only 350 townspeople, along with about 90 families scattered through the surrounding countryside. It is easy to imagine that the French were glad to be rid of Mobile. Fort Condé was crumbling, the ramparts were covered by weeds and bushes, and Indians wandered in and out of the entrance at will. Charles Strachan, a merchant who arrived in 1764, soon to suffer financial ruin, found the town "The most disagreeable and unhealthy place in America." He reported to his sponsors in Georgia that the populace was starving, and "most of the people

have already left and the rest are preparing to quit Mobile as soon as possible so that in short time, I expect it to be entirely deserted."

Yet the Mobilians did not entirely abandon their little village. Within four years under British rule they began to turn the economy around. Local crops improved enough to make the residents self-sufficient, although they still suffered periodic shortages of flour, rice, and beef. Plantation owners, with sizable land grants and growing populations of slaves, even obtained a measure of prosperity. The present-day historian Richmond F. Brown has described, for the later part of the British colonial period, the prototype of the great plantations that were thereafter to be the dominant features of agriculture in the southern coastal plain:

A typical planter would have a couple of dozen slaves to work his estate of between one and two thousand acres, of which he cleared less than one-tenth. He would plant corn and perhaps some rice. Some tried indigo and others tobacco, usually with disappointing results. Lumber and cattle were the most reliable endeavors. The planter kept a garden plot near his house and maintained a few fruit trees or perhaps a small orchard. He would build fences to keep cattle from trampling crops, a shed to house milk cows, and a barn for horses. Smaller animals and fowl were penned up, but hogs ran loose. His house was built with timber cut and trimmed on the site, its siding covered by weatherboard on the outside and plastered on the inside. A shingled roof extended on all sides to form a veranda. The design was simple, with few doors and windows. Floors were planking laid over the beaten dirt. There were usually two fire-places. Furnishings were modest, perhaps with some crystal or silver, and furniture was shipped from England and passed down among family members. The socially conscious planter would keep on hand port wine and Jamaican rum for entertaining. The French and Spanish masters of the central Gulf Coast had by this time worked themselves onto a slippery slope at the bottom of which lay a slave-based economy. In and around Mobile the number of African and Indian slaves approached that of the white settlers. On planta-tions, which were to become the principal source of wealth after the

decline of the Indian trade, the ratio of slave to master rose higher still. One of the earliest aristocrats whose wealth was based on land was the Chevalier Montault de Montberaut. His plantation Lisloy, which was located on Fowl River twenty miles south of Mobile, worked twenty-six slaves.

By 1795, the city was the residence of 29 planters with 192 slaves. The entire Mobile district, from the confluence of the Tombigbee and Alabama rivers south to Cedar Point and the Fort Morgan Peninsula, was home to 49 planters, all together owning 284 slaves. The names of some of the planters in the district mirror the mixed origins of the ruling families during the French and British periods: Augustin, Badon, Chastang, Dunford, Farmar, Juzan, Laurrendin, Lusser, McGillevray, Miller, Monlouis, Narbone, Rochon, Strachan, Ward, and Wegg.

As much as in any other part of the American frontier, the eighteenth-century settlers of Mobile and New Orleans depended on Indian trade for their survival. They provided European products of all kinds, from guns and steel axes to cloth and cookware, in exchange for food and labor. For a time the principal native product was deerskin, prized for gloves, slippers, and other articles of light clothing both in the American Atlantic seaboard colonies and in Europe.

During the French period, Mobile served as the key Gulf Coast center for Indian trade and diplomacy. Its services were vital for the maintenance of peaceful relations with the principal Indian nations of the interior, in particular, the Choctaws, Chickasaws, and Creek, also called the Muscogee. In order to achieve this aim, it was also often necessary to play one tribe against the other. Although the land that colonists and natives jointly occupied was vast, stretching from the Lower Mississippi Valley to present-day western Georgia and northwestern Florida, the number of people engaged in the drama was minuscule by modern standards. The whites in Mobile, still mostly French, amounted to a few hundred and those in New Orleans from the hundreds into the low thousands. In 1740, all of the region, collectively called French Louisiana, held fewer than 1,200 Europeans. By 1746, the population had jumped to 3,300 and was growing. The Choctaw, who were both farmers and hunters, numbered about 15,000. The Chickasaw, who were

mobile and primarily dependent on hunting, numbered around 4,000. The Creeks added another 9,000. All the people inhabiting the Gulf coastal plain from the Florida panhandle west to the mouth of the Mississippi, if they were time-traveled forward, could be seated in the New Orleans Superdome. Most of the seats would be left empty.

Tiny though the numbers were, the people of the central Gulf Coast nevertheless formed a rapidly evolving and explosive mix. As trade increased, visitors from the tribes settled around the colonial villages and created encampments of their own. These satellites themselves began to depend on the symbiosis. As a result, the native cultures started to dissipate. Even as early as 1725, the Natchez chief Tattooed Serpent complained, "Before the arrival of the French we were living as men who knew how to survive with what they have. In place of this, today we are walking as slaves."

Alarmed, his people decided to reverse the trend. On November 28, 1729, Natchez warriors overran Fort Rosalie, in present-day Mississippi, killing 145 men, 36 women, and 56 children, one tenth of the entire white population of French Louisiana. In retaliation, the French attacked and wiped out virtually the entire Natchez Nation, killing most of its people and selling many of the survivors as slaves in the West Indies. About the same time, the colonial military moved against the aggressive and sometime troublesome Chickasaw, calling on help from their Choctaw allies with the offer of "one gun, one pound of powder and two pounds of bullets for each Chickasaw scalp and eighty litres of merchandise for each Chickasaw slave."

The intermittent but deadly conflicts between the colonists and Indians culminated a century later, as Alabama was increasingly dominated by citizens of the United States. On August 30, 1813, a Creek war party, inflamed by the growing American presence and seeing opportunity in the ongoing war between the United States and England, attacked Fort Mims across the bay from Mobile and massacred all of its 250 inhabitants. The Creek War, as it came to be called, climaxed seven months later, when Andrew Jackson defeated and scattered the anti-U.S. "Red Stick" Creek at the Battle of Horseshoe Bend on March 27, 1814. On this day, native power in the Alabama hinterland effectively came to an end.

The Native Americans of the Gulf Coast barely survived the colonial and early American periods as organized tribes. Step by step the invaders erased

them, variously by replacement of their cultures, by massacres, by forced emigration, by introduced disease, and not least, by genosorption—interbreeding within the rising tide of European and African-Americans. Their physical presence and genes are today all but invisible. Their history of thousands of years was thereby halted forever. In the city of Mobile as elsewhere, the tragedy has been largely forgotten. The Native Americans disappeared because they were too close to us, and we needed their land. They were too few in number in the beginning and lacked the technology to defeat our depredations.

Yet the indiginées endure another way. They left their names on the rivers, the Tombigbee, the Tensaw, the Choctawhatchee, and others, on the states of Mississippi, Arkansas, Tennessee, and Alabama, and many towns and cities such as Biloxi, Tuscaloosa, Pensacola, Tallahassee, and, not least, Mobile. Today, in ordinary conversation, the children of the invaders are obliged to recite their names countless times each day.

Throughout the South during the colonial period and beyond that, until the end of the American Civil War, African slaves were the key to Southern economic growth. They were, in the eyes of their owners, fungible property—human engines of labor to accompany horses, mules, plows, and wagons.

The moral case or, more precisely, moral pretext with which slavery was practiced had deep roots. Much earlier, during the Spanish conquest of the West Indies and Mexico, theologians had already begun to debate the question of whether Indians were human beings and had souls. If not, they could be treated as animals. Fray Bartolomé de Las Casas, the great Colombian-era historian and humanitarian, won the case for human status and rights in a crusade that culminated in his debate with Juan Gines de Sepulveda at the Council of Valladolid in Spain in 1550. In theory at least, it was thereafter recognized that converting native peoples and giving them last rites was the moral thing to do. In practice, nonetheless, they were still often treated as animals.

The Mobilian African-Americans met an entirely different fate. Torn from their homeland, chained and beaten into submission as deemed necessary, they reluctantly adopted the culture of their captors—and survived. They might have remained a tiny minority after the European sovereignty over Alabama had ended, but increasing numbers were brought in during

the American period to support a burgeoning agricultural economy. By any civilized standards, the conditions under which they struggled upward in America are appalling. It took them more than one hundred years after they were given legal freedom by the Emancipation Proclamation in 1863 even to approach some measurable degree of parity, and the passage of the Voting Rights Act of 1965 to force their full recognition as voting citizens. There is little of which Mobile can be proud during this long stretch of history.

Most of the rest of the country has little or nothing in memory to be especially proud of either. Earlier, in the 1600s, the Plymouth settlers had mostly destroyed the Pequot Indians in a dawn massacre and then, during King Philip's War, the Narragansett, Wampanoag, and several other surrounding tribes. The principal difference between Alabama and Massachusetts in their respective genocides was largely the timing of their invasions into Indian Territory.

The North was fortunate in rejecting slavery early. There were far fewer slaves in the North than in the South, with only 1,488 still remaining in New England at the time of the 1800 census. The number imported was very small compared to the roughly half million brought into all the American colonies and, later, the United States. But that number in turn pales before the 10 million carried across the Atlantic to the New World as a whole. Largely because of its climate and agrarian economy, the South built a large slave population. The North built an increasingly industrial and maritime economy, with ready trade across the Atlantic and hence less need for slave labor.

The persistence of slavery for decades longer in the South was indeed the casus belli of the Civil War. The leaders of the first secession, in South Carolina and immediately afterward in the Confederate states, cited the preservation of slavery as their primary motive. But the historical roots of the moral failure and great tragedy were economic, not moral. In fact, Southerners rationalized their position and managed to be as contemptuous of the moral fiber of Northerners as Northerners were of theirs. As a child in Mobile during the 1930s, with much of the Old South still in place, I felt the dislike vividly—as illustrated by an incident involving my great-grand-aunt, Nellie Wilson. She had been a little girl when the Union troops occupied the city in 1865. A soldier patrolling the block in which our Charleston Street house was located stole one of our chickens. Her mother,

my great-grandmother, complained to his immediate commanding officer. This Northern gentleman reprimanded and replaced the guard, then apologized to the family. Aunt Nellie said to me with complete solemnity, "I just want you to know not all Yankees are bad."

An agrarian, slave-based economy sowed the poison seeds of racism upon the fertile soil. Yet that is far from the complete story of race relations. Some blacks purchased their freedom or were given it by their masters. Spanish Mobile saw a surge in black power and influence. Mulattos born of concubinage, and recognized as children of their white fathers, accelerated the trend. By 1788, 20 percent of Mobile's free population were people of color; by 1805, they made up 30 percent. Free blacks and mulattos worked as sailors on local supply ships. Others on record included a male nurse, a master mason, a baking contractor, and, in 1811, the commander of an all-mulatto militia.

Mobile during the colonial period resisted any attempt to be properly Europeanized: it was too multiracial, too polyglot. Its populace spoke variously French, German, and English, with an infusion of West African dialects which, when blended with French, became the basis of Louisiana Creole. In the end, New Orleans preserved much of this archaic culture, while in Mobile it faded before a more intense pressure of Americanization.

The colonial history of Mobile may seem faint in memory today. There is scarcely a trace of the Spanish occupation anywhere, and the British period served as little more than a prelude to the more robust American colonization that followed. The French left some architecture, including balcony grillework scattered about in the old part of the city, and the names of towns, streets, and Gulf islands. The Mardi Gras they started endured and grew into a weeks-long carnival. Also ultimately French, with a touch of West Indian, is the Creole cuisine from New Orleans. As a child, without knowing or caring where it originated, I relished the crab gumbo, shrimp jambalaya, and baked red snapper passed down over generations, whose recipes were still known to my father but, sadly, not to me.

The colonial period, coinciding almost exactly with the eighteenth century, created the world in which the events of the nineteenth century inexorably unfolded, and to a substantial degree it preordained what Mobilians are today. The colonists and slaves, black and white, did what was necessary, or at least what they deemed necessary, to survive. They gathered in

relatively tiny communities under parlous conditions with few choices for advancement. They were whipsawed between the imperial adventures of the major European powers. Having no immediately available mineral riches or gold-laden native kingdoms to plunder, Mobile and nearby Pensacola were valued chiefly as citadels to defend. They served as place-holders for a later, largely unplanned territorial expansion into the interior. When the mother countries feared expansion of their European rivals, the colonies did well; but in other times they were left to their own devices, and survival became a daily struggle.

Infant New Orleans alone had a slight advantage over other Gulf Coast ports. France, the mother country, envisioned it as the key to empire. It would service French expansion down the Mississippi Valley from the Canadian stronghold. Versailles also understood the necessity of controlling the river's entrance to the Caribbean Sea. Otherwise, the colonies were isolated. They lacked the direct and relatively easy access to the markets of Europe enjoyed by the Eastern Atlantic coastal cities from Halifax to Charleston and Savannah. Nor did the Gulf Coast colonists have ready contact by overland routes. During the eighteenth century, the interior from the banks of the Mississippi across most of the Mobile River basin, covering a large portion of the present-day southeastern United States, was still occupied by strong Indian nations.

The best the colonies could do was to build trade with the tribes closest to them while gradually developing agriculture inland. Under the conditions they faced, there was little opportunity for wealth to be generated by single families of freehold farmers. They were not in the position of the sturdy English pioneers who could push west from the established cities of the Atlantic seaboard, bolstered by industries and markets that remained within their reach. The closest model they had to build security and prosperity was southward across the Caribbean to the West Indies, where the Spanish and English were making great fortunes with sugar plantations and African slaves. And so it came to pass that the Deep South, with Mobile at the center of the Gulf of Mexico coast, slid into a reliance on agriculture and thence a slave-based economy.

A FAILED EDEN

On April 13, 1813, when the hapless Spanish garrison surrendered to American troops at Fort Charlotte, the population of Mobile stood at 300. The metropolis they inhabited was a mud village divided into only fifteen blocks. Six years later, when the town was incorporated into the new state of Alabama, its population was still only 809.

In the meantime, another event occurred that seemed to threaten Mobile's future as a port city altogether. Throughout its colonial history, the shallowness of the bay at the mouth of the Mobile River, and the mud banks strewn in front of the town dock, had been formidable obstacles to trade. Heavier shipping had to be offloaded at a landing well south of the town. Then, and abruptly, a rival town with a better harbor was created on the opposite side of the bay. This was Blakeley, located near the mouth of the Tensaw River. In 1814, the legislature of the Mississippi Territory, which still included the soon-to-be state of Alabama, authorized Josiah Blakeley and a consortium of New England businessmen to build a town at the head of the Apalachee River, at the spot where that short waterway branches away from the Tensaw. It was designed to include an excellent harbor reached by a sixty-foot-wide street.

The town of Blakeley was intended to be a utopian community. The call went forth, and by 1818 between 4,000 and 8,000 people had settled there. This sizable community even had a newspaper, the *Blakeley Sun*, which could justifiably claim:

> What a wonderful country is ours! How like enchantment towns and villages rise up! Blakeley, eighteen months ago, was a wilderness of impenetrable woods. Nothing is now seen or heard but the din of business and the stroke of the ax resounding in the distant woods — buildings raising their heads in almost every quarter of the town, and the constant arrival and departure of vessels present a scene both interesting and beautiful to the contemplative mind and the men of business.

The writer was confident that Blakeley would prevail as the principal seaport of Alabama. The continued existence of a feeble Mobile across the bay would be of little consequence.

The history of Blakeley has personal significance to me, because one of my great-great-grandmothers, Mary Ann Hodge, was born there in 1826. Her family soon moved to Mobile, where she grew up and married Henry Hawkins, newly arrived as a marine engineer from Providence. Three decades later, my great-grandfather, James Eli Joyner, came as a Confederate soldier to the same utopian place, then called Fort Blakely (oddly without the second *e* in Blakeley), to participate in the last major battle of the Civil War.

So why is Mobile today the port of Alabama and not Blakeley? There were three reasons, all of which can be grouped under one category: Bad Luck. First, the dredging of Pinto Pass provided Mobile an even better harbor than the one at Blakeley. About the same time a disastrous market decision by Mr. Blakeley almost ruined the economy. Finally, and decisively, two epidemics of yellow fever swept through the little town, killing many adults and children. The insect carrier was, we know today, the mosquito *Aedes aegypti*, which abounds in the swampy locality. Some believed the "Saffron Knight," as they called it, might be responsible, but a majority decided that the air at Blakeley was the main problem. So, as abruptly as it had risen, the town was abandoned. Its citizens scattered variously to Mobile, Pensacola, back to the Northern states, and elsewhere. By the mid-1830s, Blakeley was finished. It had become, in the words of the local historian Kay Nuzum, "perhaps the 'deadest town' not only in Baldwin County but all of Alabama."

THE COTTON BOOM: A TRAGEDY FOREORDAINED

Then Alabama, the future Heart of Dixie, opened its rich soil to cotton production, and Mobile, the only port on the central Gulf Coast east of new Orleans, metamorphosed into Cotton City. The global demand for cotton gave to Alabama its economic miracle. From the American accession in 1813 to the outbreak of the Civil War in 1861, the population growth of Mobile was exponential. The town sprinted from a tiny frontier outpost to one of the most prosperous cities in the antebellum South.

Mobile's cultural growth was equally dramatic. The village began with a spiritless hodgepodge of colonial cultures. In 1817, according to an American military officer stationed there, Mobile was home to "a mixture of the Creoles (principally colored) and emigrants who are governed entirely by personal interest; and exhibit very little of what may be termed *National feeling*." A merchant from Liverpool found it "an old Spanish town, with mingled traces of the manner and language of the French and Spaniards."

That image was soon wiped away. A flood of immigrants entered Alabama's cotton port, and Mobile became, one of them recorded, "a place to make money." By 1822, the population had reached 2,800. "Distant adventurers of every description," as one physician described its immigrants, "fled hither as to an Eldorado." They included attorneys, doctors, merchants, and mechanics. In the same year, the *Niles' Register* reported that "Mobile is becoming a place of great importance, and may soon be one of the most populous of our southern cities."

The growth of cotton production and with it the rise of Mobile was made possible by the defeat of the Red Stick Creek Indians at the Battle of Horseshoe Bend in 1814, which effectively ended the Creek War. With the new territory opened to unimpeded settlement, waves of pioneers entered, principally overland from Georgia, South Carolina, and Tennessee, but also upriver through the port of Mobile. Among the earliest arrivals, both from South Carolina, were my forebears: John McKnight, a Revolutionary War veteran; and Taliaferro Shelton, who made it across the border even before Alabama became a state. They reproduced well and generated a considerable tribe across northern and central Alabama that included Sheltons, Freemans, and their collateral lines, among which was my mother, Inez Freeman Wilson.

Many of these overland pioneers were freeholders, living on the varied produce of their land and trade. For most, however, cotton was the equivalent of the gold, timber, and oil that served other American frontier regions as their economic base.

Mobile, the only outlet of the vast Mobile River basin and the logical port of the Gulf of Mexico east of New Orleans, was the conduit through which the cotton flowed. In the interior, the way to success for settlers was straightforward: buy land upriver to the extent your capital allows, cut the forest,

build your house and shelter for slaves, and start sending the bales down-river to Mobile. Then, invest some of the profit in more land and more slaves.

The cycle was fundamentally corrupt, but the growth in Mobile it fostered was phenomenal. By 1830, the population reached 3,194. In the next ten years, it quadrupled to 12,672; by 1850, it grew by half again; and in 1860, at the brink of the Civil War, it had reached 29,158. In only three decades, covering less than two generations, the population had multiplied almost tenfold.

Mass production of cotton on slave-powered plantations was the opportunity presented white farmers, and most of those in Mobile and inland south and central Alabama who could raise sufficient capital seized it. The principal reason the economy went this way was geography. The central Gulf Coast became American territory only during the early nineteenth century. It was relatively isolated throughout, within reach of the eastern seaboard and Europe beyond only by long voyages around the Florida Peninsula.

Also important was demography. Despite their exponential growth, the Southern ports started late, drastically so in comparison with those in the northeastern United States. The population of Boston in 1680, for example, was already 4,500, exceeding that of Mobile in 1830. By 1860, near the outset of the Civil War, Boston's population had swelled to 177,840, six times that of Mobile in the same year. Philadelphia had 80,862 residents in 1830 and more than half a million in 1860. The New York Urban Area, including Brooklyn, grew from 185,000 in 1830 to more than 1 million in 1860. The population of New Orleans, thanks to the opening of the Midwestern croplands and the city's role as the depot of the Mississippi River basin, had grown to 168,675 in 1860, making it the sixth largest city in the United States. Mobile, in contrast, still had reached only twenty-seventh in rank.

From its birth, the state of Alabama, moving swiftly to exploit its fertile coastal plain and piedmont, was locked into an agricultural economy. It had neither the time nor the circumstance to achieve significant industrialization.

Reliance on slave labor had been routine throughout the century-long colonial period of the Gulf Coast. In and around Mobile, African slaves and their families were from the start a large fraction of the population. Slavery could not be banished, at least not suddenly, without destroying the society built upon it.

Mobile was the center of the slave trade in Alabama, and as such perpetuated the dehumanization of the people that had begun with their capture in West Africa. The casual debasement was set forth excellently well in the *Mobile City Directory* of 1856 by one M. Boulement, a merchant who conducted auctions day and night on the corner of Royal and Dauphin streets:

> Particular attention given to Selling *Real Estate, Negroes, Horses, Carriages, Furniture, Groceries, Liquors, Clothing, Dry Goods, Jewelry, Gold and Silver Watches, and all kinds of Staple and Fancy Goods.*

Night auctions, the advertisement helpfully added, were "devoted principally to Fancy Goods."

Newspapers and posters were replete with dehumanizing language. An advertisement by John M. Edney in the February 3, 1823, *Mobile Commercial Register* offered three "Negroes for Sale" as follows:

> A Likely Negro Fellow, about twenty five years of age, who is an excellent field hand, and a Girl about eighteen years of age. Both of them are healthy and likely. Also,—An Old Woman, who is a good House Servant. Persons who may wish to purchase can call and see them. Terms—Cash, Cotton, or approved town acceptances at 90 days.

If conditions for the slaves were bad on Mobile's auction blocks, they were worse upriver on the frontier where new plantations were being put into production. Being a "big ticket" investment, the cotton growers could not allow slaves either to escape or become laggard on the job without severe financial loss. They had to be kept in total physical submission and mental thrall.

A valuable independent picture of the Alabama frontier has been provided by Philip Henry Gosse, a young English naturalist who traveled up the Alabama River out of Mobile in 1838. He took a teaching job on a plantation owned by Reuben Saffold in Dallas County, near Selma. For eight months he wrote detailed notes on natural history and the lives of the settlers in the region. Returning to England, he published the material in *Letters from*

Alabama U.S. (1859). He enjoyed a career as one of England's premier nature artists, and was elected to the Fellowship of the Royal Society of London. In *Letters*, Gosse painted the archetypal portrait of the Southern planter:

> The manners of these Southerners differ a good deal from those of their more calculating compatriots, the Yankees of the north and east. In many respects the diversity is to the advantage of the former; there is a bold gallant bearing, a frank free cordiality, and a generous, almost boundless hospitality, in the southern planter, which are pleasing. But the abiding thought that "the people," as being the source of law, are therefore above law, which is deep-seated throughout this land of "free institutions," is much more frequently made operative in the south than in the north. Here "every man is his own law-maker and law-breaker, judge, jury, and executioner."
>
> The darkest side of the southerner is his quarrelsomeness, and recklessness of human life. The terrible bowie-knife is ever ready to be drawn, and it *is* drawn and used too, on the slightest provocation. Duels are fought with this horrible weapon, in which the combatants are almost chopped to pieces; or with the no less fatal, but less shocking rifle, perhaps within pistol-distance.

If this account seems at all exaggerated, it should be kept in mind that at the time Gosse visited Alabama, Andrew Jackson, newly retired as the most bellicose president in American history, carried in his body a bullet put there by just such a duel.

The usual homes of the pioneers were very far from the pillared Greek Revival mansions of popular imagination. A few did exist in antebellum Mobile and survive today, such as the Bragg-Mitchell and Fort Condé–Charlotte homes. But pioneer homes were very different:

> The roof is of a piece with the rest; no ceiling meets the eye; the gaze goes up beyond the smoke-burnt rafters up to the very shingles; nay, beyond them, for in the bright night the radiance of many a star gleams upon the upturned eye of the recumbent watcher, and during

the day many a moving spot of light upon the floor shows the progress which the sun makes towards the west. But it is during the brief, but terrific rain-storms, which often occur in this climate, that one becomes painfully conscious of the permeability of the roof; the floor soon streams; one knows not where to run to escape the thousand and one trickling cascades; and it is amusing to see the inmates, well acquainted with the geography of the house, catching up books, and other damageable articles, and heaping them up in some spot which they know to be canopied by a sound part of the roof.

Now poor and mean houses may be found in every country, but this is but one of the many; it is not inhabited by poor persons, nor is it considered as at all remarkable for discomfort; it is, according to the average, a very decent house.

The ambitions of the early plantation owners did not stop with these rustic dwellings. They dreamed of the display and comfort of an aristocracy of their own creation. Gosse saw a few "much superior" country homes. "These are frame-houses," he wrote, "regularly clapboarded, and ceiled, and two, or even three stories high, including the ground floor. They are mostly of recent erection, and are inhabited by planters of large property; these have comforts and elegances in them which would do no dishonour to an English gentleman."

"Large property" meant more land, more slaves, more cotton, and still more land. Upward mobility was achieved on the backs of human beings treated as little more than farm animals. Because they were, however, inconveniently intelligent and possessed of free will, they had to be cajoled, threatened, and punished to perform at the required levels—by any means and to whatever degree necessary to break resistance. Anything less meant economic failure. Altogether, the practice of mass agriculture in early Alabama, according to Gosse, was not a pretty sight:

Slavery, doubtless, helps to brutalize the character, by familiarizing the mind with the infliction of human suffering. If an English butcher is popularly reputed unfit to serve on a jury, an American slave-owner is not less incompetent to appreciate what is due to

man. I had intended to give you some particulars of the working of "the domestic institution," for I have witnessed some of its horrors; but I will not allow my pen to trace much of this, especially as you may learn it from other sources. I am obliged to be very cautious, not only in expressing any sympathy with the slaves, but even in manifesting anything like curiosity to know their condition, for there is a very stern jealousy of a stranger's interference on these points.

Still, facts will ooze out: in confidential conversation I have heard things not generally known, even here, which are truly dreadful. Instruments of torture, devised with diabolical ingenuity, are said to be secretly used by planters of the highest standing, for the punishment of refractory negroes; devices which I dare not describe by letter. It is but right, however, to say, that these practices were told me with expressions of reprobation.

In 1838, when Mobile was still on the upward curve of its boomtown success, Gosse, in one elegant paragraph, forecast the fate of the Old South:

What will be the end of American slavery? I know that many dare not entertain this question. They tremble when they look at the future. It is like a huge deadly serpent, which is kept down by incessant vigilance, and by the strain of every nerve and muscle; while the dreadful feeling is ever present, that, some day or other, it will burst the weight that binds it, and take a fearful retribution.

The leaders of Mobile never read these words—they came too late—but in their hearts they shared Gosse's foreboding. Some understood that a tragedy of Hellenistic proportions was unfolding. By the time of the earliest stages of its economic success, the Old South had already passed the point of no return. Those with foresight knew that slavery could not be abolished, or even much restricted, without destroying the existing order. Some must have asked, albeit in whispers, *What would happen to us and our families if hordes of bitter, vengeful negroes were released into the countryside?* They must have been mindful of the slave uprising of 1791 in the French colony of Saint-Dominique. It was followed by the expulsion and slaughter of their French

and English masters and the setting up of black native control over Haiti by Toussaint-Louverture, followed by a string of tyrants, beginning with the reign of Henri Cristophe, self-designated as King Henri I. The uprising occurred only a few days' sail from the Alabama Gulf Coast. As self-confidence and pride in the success of Mobile as a city rose, so did anxiety over the ultimate consequence of their ultimate genesis in the hinterland. The Northern states, after putting behind their own slaveowning history, became increasingly militant over continuance of its practice in the South. Slavery, people in Northern states argued, was obscenely immoral and unworthy of the Republic. It was contrary to the Constitution and, even more important, to the eyes of God.

One response among Mobilians was to sink the roots of racism ever deeper. The extreme conceivable argument in favor of slavery was posed by Dr. Josiah Nott, who, in 1850 after years of measurements of skull size and other evidences, argued that the two races were different species. God, he concluded, designed the Caucasians to be superior in intellect and ability over black Africans, who were engineered to obey and serve. Slavery is God's will, and we should not worry further about the matter. Moreover, for the good of society as a whole, citizenship should be limited to the white race. Nott ran into a bit of trouble with the biblical literalists of the South, however. The Old Testament, they pointed out, says that the Good Lord created Adam and Eve to be the ancestors of *all* people.

There were, fortunately, also moderates in the ongoing debate on race. As the antebellum period raced toward its bloody climax, members of the Southern Rights Association, led by Mobile's legal and political elite, expressed less concern about the rightness of slavery and ever more about the economic and political future of the South. They feared that the sovereignty of the individual states would be lost and hence ultimately their own power. The Compromise of 1850, which limited the spread of slavery into the virtually unlimited new territories of the frontier West acquired during the Mexican War, was seen by some as a slide down a slippery slope. As written, they believed, geography alone would eventually enable the federal government to control Congress and dictate to the Southern states.

Remarkably, and to their credit, a majority of the members of the Southern Rights Association considered slavery a bad idea. They wanted

to focus public policy on economic growth and education for all, leading to the eventual release of slaves into the free labor market. Among them was John Archibald Campbell, an Alabamian and associate justice of the U.S. Supreme Court, who argued that education would in time raise African-Americans to the same level as whites.

The pragmatic and benevolent policy of Campbell and the Southern Rights Association was nevertheless countered by the fear generated by Josiah Nott and his fellow radical racists. In his time, Nott had a lot of prestige. He was perhaps the most famous Mobilian of the day, to be rivaled later only by Admiral Raphael Semmes, hero of the Confederate Navy. In fact, it is odd that Nott turned out as he did. Trained in the North and in Paris, he was a distinguished and farsighted physician who fought for the improvement of medical practice in Alabama. He established the Medical College of Alabama in Mobile, and his own practice in the fledgling city was renowned for its excellence. When he died in 1873, large crowds lined the streets to witness the funeral procession. Among the mourners were the mayor, other city officials, and physicians of Mobile. A brass band led the carriage bearing his body to Magnolia Cemetery.

At the same cemetery already lay my Mobilian ancestors, and many more blood relatives to follow in later years. I think it likely that there were Hawkinses, Joyners, and Wilsons lining the crowd watching the procession go by. But I have another link to the premier physician and arch racist. And therein lies a tale with a moral of its own.

When I was a student at the University of Alabama, in Tuscaloosa, from 1946 to 1950, I worked in a laboratory space given me as a freshman in Josiah Nott Hall. At that time the three-story building housed the entire Department of Biology. When I wasn't at home in Mobile, or sleeping in my dormitory room in nearby Northington Campus, or out on field excursions, I virtually lived in Nott Hall. I was the youngest in a tight-knit group of five friends, all equally devoted to biology and natural history. The four other than myself were combat veterans of World War II. Three were also Yankees, from out of state. From Michigan came George E. Ball, who only a year before had been with the Marines on Okinawa. From Illinois, I recall but cannot be sure of his origin, came Hugh Rawls, partly disabled from injuries received during the Marine landing on Tarawa. Barry Valentine, a New

Yorker, was with the Army on Bougainville. My single Alabamian friend, Herbert Boschung, had served a full tour in B-24 bomber raids over Germany. I myself was a year too young for military service during World War II. Eagle Scout and emergency bicycle courier for Civil Defense on the streets of Mobile were my notably modest contributions.

It is curious that none of us knew or cared about the identity of Josiah Nott. His was just a name engraved above the entrance of the building in which we worked. Nor was any one among us, whether from the North or South, the least concerned about the all-white composition of the university, both in the faculty and student body. Given the segregation in the city, blacks were all but invisible. My out-of-state friends had been drawn to Tuscaloosa by the presence of Ralph L. Chermock, a charismatic young assistant professor of entomology from Pennsylvania. Our talk was almost entirely about the natural history of Alabama, which we proceeded to explore from one end of the state to the other. We read and argued over the newest ideas in evolutionary theory. My veteran friends almost never talked about their very recent experiences in the war, and the racism and poverty all around us we knew to be evil but were battles we would leave to the next generation.

There are nevertheless deeper and more admirable meanings that can be read in the remembrances of our fellowship. Two world wars, only twenty-three years apart for America, had united the nation as never before. At the university we learned that it is knowledge, more than geography, religion, and common race, that draws people together. Knowledge is the sole author of pooled human minds. It was, we intuitively understood, transcendent and liberating.

Yet it was entrance to Harvard that forced me to confront fully my own racism. On arrival at the graduate student dormitory, I was immediately introduced to my biases in a serious manner. My roommate turned out to be a Nigerian—and a revolutionary at that. With other of his black countrymen, he was plotting the campaign for liberation of Nigeria from Great Britain. Well, I thought, my forebears had done the same thing, twice, in two successive revolutionary wars, had they not? We won the first and lost the second. Hezekiah Oluwasanmi and I soon became good friends, which was to last through the independence of Nigeria, Hezekiah's rise to head of the University of Ife, and finally his unfortunate early death.

A little later, in 1965, as a young professor at Harvard, I was invited by the University of Alabama to chair a committee for the outside evaluation of the Department of Biology. This key unit of the state's flagship university showed signs of stagnation. The three members of the committee were asked to consider two compelling problems. The university had not yet come to grips with the rise of molecular biology, and for that matter it was not establishing regional leadership in any particular discipline of biology. The committee diagnosed the root cause: the university was having very little success in attracting molecular biologists and other first-rate faculty members from elite graduate schools in other parts of the country. Their resistance was due to the persistence of racism and the overall strangeness of the still segregated Alabama culture.

Being young and reckless, I chose a bold gambit to address the racism issue. When our committee met with the dean of the School of Arts and Sciences, I suggested that the University of Alabama confer an honorary degree on Martin Luther King, Jr., who the year before had received the Nobel Peace Prize. That gesture, I said, would get national attention, alter the image of Alabama, and perhaps persuade some of the best young scientists in the market to consider a career in Alabama. Certainly, the opportunities for personal growth in the state were greater than the burden imposed by its racial handicap.

The dean, a distinguished scholar in his own right, shook his head. He said, in effect, "Ed, I could not agree with you more. But the Alabama Legislature decides our budget. They don't think the way you and I do. If we did what you say, they would kill us." I repeated the suggestion to the provost and got the same response. Later the same day, when the committee met with Frank Rose, the president of the university, my nerve failed me and this time I didn't even try. I regret that failure. At least I should have made the gesture.

I've often wondered how Dr. Rose, a wise and well-disposed gentleman, would have responded. Perhaps not by rejection but equivocation. He was by nature a mediator who insisted on obedience to the law and on acceptance of the constitutional authority of the federal government. Two years earlier, when Governor George Wallace had come to the university to personally and physically block the door of Foster Auditorium to the first two black University of Alabama students, Rose had finessed the crisis by means

of equivocation. Declaring himself neither segregationist nor integrationist, he talked the governor and the opposing federal authorities into stepping away. The students entered, and a new era began in the history of Alabama. The years to follow have seen a complete integration of the University of Alabama, immensely fruitful to all the academic community and to the state. But in 1965, the fear and hatred implicit in Governor Wallace's display to the racist majority of voting citizens still lingered, in Tuscaloosa, in Mobile, and in the rest of Alabama.

THE CIVIL WAR

More than a century earlier, many in Alabama understood that somehow slavery had to end, followed by the demise of segregation, and then the more egregious forms of bias, before the state would ease its agony and tap the potential of all its citizens. But its slave-based economy paralyzed Alabama, and the state joined the rest of the South in its slide toward secession and Civil War. The fatal outcome was foreshadowed by the Missouri Compromise, passed by Congress in 1820, which essentially split the nation into states in which slavery was allowed and states in which it was prohibited. Thomas Jefferson, the South's most famous slaveowner and now at an advanced age, was shocked by what he saw as a threat to the Republic. Such a geographical line, he declared, "coinciding with a marked principle, moral and political, once conceived and held up to the angry passion of men, will never be obliterated; and every new irritation will mark it deeper and deeper."

Indeed, the South perceived itself growing more isolated and weaker relative to the rest of the nation. Congress blundered again with the Compromise of 1850, a set of five bills. The measures were meant to ease the national division, but in fact they deepened it. The South was offended by the law mandating California and the District of Columbia free of slavery. The North was even more roiled by another of the laws that required federal officials to arrest runaway slaves.

The Compromise of 1850 at least posed the desire for a national status quo. It delayed secession by the Southern states for ten years but only at the cost of irreversibly deepening their desire for independence. During this

final period, the North accelerated its industrialization and its economy grew stronger, while that of the South remained agricultural and relatively stagnant. As the perceived noose tightened around the neck of the South, outright secession appealed to more and more white Southerners. The rights and independence of the individual states, in addition to the health of the economic base, hence slavery, became the driving issue. The South viewed the Constitution of the United States as no more than a partnership among the states, to be entered or abandoned as circumstances demand. If it were not so, the South risked evolving into a helpless appendage.

The tipping point was the election to the presidency of Abraham Lincoln in 1860, viewed by the South as its mortal ideological enemy. Almost immediately, South Carolina seceded from the Union, and by early February 1861 six more Southern states, including Alabama, followed. On February 7, the seven states founded the Confederate States of America, adopted a provisional constitution, and established a temporary capital at Montgomery. Militia under their command were ordered to seize all federal forts within Confederate territory. When one of them, Fort Sumter, in the harbor near Charleston, resisted the takeover, it was bombarded and subdued by Confederate forces. Thus began "the noblest and least avoidable of all the great mass conflicts of which till then there was record," as Winston Churchill later called it in his *History of the English-Speaking Peoples.*

Inflamed Southerners considered the conflict a war of independence and nothing less than a second American Revolution. They asserted their God-given right to have their own country, with its success or failure their own making. To the majority who did not own slaves, the practice of slavery was not the central issue, as it was in the North. If the practice was to be ended, as many in the South expected and hoped, it would be by their own action, not by orders from another government.

The Civil War was the defining moment in history for the South. The Confederate forces fought against great odds, with the kind of immense courage that can only be summoned by true patriotism and an intense sense of place. They kept fighting until the last battalion was encircled and overrun. There were aristocrats among them, such as Tidewater Virginians and Savannah elites, usually officers leading on horseback with sword and pistol, but the vast majority were freehold farmers and hired workingmen of

frontier stock. They also fought for honor and the preservation of a home-land. Like most of the rest of America, in the process of destroying the Indian nations and enjoying without complaint the economic fruits of Southern slave labor, they were racist. But they did not choose to face crip-pling injury or death at Chancellorsville and Gettysburg just in order to save other men's slaves. I know it is unpopular to this day to say it, but they fought for their region-based country and they exemplified the best of the American spirit. It was to that spirit that President Lincoln paid homage in his Gettys-burg Address, sixty-three words that resonate for Americans today.

The most remarkable single fact about the conflict was that, while the South had a vastly smaller population and inferior industrial production than the North, and while its ports were blockaded with relative ease by the Union Navy, the war lasted so long. And, given a few different circumstances, the Confederacy might even have won. Had Lee listened to Longstreet and not blundered in his deployment of the army at Gettysburg, and had a break-through been thereby achieved, or if further significant federal victories such as Atlanta had been held off until after the 1864 election, resulting in the defeat of Lincoln, European nations might have aligned with the Con-federacy and forced a truce with the Union, perhaps in time attaining full independence. But in the end the Union was providentially saved, to the ulti-mate benefit of all Americans, and the world. And, after it was all over, the children and grandchildren of those who wore gray wool contributed the same spirit and courage shown as rebels to the further building of a great nation – despite the continuance of forms of racism even more vicious than those conspicuously lingering in the North.

It has been my good fortune to visit and think upon in a closely personal manner the sites where the Confederacy was born and where it ended. When I was elected to the Alabama Academy of Honor in 1995, I was invited to address my fellow members during the induction ceremony in Montgomery. The ceremony was held in the same assembly room where the Alabama Leg-islature voted the state out of the Union on January 11, 1861. It is also a short distance from the Capitol steps where a month later Jefferson Davis took the oath of office as president of the Confederate States of America. I did not speak on Alabama's history or any political topic that day, for which I was not in any case qualified, but instead focused on the state's swiftly vanishing

wildlands. That to me is Alabama's next great crisis, which in history will be to the twenty-first century as the civil rights revolution was to the twentieth. It will be solved like the history of slavery, or forever remembered in shame.

Several years later, I attended a reenactment of the Battle of Fort Blakely. The site is located in Baldwin County near the northeast corner of Mobile Bay, a short distance up from Spanish Fort. The battle was fought eight hours after Lee signed the instrument of surrender at Appomattox Courthouse, too short a time to get word to the opposing forces. It is remembered as the last major battle of the war. The event is of more than passing interest to me. My great-grandfather, James Eli Joyner, was one of the 4,000 Confederate soldiers who fought there and lost.

At the outbreak of the war, Joyner had been one of the "Mobile hotheads" who quickly volunteered for service. At the age of seventeen, on May 4, 1861, he joined Company A of the Alabama State Artillery and stayed with it at Shiloh, Murphreesboro, Chickamauga, and other battles, mostly in Tennessee. He was still fighting when the unit was driven south through Dalton and Atlanta—and finally trapped at Fort Blakely. He endured what must have been a terrible four years of marching and combat, followed by more marching and combat, and then still more marching and combat. Reading archival on-the-spot monthly reports by the clerk of Company A, I felt this history come alive. Below, for example, are the events for the month of November 1863 in the reports. After Gettysburg four months previously, the Confederate forces have begun their slow southbound retreat out of Tennessee:

Nov. 12th ordered to Lookout Point arrived there on the afternoon of the same day. Shelled the enemy's trains and fortifications at intervals daily. 22d ordered to report to Brigadier Genl. Anderson on Missionary Ridge. Arrived there about 9 A.M. On the 23d not engaged during the day. 25th opened on the enemy's Pickets and kept up a steady fire until forced to retire by the Infantry giving way, and arrived at Chickamauga about 10 o'clock P.M. 26th marched from Chickamauga. Arrived 4 miles from Ringgold same day distance about 16 miles. 27 arrived at Dalton, Ga.

In the final stand, at Spanish Fort and nearby Fort Blakely, the 4,000 Confederates faced 16,000 Union soldiers, newly arrived from Pensacola. The Northerners included a large contingent of African-Americans, who must have been exhilarated to bear arms as full citizens, even as they risked falling in battle. The Southerners felt no such comfort. They were at the end of the line and had no place to retreat, at least as an organized force. To their back was the Apalachee River, a terminal branch of the Tensaw that opens into Mobile Bay. Across the Apalachee lay the great Mobile-Tensaw Delta swamp. The odds were overwhelming, the fight furious, deadly, and short. In just eighteen minutes, the Union forces flowed over the Confederate lines, killing some of the defenders and capturing others, while a few fled singly or in small groups to the nearby refuge of river and swamp.

Five years later, at the age of twenty-six, James Eli Joyner, then a marine engineer like his father-in-law, died in a boat fire in Mobile Bay. His wife watched the fire and smoke at a distance from the top of the Charleston Street house, unaware of what was happening. Afterward she made a living by setting up a private school in the house. Her daughter, Mary ("May" to family), an infant at the time of the boat accident, studied in her mother's classes, married, gave birth to my father, and lived the rest of her life all in the same house. On April 15, 2010, during a celebration at Fort Blakely State Park, I presented my second cousin, Elizabeth Coven, Joyner's great-great granddaughter, the gold watch chain with dolphin catch that had been taken off Joyner's body and kept in my line of the family for 140 years. Coven was the family genealogist and her line never left Mobile. The transfer was appropriate. No—it was mandatory. That is just the way Southerners are.

During the reenactment I attended at Fort Blakely, I stood as a faithful son of Mobile near the line of Confederate cannons. I was startled by the loudness of the blasts, then pleased during the first Union advance and retreat to see boys run from the Confederate line to give water to the "wounded" enemy soldiers lying on the field. Later, I was welcomed back in the Confederate reenactment camp and talked with some of the men as they folded the battle flags and prepared to leave. I admired the authenticity of the guns and every article of hand-stitched clothing worn by the reenactors. All were duplicates made as closely as possible to the original accoutrements of that long-ago battle.

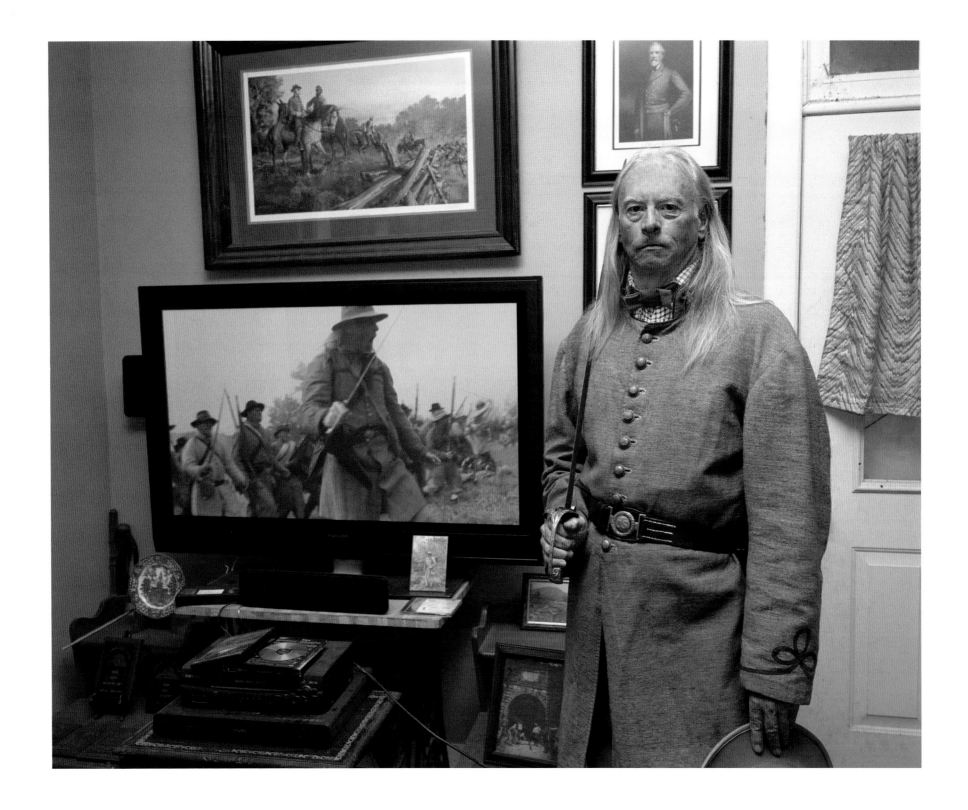

KEN McGHEE, MAGEE FARM, KUSHLA

I could not help but feel a strong comradeship with these men. But also from time to time I have wondered: Why did the reenactors, like daguerreotypes come to life, work so hard to achieve realism in every detail of clothing and performance? It is out of respect, I believe, to those on both sides who fought and died. But another reason is that no performance on any stage provides a greater thrill than the exact imitation of an historical event. And yet more, because authenticity in anything is such a rare quality in American culture today. And then surely—probing even more deeply—because we were all that day, reenactors and spectators alike, aware of a special grace of honor and courage yet emanating from the final battle of a "lost" war.

Four days after the real Battle of Fort Blakely, in the afternoon of April 13, 1865, Union forces under General Gordon Granger crossed the bay and marched down the streets of Mobile to the tune of "Yankee Doodle." In the days to follow, women venturing out of their homes walked down the middle of the streets in order to avoid going under the American flags that now hung on the building fronts. Mobilians were at first afraid of the invaders. They had heard of Sherman's march to Savannah and believed Union troops were capable of any crime imaginable. Mary Waring, the daughter of a prominent citizen, expressed her contempt in the pages of her diary. "The city is filled with the hated Yanks," she wrote, "who differ in the greatest degree from our own poor soldiers—the commonest, dirtiest-looking set I ever saw."

Yet, my great-grand-aunt, Nellie Wilson, who as a little girl also witnessed the arrival of the conquerors, told me they turned out to be surprisingly well behaved. Mary Waring could add in her diary at the time: "To do them justice, however, I must admit, though reluctant to do so, that they are very quiet and orderly, and they entered the city with extraordinary order and quiet, so different from what we had anticipated, from the numerous accounts of their behavior in captured cities. We are thankful for it and hope such conduct will be preserved throughout their stay here."

Some of the tranquility resulted from the policies of the regional commander of the region, General Edward Richard Sprigg Canby. He was praised by an opposing Confederate commander for his "intelligent, comprehensive, and candid bearing" and Lincolnesque "liberality and fairness." But another reason for Mobile's relatively mild treatment was simply that the

war was over and Union soldiers had not been forced to fight their way into the city.

General Dabney Maury of the local Confederate forces now prepared to surrender the remnant Confederate units still holding out north of Mobile. He would not allow another battle. His farewell message to these troops embodies the better side of the spirit under which the Southerners had waged their war. It reminds us that, even though the evils born of slavery were diminished neither then nor by the passage of time, those who had volunteered fought in defense of their country.

> Soldiers—our last march is almost ended. To-morrow we shall lay down the arms which we have borne for four years to defend our rights, to win our liberties.
>
> We know that we have borne them with honor; and we only now surrender to the overwhelming power of the enemy, which has rendered further resistance hopeless and mischievous to our own people and cause. But we shall never forget the noble comrades who have stood shoulder to shoulder with us until now; the noble dead who have been martyred; the noble Southern women who have been wronged and are unavenged; or the noble principles for which we have fought. Conscious that we have played our part like men, confident of the righteousness of our cause, without regret for our past action, and without despair of the future, let us to-morrow, with the dignity of the veterans who are the last to surrender, perform the sad duty which has been assigned to us.

THE LONG STRUGGLE FOR CIVIL RIGHTS

Now a great change swept over the South. The slaves rejoiced at the breaking of their chains. But few had any idea of what might come next. As it turned out, nothing was as elevating as they had hoped. Throughout the former Confederacy the racism of slavery was replaced abruptly by the racism of fear. The white landed aristocracy and middle classes were afraid their property and privileges might be taken away. Those in the white working

class feared they would lose their jobs to blacks and carpetbaggers. All of the white classes needlessly feared for "the sanctity of their women." Everyone dreaded the impact of what they wrongly saw as a barbarian horde loosed upon the land.

All had long visualized the chaos coming. Suddenly, it was there. An economy based so much on slavery having sown the dragon seeds of fear and hatred, black and white alike were about to pay a painful price.

The new racism was expressed in the attempt to hold on to the status quo ante by "keeping negroes in their place." It launched a vicious and prolonged episode of internal strife and atrocities second only to the earlier and ongoing genocide of the Amerindian nations.

The majority of Southern whites were prepared to use any measure available to suppress the newly freed African-Americans, up to and including lynching. At the milder end were Jim Crow laws that specified where they could go and what they could or could not do. For a century following the Civil War blacks were forcibly segregated to the rear of buses and theaters, apart to separate drinking fountains, hotels, restaurants, and bathrooms, and into ghettos. With rare exceptions they were not viewed in the Deep South as social equals or allowed in white habitations except as workmen and domestic servants.

I recall vividly how organically natural segregation seemed to the white middle class of Mobile in 1939, when at the age of nine I prepared to travel to Washington, D.C., with my parents. Several adults in the family teased me. "Sonny," they said, using my pet name, "colored people are allowed to sit up front in the buses in Washington. What are you going to do when one of them sits down next to you?" I felt a little afraid, to tell you the truth. What *would* I do? To this day I feel a twinge of shame—embarrassment might be the better word—when I think of it. This was a time when quite a few otherwise law-abiding white criminals, still calling themselves Christians, participated in assault and even lynching by gun and rope to keep their fellow Americans intimidated. Sexual innuendos in the presence of a white woman, excessive back talk, or "troublesome" behavior of any kind was justification for violent reprisal. Even an accusation of rape was sometimes enough to condone murder. Worse, black males were occasionally killed at random just to send a message.

Police brutality was commonplace. Once, when I was delivering the morning paper before dawn in downtown Mobile, I stopped to watch three or four white policemen who had a black man crowded against a patrol car. One was saying, "Go on, go on and run, we'll let you go. Go on and run." The man stayed put. The cops paid no attention to me, even though I was less than fifteen feet away. I have no doubt today that, if the victim had tried to run, he would have been beaten or shot with impunity. After about a minute, I left. The incident made an impression on me, but at the time I saw nothing out of order. Police brutality was the crime with no name in 1942.

The Ku Klux Klan, the most public of racist organizations in the United States, reached a peak of 3 million members nationwide in the 1920s, then steadily declined to noisome irrelevancy. It was finally terminated as a legal entity in Alabama by a legal suit in 1987 that bankrupted it. The city of Mobile made a symbolic gesture of enlightenment on its own when it changed the name of a street to honor the victim of a Klan lynching.

The second half of the twentieth century saw a painfully slow climb from racism—not just in the South, where it was aggravated, but all across America. It came about by law and the change of generations and equally by the witnessing of the many achievements of African-Americans whenever and wherever the doors of opportunity opened to them. It is difficult, we discovered, to look down on people you are forced to admire for their character and for the higher status they have earned the hard way, against opposition. By the start of the present century, racism has significantly faded. In Alabama, it has largely fled the cities and retreated to more isolated rural areas. Now, white people who disparage the black race in public are held in contempt.

Black and white alike are greatly benefiting from the relaxation of the old tensions. They are coming to understand that the civil rights movement has freed both races. Friendships across the old racist barrier are now commonly formed naturally and powerfully, by socioeconomic class and shared interests rather than color of skin. Intermarriages, unheard of when I was a boy, are now accepted. Yet the "huge deadly serpent," as Philip Gosse described the evil in 1838, is not yet finished. It still occasionally shudders and writhes. It requires yet more reason and common decency in order to be completely dead and gone.

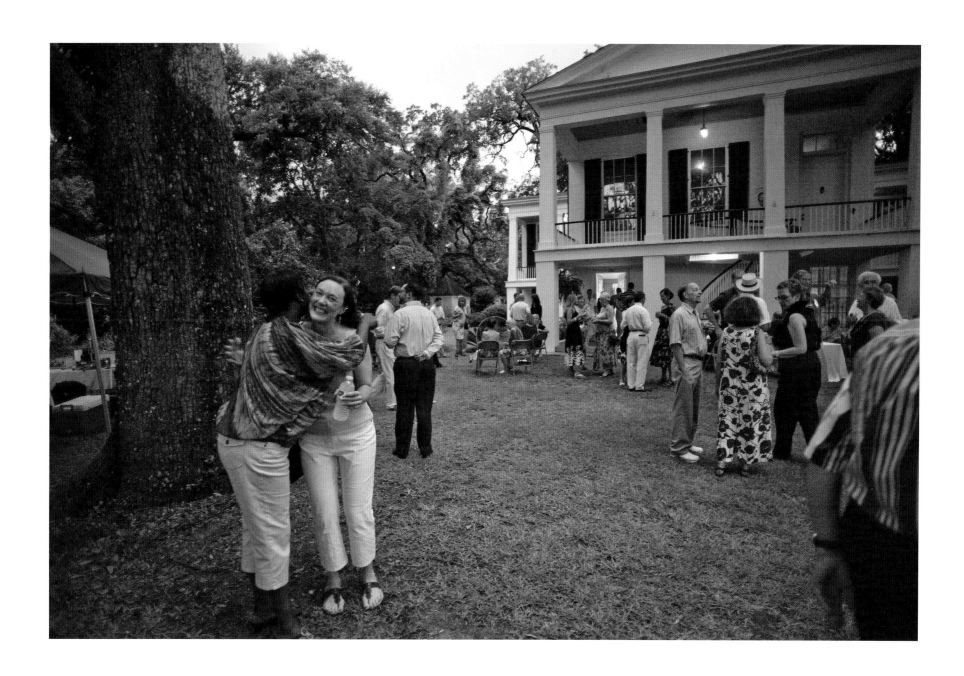

BRAVERY AND BEAUTY MINT JULEP PARTY, OAKLEIGH HOUSE, MOBILE

As an heir to the racial privilege that ran deep in the history of Alabama, I know I cannot mentally plumb the despair and humiliation suffered by the black Americans who were my contemporaries. But I can travel the surface of these indignities and listen to the voices and stories of those who endured them.

Claudette Daphins was one of the African-Americans who witnessed this transition. In October 2010, she spoke to Alex Harris of an incident that occurred during the late 1950s, when she was in her middle twenties. She was looking after the two children of her older sister, Hazel Fournier. They boarded one of Mobile's buses, which had recently been integrated by federal law. No longer were blacks required to move to the rear in public transportation. This day Claudette and the children set down on two long seats at the front.

> The driver turned around and said, "Where do you think you are going on that seat, nigger?" I said, "Well you are going downtown, aren't you?" Oh that man was so mad at me. It was not a full bus but there were a lot of people on there. Black and white sitting where they wanted to sit. But anyway when we got downtown all the black people got off the bus from the rear entrance because they must have felt "I don't want to be part of this! [laughing] This going to be a mess." Because he wouldn't open the front door for me and I wasn't going to go all the way in the back. So I told the children, "Stand right behind me because we aren't going out the back." So he was so mad. I said, "What is your bus number? I have more time than you have. And I'll just stand here and wait till someone comes and either move me or move you." That man opened the door and it knocked the children and it knocked me. But we got off that bus.

Claudette Daphins was nevertheless aware that the racism of Mobile was more muted in expression than in other parts of Alabama and even in Los Angeles, where she earned a master's degree in education. "Out in L.A.," she said, "I came into more prejudice than I did here in Alabama. That's because I came into 'open prejudice' in Los Angeles." Still, plenty of prejudice existed in Mobile. "You knew how to expect it, and you knew how to avoid it

here. You expected it. You were an agitator." Racism was kept more below the surface for economic reasons. Mobile was struggling to maintain a respectable face.

You have to remember [Claudette continued] that Mobile is a seaport town. And you've got Mardi Gras. And the upper echelon did not want us to be on the front pages. They did not want it to be a Montgomery, Alabama, where you marched. They did not want it to be a Birmingham, Alabama. Mobile has an economy connected to the seaport and Mardi Gras. That is part of our economy. And if you do something that is ugly like that [response of the bus driver] you give Mobile a bad name. Mobile did not want to be ugly.

Claudette Daphins is a member of what deserves to be called the great generation of America's cultural revolution, those African-Americans who carried the country into the era of civil rights—by character, personal achievement, a lot of hurt, and in the end a remarkable lack of acrimony. Her brief reflections revealed how the transition was eased by the inner strength of individuals, tempered by hard work and a determination to succeed.

My first job out of the house was to work in White Swan Laundry. If I had my way every dropout in Mobile would have to work in a laundry. [laughing] It was hot. You going to work in the laundry, baby, you will want some education. I worked there for 3 months. And I did hand finishing. Not only is it hot but the iron is steaming. And my check at the end of the week was 11 dollars and something. That was my money that I earned to go to college. Paid my tuition at Bishop State over there. $25 a quarter, $75 a year.
So when I went to Southern Cal for my master's they went to tell me that I was not educated in Alabama. They would not believe I was educated in Alabama. My professor said that I talked too fast. I said, what you mean? He said, what college did you go to? And he hadn't heard about my college. But I had good teachers. Dr. Bishop himself taught me. Need I say more. He was something. He was also my mentor.

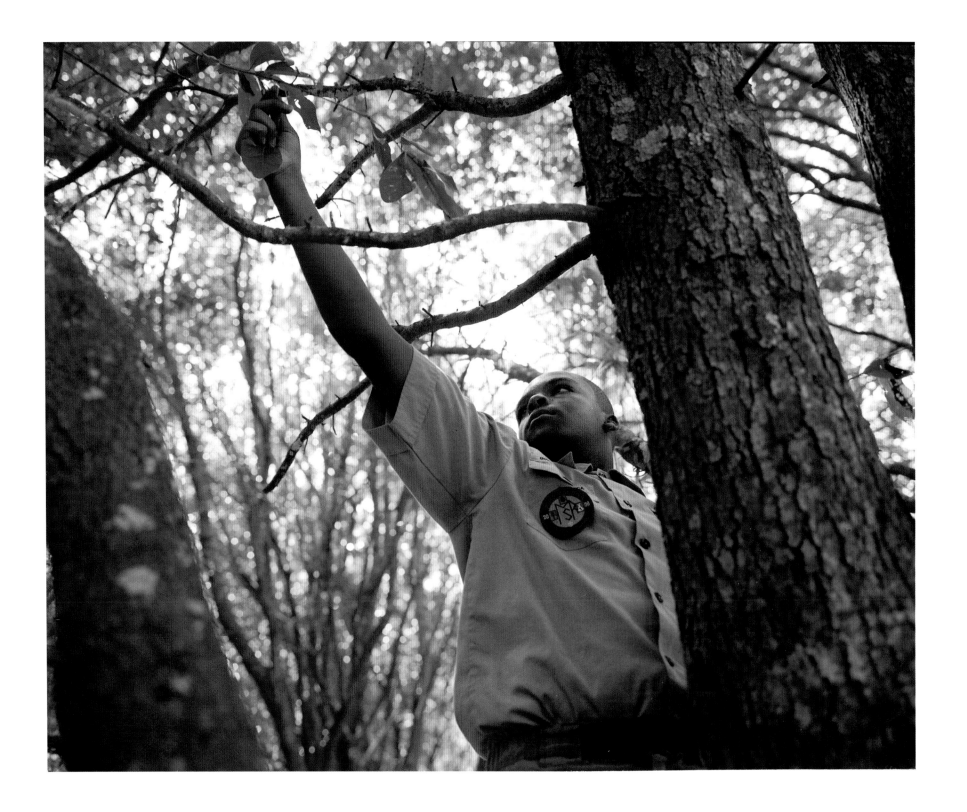

JASIRUS ROX, FIVE RIVERS STATE PARK

The change did not happen in a single generation. The way to the breakthrough was prepared by earlier heroes. One was Mobile's Clarence Mathews, the father of Claudette Daphins and Hazel Fournier. Mathews was a chauffeur who served a wealthy white family all his life. He had only a fourth-grade education. Yet out of his own meager resources and a powerful spirit, he made history in Mobile. During the late 1920s, while in his mid-thirties, Mathews decided he would create the first troop of black Boy Scouts in the Mobile area. First he created a local chapter of the Allen Life Guard, a pre-existing religious organization for black youths. Then he set out to transform its members into Boy Scouts. His determination was based on his often-stated conviction that, despite their great handicaps in race and poverty, "My boys are as good as any in this town."

He dressed himself and his followers in Army surplus khakis and secondhand Scout uniforms, minus the official Boy Scout insignia because they were not yet officially recognized. Under Mathews's strict guidance, the boys studied the official manual and followed the rules of the Boy Scouts it laid down. Then, mortgaging his own home, he took forty-three of his charges by train to visit the George Washington Carver Institute (now Tuskegee University) at the veterans' facility in Tuskegee, Alabama, where they saw black doctors and nurses at work. They proceeded on to Washington, D.C., where on their last day they were greeted by President Herbert Hoover in the White House. Soon after their return to Mobile, amidst much publicity, they were officially granted not one but three Boy Scout troop charters.

Another peaceful warrior of Clarence Mathews's generation was Walter Hugh Samples, who was ninety-two years old when Alex Harris met him and his granddaughters, Crystal Samples and Sharon Rene Samples. By grit and determination Walter Samples worked and fought his way in difficult times to leadership in the life of the city. He started in a special school for "colored" students in the suburban community of Whistler. There, the children used different books from those used by white kids. Their teachers were paid less, and the building was essentially a barn furnished with outside privies, one for boys and one for girls. Water was drawn from an outside pump with a wooden handle, and it always came up muddy.

Walter Samples soldiered on and made it through Dunbar High School, designed for African-Americans to be an equivalent to the all-white Murphy

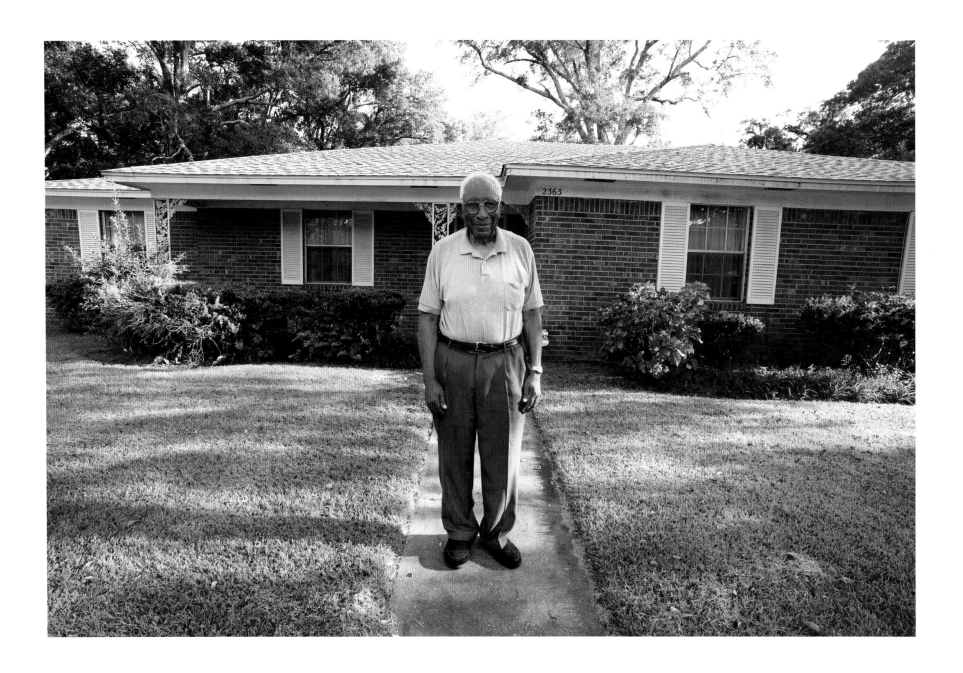

WALTER SAMPLES, MOBILE

High School (which I attended in 1943). It was parallel—but far from equal. Dunbar School was vastly inferior, in staffing, size of classes, equipment, supplies, and services, to the other public high schools in Mobile—namely, the million-dollar Murphy High School. Dunbar only cost about $40,000 to build.

At Dunbar, classes were overcrowded. A seat designed for one had to be used for two pupils. There was no library, no cafeteria, no biology or chemistry labs, no gymnasium, no athletic field or tennis court; no physical education classes and no free textbooks. Also, Murphy had a swimming pool that Dunbar did not have. There were no vending machines with snacks or drinks. On campus in the rear there was a small building from which a Mr. and Mrs. Owens sold coffee, rolls, cookies, candy, and a nickel fish sandwich. But many students did not have a nickel. Students were expected to bring their lunches from home. Some who lived nearby could go home for lunch.

But Dunbar High School had dedicated teachers—and one an inspirational figure, whose presence and high degree of excellence showed everyone what education and leadership could accomplish in the black community, even when smothered by a deeply segregated society. Walter Samples presented the following account on November 18, 2001, at the Golden Anniversary Recognition of Dunbar High School:

During my freshman year a new teacher who was destined to make the greatest positive impact on the school for many years to come was added to the staff. She was Miss Lucy Ariel Williams, a graduate of Fisk University, an accomplished pianist with an operatic soprano voice. She was a French and Music teacher. She composed the words and music to what became the Alma Mater of Dunbar High. Miss Williams initiated what became the biggest event and fund-raiser of the year: Dunbar Night. Dunbar Night was tantamount to a course in Music Appreciation. This program included singing, dancing, reciting, some musical instrumental numbers, solos, duets, and choruses. Its repertoire included work songs, folk

songs, jazz, popular music, classics and some operatic numbers. This annual activity plus the school song did much to engender school spirit, pride and morale. Each program usually ended with the singing of a Negro Spiritual or a medley of Negro Spirituals.

The first male teacher whom I ever had was a substitute teacher for algebra and related subjects during my sophomore year. He was a Mr. Joaquin M. Holloway. It was rumored that more than one of the female faculty members were vying for the affections of this gentleman. Within a few years after he came on the scene and after I graduated, he and Miss Lucy Ariel Williams exchanged wedding vows. After that occasion she was called Mrs. Ariel Williams Holloway. She was later appointed a Music Supervisor in the Mobile School System, thus becoming the first Negro to serve in that capacity. The Ariel W. Holloway Elementary School is named for her.

Yet it was a white friend and counselor who pushed Walter Samples into higher education and the realization of his potential as a leader of Mobile.

I didn't plan to go to college, because my folks couldn't send me to college. It was 1936 and I'd just finished High School. I was running around doing nothing. One of my friends said to me, "What you want to do next year?" I said, "I don't know, I'm waiting to go on a ship." He told me he was going to college on a work scholarship. "You go to Dunbar High School." So I went back to Murphy to ask about work scholarships to college. They asked me if I lived in Methodist Town or Baptist Town in Whistler. Whistler for black folks had two sections, a Methodist section and a mile or two away a Baptist section. They asked to see my report card and I rode back the next day on my bicycle. She took one look at it and said, "Boy you are going to college." She said, "Don't tell me what you can't do. I'm tired of you Negro boys telling me you can't do." She asked my parents to sign a paper which meant I could earn $10 a week and told me I might be able to go to Alabama State Teacher's College (that was the Black teacher's college in Montgomery) branch in Mobile.

Walter Samples went on to graduate from the Alabama State Teachers College. In 1942 he joined the Army, then still segregated, attaining the rank of first sergeant. After discharge, he entered the U.S. Postal Service, rising to stationmaster in 1973. To obtain an entrance postman's job, however, and promotions thereafter, he had to fight discrimination within the service each step of the way. Using his high personal performance ratings and bringing suit under the Equal Employment Opportunity Act, Samples became the first African-American given a supervisory role in the Mobile Post Office system in fifty-two years. He expanded his activities to promote the hiring of black policemen and led in efforts to improve local black schools. He followed Clarence Mathews in expanding and upgrading the Boy Scouts, for both black and white. For his achievements, he has received more than twenty awards, local and national. They include four Tribute of the Week Scroll Awards from the *Mobile Press Register*; the Silver Beaver Medal of the Boy Scouts of America; and the Patriot Award of the City of Mobile.

In 2010, Mobile had a black mayor, chief of police, and administrative assistant to the mayor, as well as a black woman postmaster. But Walter Samples knew all the advances were just a beginning in a city whose population is almost half African-American. "We have seen considerable changes," he said. "We need some black doctors and dentists. There are very few. But we are crawling a little bit, piece by piece."

What counts most for harmony now, as in any city, is the growth of the black middle class. Walter's granddaughter, Crystal Samples, is an example of the result. Raised after the civil rights revolution, she has traveled far, earned an advanced degree, and returned to Mobile with a wise assessment of the future of race in the beloved city.

I think it's a generational thing, in the South especially. Back in the 50s, 60s, and 70s there was more of a need for them to have things, clubs, and groups for black people because they weren't included in a lot of the things for white people. So they needed something. So they created them. These things have lasted over the decades. So it's just a tradition. You know my Mom did it so I'm going to do it kind of thing. So I don't think there are a lot of "for blacks only" things

being created today. I'm not saying there aren't any, but not as many as before. These groups are just continuing from the past. Like their mothers or fathers were in it so it's a generational thing, like a tradition.

At work it's pretty mixed. And people of different races work together and they get along fine together at work. But then people will say certain things. Like I have this co-worker whose daughter was going to be in a "court" and had to learn to curtsey. It was a black Mardi Gras thing. So they are not racist at all but this is what they have been brought up to do so this is what they do. You participate in these events and then you get together [and] you see that people are pretty much the same, especially in the South I think.

Now I think that divisions between people are more socioeconomic than they were in the past. In the past socioeconomic divisions were racial divisions. Black people were poor and white people were less poor, or else rich. And now that is getting blurred and I think that's why racial lines are getting blurred too.

THE TWO ALABAMAS

In order to understand Mobile, it is important to know there have always been two Alabamas, in addition to that based on race. The division was of one kind before the Civil War and of another afterward. During the antebellum period, Mobile was the first Alabama and the rest of the state was the second. After the Civil War, the succeeding division was between the cities and towns on one side and the rural areas on the other.

By the time of the American accession, in 1813, Mobile was already venerable by Gulf Coast standards. It was also of mixed origin and polyglot. It had endured a century-long ownership under three European masters. Its population could be counted only in the hundreds, and during hard times it came close to extinction. With American ownership and the inland frontier open to colonization, the population of the city began its boomtown growth. The new Mobilians poured in by sailing ships from the American Atlantic

seaboard, Europe, and the West Indies, as well as New Orleans and other settlements along the Gulf Coast. The religion they brought was predominantly Protestant and, secondarily but still prominently, Roman Catholic. There were also elements of African tribal religions that had survived the stresses of slavery, although these diverse beliefs were never as strong as in New Orleans or the black republic of Haiti.

My own paternal forebears illustrate the heterogeneity of the Mobile immigrants: the Hawkinses of New England, ultimately of English descent; the Hodges and Joyners, probably of English origin; and then, to notable degree, William Christopher ("Black Bill") Wilson, an Irish Protestant shipwright from Baltimore, and his Jewish wife, whose parents came from Germany.

While Mobile received people of multiple origins, northern and central Alabama was being filled with pioneers of a different and less variable kind. After the Spanish handover of Mobile in 1813, followed by defeat the following year of the Red Stick Creek at Horseshoe Bend, freehold farmers and traders began to take up land along the abundant waterways of the Tennessee and Mobile River basins. They included my mother's antecedents and their collateral lines, the McKnights, Sheltons, Crumlys, and Freemans. Those Northern settlers who could afford slaves brought them in, and in short time plantations were sprinkled across all of Alabama.

Everywhere the land proved richly productive for agriculture, and farmers did well. For a while, the new town of Huntsville, in north-central Alabama, had a larger population than Mobile. In 1817, Montgomery was laid out as "New Philadelphia." Thirty years later, this city along the Alabama River far in the interior, became, instead of Mobile as might be expected, the permanent capital of Alabama.

The white population of northern and central Alabama was predominantly descended from the "Celtic fringe" of the British Isles, comprising the Irish, Protestant Scots-Irish, and other stocks from the western and northern uplands of England, Wales, and the Hebrides. Throughout the history of the South, from 1790 through 1860, about half of the white population was Irish, Scottish, or Welsh in origin, and half of the remainder were extracted from peoples originating from the western and northern English uplands. In contrast, nearly three fourths of the Yankees of New England originated in

the southeastern lowlands of England, and this dominance continued until the massive immigration of Irish that began with the Great Famine of their homeland during the 1840s.

There remain to this day strong cultural differences between the Northern and Southern United States that can be attributed, in the view of many historians, to the original characteristics of the Celtic fringe peoples. As Grady McWhiney has noted in his *Cracker Culture*, the statistically average personality in the Old South was not a stereotype but widely distributed and deeply rooted in the region's demographic history.

> Throughout the antebellum period a wide range of observers generally characterized Southerners as more hospitable, generous, frank, courteous, spontaneous, lazy, lawless, militaristic, wasteful, impractical, and reckless than Northerners, who were in turn more reserved, shrewd, disciplined, gauche, enterprising, acquisitive, careful, frugal, ambitious, pacific, and practical than Southerners. The Old South was a leisure-oriented society that fostered idleness and gaiety, where people favored the spoken word over the written and enjoyed their sensual pleasures. Family ties reportedly were stronger in the South than in the North; Southerners, whose values were more agrarian than those of Northerners, wasted more time and consumed more tobacco and liquor and were less concerned with the useful and the material. Yankees, on the other hand, were cleaner, neater, more puritanical, less mercurial, better educated, more orderly and progressive, worked harder, and kept the Sabbath better than Southerners.

Although the concept is controversial, McWhiney and some other historians have argued that the difference does exist and is due substantially to the baseline traits of the Celtic peoples from which the population of the Southern states was drawn. These qualities are due to geographic and economic circumstances that are centuries old. According to Forrest McDonald, "Most of the inhabitants of the upland areas whether Gaelic, Brythonic, Norse-Gaelic, or some other form of hyphenated Celtic—remained isolated from and hostile to their English neighbors, and they remained tribal, pastoral, and warlike."

To recognize the persistence of such traits is not to suppose they have a genetic basis. More likely, their origin is entirely cultural. Children today still learn attitudes and behavior, including dialects, substantially from their families in early life and before the clamor of television, the Internet, and social networks fully envelop them. There are regional differences in dialect even within Alabama—for example, between Mobile and Wilcox counties, only a few counties apart—that can be detected by natives. American history, and particularly the history of the Deep South, has not been so lengthy as to erase the more stubborn cultural traits. There were still about a dozen veterans of the Revolutionary War alive at the time of the Civil War, and there are people alive today, in the early twenty-first century, who knew veterans of the Civil War.

Another force in the formation of the Southern character was, of course, the corrosive impact of slavery. To be wealthy in the antebellum South was usually also to own slaves. The new aristocracy distained common labor. Its members preferred the conspicuous display of leisure activities to showcase their status. Hunting, lavish parties, exaggerated good manners, and stylishness of dress were standard. Nor did the poor and landless whites think of themselves as a hereditary lower class. For the most part, they too aspired to wealth, perhaps slaves, and the timeless idle pleasures of the good life.

Before the Civil War, Mobile was urban, seafaring, and connected to the rest of the world. In contrast, the rural interior was agricultural, land-bound, and relatively isolated. Seen from Mobile, "interior" meant the cotton-growing plantations of the Mobile River basin, stretching north from above Mobile across the southern and central parts of Alabama for almost two thirds of its entire area. From this immense region, Mobile initially drew most of its wealth.

By 1860, Mobile had patrician families and international banking and trading firms. It had two newspapers, a pioneering public school, Barton Academy (which both my father and I attended), and an esteemed liberal arts college at Spring Hill. There was a small cadre of intellectuals, some of whom, contrary to a common impression, had begun to question slavery and the reflexive assumption of innate white superiority.

It was inevitable that the culture of the Alabama interior should fuse with that of the port city. But there were also the Mobile patriotic hotheads,

167

obedient to the rule of honor and courage, chafing to be unleashed at the outbreak of war. There may be found in old albums daguerreotypes, such as that of a teenager Mobilian newly enlisted in the Army of the Confederate States, wearing a Bowie knife, clasping a single-shot pistol across his chest as though taking an oath. He could have come from a plantation of the kind described by Philip Gosse.

There were wealthy citizens who came from upriver plantations on paddlewheelers and stayed either in hotels or in private second homes they maintained in the city. They met in city offices with their commercial representatives. From well-stocked stores they bought furniture and fancy goods for their homes and gifts for families and friends. They walked down to the waterfront market to look over slaves for sale. Others entering were failed farmers and the sons of upstream landowners in search of work and a new start offered in the welcoming venues of the city.

They were predominantly "crackers"—those with the manner and culture we today usually associate with the Southern white working class and rural yeomen. In antebellum times, they included a mix of slave-run plantation owners and freehold farmers. Crackers are nowadays diced taxonomically into subtle regional variants and graded intensities of class distinction and, accordingly, are designated rednecks, hillbillies, peckerwoods, doughfaces, and honkies. They are a proud, confident people, able to trade self-deprecating jokes ("You are a redneck if you think duct tape can fix anything or if you stare too long at the word 'concentrate' on a carton of orange juice"). For the poorest and most conspicuously ill-mannered, there is the pejorative "white trash."

At our Charleston Street home, we never heard the word "redneck." We called the rural poor "peapickers." During World War II, when large numbers of these worthy citizens poured into Mobile to work in the shipyards, we regrettably looked down on them. We dismissed them as "those peapickers with their towheaded kids." "Towheaded" meant blond, so in a bizarre reversal of racism, we discriminated against the high proportion of light-skinned people of northern European descent—for no other reason than they were poor and invading our city. The response illustrates the principle that racism is an expression of tribalism. It has no fixed rules and is diminished little by the use of any reason or feeling of shame.

My Mobile forebears never, thankfully, owned slaves, although not for lack of approval of the practice. My contemporary relatives when I was a boy were polite, or at least semi-polite, members of the urban middle class. We called our black neighbors "negroes" or "colored people"—with considerable respect, so long as none moved too close to the city block on which we lived. White trash, whom we respected less, called them "niggers." I always hated that term, partly because it lowers the speaker and partly because, even as a boy, I was a Christian and had an instinctive feeling that it was sinful to use it. In present-day Mobile and elsewhere, the acceptable term is "African-American." Or "black," if you want taxonomic symmetry with white—for that reason, or else if you are a journalist without enough space to squeeze the seven syllables plus hyphen of "African-American" into your text. In any case, it is proper to keep in mind that their family pedigrees are among the oldest in Alabama and, further, that they did not work their way down from a higher socioeconomic class to the lowest, as did many white trash, but instead were put in the lowest level, held there for a long time, and are now rapidly working their way up.

In contemporary Mobile, it is expected that African-Americans will occupy high positions in business and government. Even just a visit from the great baseball player Hank Aaron, a Mobile native son, is the occasion of front-page newspaper coverage. Among the city's most distinguished residents is another native son, Major General (ret.) Gary Cooper, who in Vietnam became the first African-American officer in Marine Corps history to lead a company in combat (earning two Purple Hearts along the way) and later to command a major Marine reserve unit.

Today, the old stereotypic traits characterizing Southern whites are also fading, as fewer people remain in rural areas, with urban and small town populations growing correspondingly larger. Immigration from other parts of the United States and abroad is increasing, and educational levels are rising across all the Southern states, with some college training becoming routine. Members of the educated middle class, now ubiquitous and socially dominant, are also vastly more racially tolerant than were their parents and grandparents.

It is further true that America is evolving toward homogenization. But in Alabama there remains a hard, enduring core of Southernness, black and

white, and I am glad of it. I love the rhythms, the ambience, and the history-conscious and pedigree-besotted culture. Mostly defanged and settled down now, it retains a residue of great charm. Its most secure sanctuary is our blessed backwater city of Mobile.

As soon as the Civil War ended, Alabama was cleaved again into two social worlds. On one side were the poor, badly educated black and white of the rural outback and mill-town enclaves. On the other side were the better educated working and middle classes, heavily concentrated in towns and cities scattered across the state. For more than a century, the two populations diverged still further. In the 1930s, those who traveled to a city or small town in Alabama usually found themselves in a First World setting close in look and feel to that of their counterparts elsewhere in the United States. If they went out into the countryside, however, and took a turn onto a blacktop byway—or, better, one of the countless unmarked dirt roads—they found themselves in an American Third World. Everywhere were shabby little houses with sagging porches, the ruins of old automobiles kept for parts in the front yard, meager plots of cotton and corn. There were outhouses, water pumps, and yards chaotically populated by dogs and chickens. The people were proud, cautious, and out of dire necessity cheaply dressed. Having nothing but distant emergency medical care available, if that, many suffered from hookworm, pellagra, and other treatable diseases.

The cleavage into two worlds was inevitable, and came into being as follows. When the Civil War ended, many of the freed slaves in Alabama chose to stay on the plantations, if they could, in order to make a living there as free employees. Others moved to Mobile, Montgomery, and other centers of population in search of work, or they left the South altogether, some to the newly opened Western frontier. Joining them in the diaspora were landless whites forced to seek new kinds of employment.

A great many of the dispossessed—black and white—found a solution in sharecropping. Cotton remained the flywheel of Dixie's economic engine, and the plantation masters still needed cheap labor to grow it. To survive themselves, they provided plots of land to the sharecroppers, lent them dwellings, a mule, and a cow, and the permission to raise garden crops for food. In return, they received a portion, typically half, of the cotton or other

produce that came from the rented fields. The system worked, more or less. But it was still a form of servitude, and it generated widespread poverty.

For three quarters of a century, sharecropping helped to keep agriculture alive and gave time to reorganize the economy. One great additional resource to which the Southern states could turn was their vast forests, especially the longleaf pine stands that covered 60 percent of the remaining natural acres. "Yellow pine," as it was often called in the logging industry, rivals white pine and redwood as the best timber in America for construction. By 1900, lumber joined cotton as one of the two principal products pouring into Mobile from the hinterland of the Mobile River basin. Sawmills crowded the perimeter of the port city.

Further north, the rich coal deposits of central and northern Alabama provided the basis for industrialization. A potent combination now came together throughout the state: coal for energy in order to turn cotton into cloth and wood into pulp, paper, and fiber.

The resulting industrialization brought a large fraction of the rural poor into the towns and cities, where they provided cheap labor for coal mines, cotton mills, and factories. In this desperate period, the South climbed slowly out of the poverty trap foreordained by the antebellum slave-based economy and deepened by the punitive policies of Reconstruction. The new rich who benefited most allowed nothing to stand in the way of economic growth. The forests were clearcut, the rivers and streams were dammed and contaminated, and the air was polluted.

The heedless advance continued far into the twentieth century. When I was a student at the University of Alabama during the late 1940s, the sewer-like smell of hydrogen sulfide from a nearby paper mill on the Black Warrior River blew in over us on workdays whenever the campus was downwind. We joked about the nuisance a lot, but almost no one made any serious objection. It was the "smell of progress." When I journeyed north to Knoxville in 1950 to begin my doctoral research at the University of Tennessee, a fog of particulate pollution generated by nearby industrial plants frequently enveloped the campus. If a window of a campus building were left open for more than a day or so, a film of solid pollutants began to form on the furniture inside. The gritty particles could be felt by rubbing them between thumb and index finger. Everyone complained about this outrageous condition, but again, no

SCOTCH & GULF LUMBER, LLC, MOBILE

SCOTCH & GULF LUMBER LLC, MOBILE

one to my experience openly protested to authorities. The discomfort was a small price for having a university to attend.

The price, however, was more than discomfort for the industrial workers who built the South's new economic base. Large numbers of mill workers suffered byssinosis, known popularly as "brown lung," the allergy and scar tissue caused by inhalation of unfiltered cotton dust. Miners were similarly inflicted with black lung, the suffocating disease caused by the particles of coal dust. Before the advent of strong unions, laborers were in effect industrial serfs. They frequently lost fingers and hands and even their lives, for which little or no compensation was offered. At some plants workers were paid in scrip, currency issued by their employer and redeemable only at the company store.

They were mostly proud and clannish Scots-Irish yeomen, family-centered and bound by honor and loyalty to their place of birth. They might have left for the better-paying industrial centers of the North, and a few did, but the rest stayed for life.

Those who did not know them and their descendants have been misled about their true character. As the journalist and writer Rick Bragg has written in his splendid essay *The Most They Ever Had*:

> Outsiders like to talk about working people of the Deep South in clichés, like to say their lives are consumed by football, stock car racing, stump jumping, and a whole lot of violent history. But it is work that defines them. You hear it under every shade tree, at every dinner on the ground, whole conversations about timber cut, post holes dug, transmissions pulled.
>
> They do not ask for help from outsiders, unless it is from a preacher, a lawyer, a doctor, people who have skills they do not possess. They can, most of them, lay block, pour concrete, swing a hammer, run a chainsaw, fix a busted water line, and jerk the engine from an American-made car with muscle, a tree limb, and a chain. If their car breaks down at the side of the highway they do not call the AAA. They drive the roads with a hydraulic jack, a four-way lug wrench, and a big red tool box that takes two hands to lift....

It is the work that makes them, holds them up.... People who do not work, but could, are despised. You see it, that disgust, in the tribunals of old men who linger at the co-ops and country stores, men entitled to a few final years on benches and caneback chairs after a lifetime of third shifts, stretch-outs, and see-through sandwiches.

In the hard times, sharecroppers on the land fared no better and labored no less honorably. Their livelihood was tied to the fluctuations in the world cotton trade. A prolonged economic downturn during the final quarter of the nineteenth century hit them especially hard, and they suffered even more during the Great Depression of the 1930s. Alabama sharecropper families in 1937 are minutely and painfully described in *Let Us Now Praise Famous Men* (1941). Their starved but dignified faces stare out from the photographs by Walker Evans, their threadbare possessions and dead-end lives in the descriptions by James Agee.

During the late 1930s and early 1940s, whenever my parents took me on automobile drives to the north out of Mobile, I saw some of these people. We all knew it was inconvenient to travel in the countryside on Saturdays. This was the day of the week when the roads were clogged, when the poor rural folk, mostly white, rode to the nearest town in trucks or mule-drive wagons to get supplies. On arrival, women took the children along and did the shopping, while men gathered in groups to talk. I have a vivid memory of such menfolk hunkered in tight rows along the guardrail of country courthouses, some in overalls, some smoking, others chewing tobacco. I accepted the existence of these rural and mill-town poor as just a natural, eternal part of Alabama. We never, as far as I can recall, expressed compassion for them. Like the segregation of blacks, it was just the way the world had been put together. I sometimes wondered what they were thinking, what they were saying. Just who were these strange people? Now I understand. Our forebears, of course, here for the same reason I was. They were and they are my people.

By this time, the two Alabamas of a second different kind were clearly delineated. In the cities and towns, with Birmingham and Mobile leading, the middle class had continued to expand, its wealth based on agriculture, industry, and trade. There were inevitably poor white neighborhoods on

the other side of the tracks. There were also blacks in their ghettos, but even in the latter a middle class was forming. It would display its considerable strength during the civil rights movement three decades later.

Urban and small town Alabama in this period, especially during the thirties and forties, can be likened to the present-day First World. The impoverished people of Alabama's backcountry, still a large fraction of the state's population, resembled the Third World in look and culture. There were as always farmers and baronial landowning renters among them in the hinterland, but overall it had not fundamentally changed since the Reconstruction.

Nonetheless, changes begun after the Civil War were already underway that would transform agriculture in Alabama and raise the quality of life for those who stayed on the land. By the end of the nineteenth century, the global market turned more competitive for cotton growers. At the same time improved transportation opened new markets for a diversity of other crops. At the start of the Civil War, the South had only one third the railway mileage of the North. The gauges of its tracks varied widely, whereas most of those in the North shared rails four feet eight inches apart. By the early twentieth century, the Southern states had rebuilt and greatly expanded their rail systems. They had also begun to lay paved roads throughout the countryside. One of the locomotive engineers who ran trains north to Thomasville and east to Pensacola was my grandfather, Harry Maury Wilson, son of Black Bill.

In 1915–18, King Cotton was finally dethroned by the spread of the boll weevil, which had moved out of Mexico and through the Gulf states. At the climax of the infestation in Alabama, cotton fields were devastated. Farmers regained some measure of prosperity by diversifying their crops. The results were greater stability in both produce and economic yield. Cotton recovered, but its dominance never returned. In gratitude for forcing agriculture onto safer ground, the town of Enterprise, located in the southeastern part of Alabama, built the Boll Weevil Monument. It is still there, a robe-clad woman raising a sculpture of the ravaging beetle above her head.

In 1949, when I was a nineteen-year-old senior at the University of Alabama, I took a job that enabled me to examine the crops of southwestern Alabama in detail. The infamous imported fire ant, a native of Argentina and Paraguay, had been inadvertently introduced into Mobile on marine cargo,

probably sometime in the early 1930s. By 1949, a continuous population of the pests had blanketed Mobile and Baldwin counties and was spreading outward at the rate of about five miles a year. Everyone in the Mobile area, through both the city and surrounding rural areas, was complaining about these ferociously stinging pests ("worse than the boll weevils"). Within three decades, the imported fire ant reached the Carolinas in the east, Texas in the west, and the Tennessee border to the north.

Once again the South found itself invaded by overwhelming numbers of an implacable enemy, insect instead of Yankee. The fire ant became a new legend of the South. Around Mobile from the start farmers, in particular, were complaining about the fifty or more anthills that sprang up in their pastures during a single season. They claimed that the ants were eating the crop seedlings, hampering work in the pastures, and even invading their houses.

In the course of my research I traveled almost every route that could be reached by automobile over Mobile and Baldwin counties, talked with farmers about their problems and visited their gardens and cultivated fields. I found plenty of evidence to support their complaints. I made notes on the principal crops they were growing: corn, radishes, lettuce, soybeans, peanuts, and strawberries. Cotton was also being cultivated but was in no place the dominant crop. Sixty-two years later, it is much the same. The six crops leading in acreage are, in rank order, hay, soybeans, corn, cotton, winter wheat, and peanuts. Alabama has also become a major producer of beef cattle, hogs, poultry, and its newest major industry, farmed catfish.

MARDI GRAS, BORN IN MOBILE

Today, as it enters the second decade of the twenty-first century, Mobile is a vigorous and cheerfully eccentric middle-sized American city. Within the city limits live about 200,000 citizens. If the rest of Mobile County is added, as it should be since suburban sprawl is turning the whole into Greater Mobile, the population is twice that, to a bit more than 400,000. Mobile is the most active port city on the Gulf of Mexico coast east of New Orleans. Through the public terminals of the Alabama State Port Authority pass agricultural and industrial products arriving from the vast river channels, from

ground transportation systems, and from traffic of the Intracoastal waterways. Mobile is home to the University of South Alabama, together with Spring Hill College, a symphony orchestra, an opera, a ballet company, art museums, and historic neighborhoods and homes.

All of these accoutrements are indicators of growing economic health and quality of life, the twins beloved by chambers of commerce. But they tell us nothing of the soul of Mobile. Glimpses of that deeper stratum can be found among the residues remaining of Mobile's long and epic history. The most conspicuous is Mardi Gras, begun as a Catholic tradition as soon as the French colonists founded Old Mobile in 1702. Its purpose was to celebrate Fat Tuesday (hence, literally in French, *Mardi Gras*) in order to feast and play before the abstemious Holy Week of Easter to follow. This ceremony was observed long before New Orleans existed and when Mobile was the first capital of the wide territory of French Louisiana. Through the succeeding two hundred years, Mardi Gras has evolved into the major social event of the city. With no particular religion favored, it now goes on for weeks. Mardi Gras is outwardly a celebration—of nothing. Or, more accurately, it is a harmless decorated explosion of chaos, freedom, and relaxed self-mockery, with outlandish floats and fashion parades, capering "royalty," and throws of glittering bead necklaces, candies, and fake doubloons to the spectators. These are displays by groups called "mystic societies," most of which have no outward purpose other than to have parties and be represented in the carnival parades.

The American Mardi Gras began, more or less, in 1830 as a New Year's celebration. Fired-up young men concerned only with entertaining themselves marched through the streets of Mobile in what they called the "Cowbellion de Rakins." The annual celebration came to an end at the start of the Civil War. With the naval blockading of its port by the Union fleet and then the occupation of the city by Union soldiers in 1865, the mood of Mobile's citizens was grim and foreboding.

What Mobile needed then was a new festival, as unbuttoned, insolent, and obstreperous as the old one. Precisely the right kind was invented by the Clerk of the City Market, Joe Cain, who, on Fat Tuesday in 1866, dressed up as an absurdly costumed Indian chief and paraded back and forth in the streets of downtown Mobile. The citizens were surprised and delighted. The next year "Chief Slackabamirimico" struck again, this time borne in

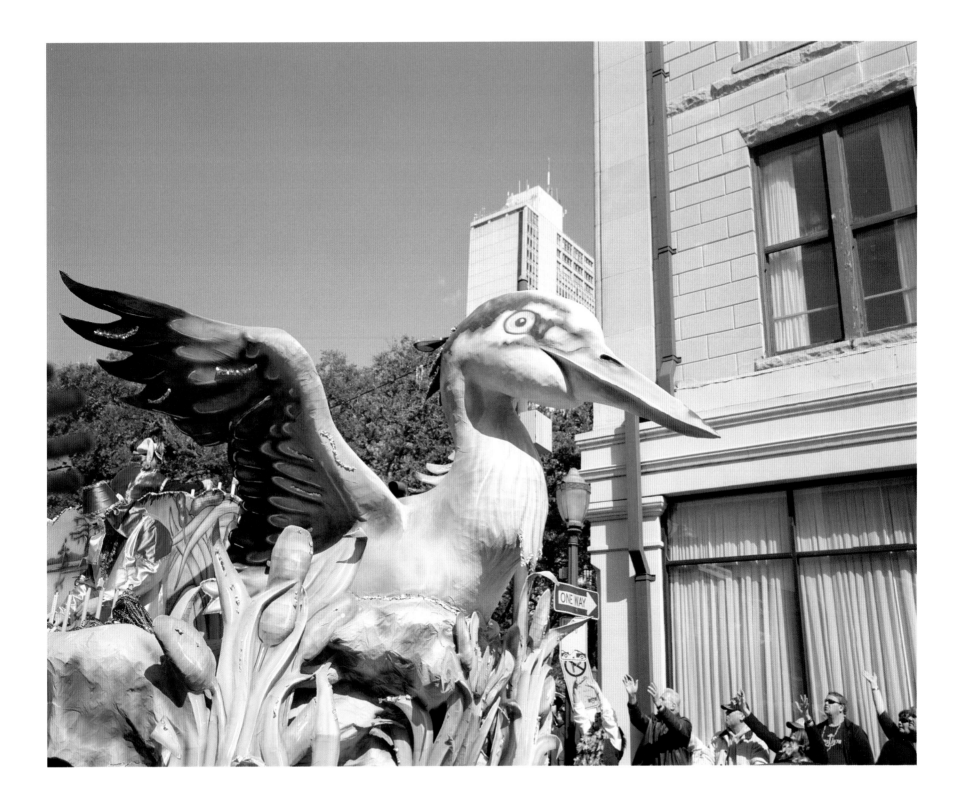

MARDI GRAS PARADE, MOBILE

a decorated charcoal wagon and accompanied by musicians, including a band of sixteen Confederate veterans calling themselves "The Lost Cause Minstrels."

The Mobile Mardi Gras thereafter expanded into a citywide annual carnival. Mystic societies multiplied. They competed for prizes in originality and excessiveness of their costumes and floats and threw gaudy necklaces from the floats to the cheering crowds. A ruling king and queen were selected, along with an attending court. Parties were given by the proliferating societies. At length the festival was extended by days and then weeks, as the parties grew more elaborate. The celebrations became high points of society life, planned well in advance for the Mardi Gras season. For daughters of well-heeled families, the beginning of Mardi Gras each year became the ideal time for coming-out cotillions—and a good time to find husbands, as one former participant recently told me.

Well back, in 1884, David Levi, a local citizen born in New York City who came to Mobile by way of New Orleans, added a new role to the multiplicity of Mardi Gras functions. His invention was the "Comic Cowboys," who with satirical floats and skits lampooned any absurdity they found in politics, business, national events, or leading personalities around Mobile. It was a healthy addition to Mobile's freedom of expression and growing self-confidence. An example, from 1916, has been provided by Samuel Eichold in *Without Malice*:

> In a variation from the past, the emblem float showed a quaint, mysterious lodge where a seeress sat and told visitors entering her lair what was coming to Mobile in the future years. The float was crowded with those eager to learn the destiny of our city.
>
> High above the float was the old cow bell with the emblems of the society. The first float recalled to the minds of Mobilians the long looked for visit of the famous Liberty Bell. It was supposed to return from San Francisco via the Port City, and in expectation

MARDI GRAS PARADE, MOBILE

there was depicted a "Miss Mobile" who was looking through a telescope for the long lost Liberty Bell.

Float two ridiculed the "Pathfinders" and was entitled "Looking for the Jackson Highway." On the float was a badly battered Ford automobile which looked as if it had been unable to find even a track across the countryside. This was a dart at those who found the "pathfinder" did not have the information they needed and wanted regarding travel.

Float three was entitled "The Bug House Skating Party, A Society Event," and poked fun at roller skating that had just become a fashion in this area.

Float four was entitled "Moving Picture Mysteries," and alluded to the various movie serials drawing thousands to local picture houses. Miss Lucill Love, who took the lead in many of the pictures, was having her picture taken by a very busy camera man exposing many feet of film as she changed poses.

By the time the Comic Cowboys approached their centennial, their floats had multiplied and the targets had expanded to national events, as exemplified in the report from 1981:

The Comic Cowboys were close behind the Royal Court's float. A "Transvestige of Beauty," the "Queen" of the Cowboys, led the parade.

The first float tossed barbs at the EPA, IRS, OSHA and FICA. The second float featured all time losers: such as Jimmy Carter, an Iranian "holy man," the New Orleans Saints football team and several government bureaucrats.

The third float satirized a federal judge and his effect upon the city. Float four focused on sports with signs on Auburn University's coach situation, Pac-10 degrees, Alabama's "Irish Hot Potato" and the New Orleans Saints.

The theme of float five was "National Politics," which showed films on the capital, coming attractions, and in retrospect, inauguration and play girl's after dark (of Capitol fame). Float six was

"Foreign Policy and Economics," which let the viewer know what was taking place in Washington. A sign read: "Do folks like jelly beans more than peanuts?"

Float seven lampooned Barton Academy, the Chamber of Commerce and Wragg Swamp. Number eight took a swipe at nickel-a-name judges. "Mobile's Historical Places of Crime" was the theme of float nine.

From its long-ago origin in French colonial Mobile to the present time, the history of Mobile's Mardi Gras can be divided into five periods. The Lenten celebration of the French was succeeded by the New Year's hellraising antics of the Cowbellion de Rakins in 1830. Next, with tomfoolery and merriment, Mobilians rose in 1866 from the heartache of their defeat in the Civil War. The annual celebration, now returned to the original date of Fat Tuesday, evolved a complex kaleidoscope of mystic societies, where all Mobilians could, if they wished, find membership and identity. Inevitably, prestige accrued to some of the oldest and more exclusive societies. They added the serious function of cotillions and the coming out of debutantes. Early in this period, the Comic Cowboys began to contribute social and political satire.

The fifth and last period, in which Mardi Gras now exists, has seen the emergence of the festival as a strong unifying force. Mardi Gras has a role beyond the frenzy of its celebration. It serves as a connection to Mobile's confused origin as a polyglot society, based first on its multinational colonial past and then on the great Cotton Rush of immigrants from around the world in 1820–60. Of course, it might at first seem that the exact opposite is true, because the mystic societies are a parsing of the larger municipal community. They are tribes, with tribal dress, rituals, and floats by which they identify and present themselves to others. A few of the societies are exclusive, but even they come together in mandatory common tribute and self-mockery. Everyone can belong to a society. They are formed at will and celebrate only one entity: Mobile. Mardi Gras is a paradox that works. It celebrates division and diversity in a way that promotes unity in the larger community.

There has been an obvious final barrier to overcome, made clear by the persistence of two parallel Mardi Gras celebrations, one white and one black. That, too, is a residue of Mobile's past but one that has begun mercifully to

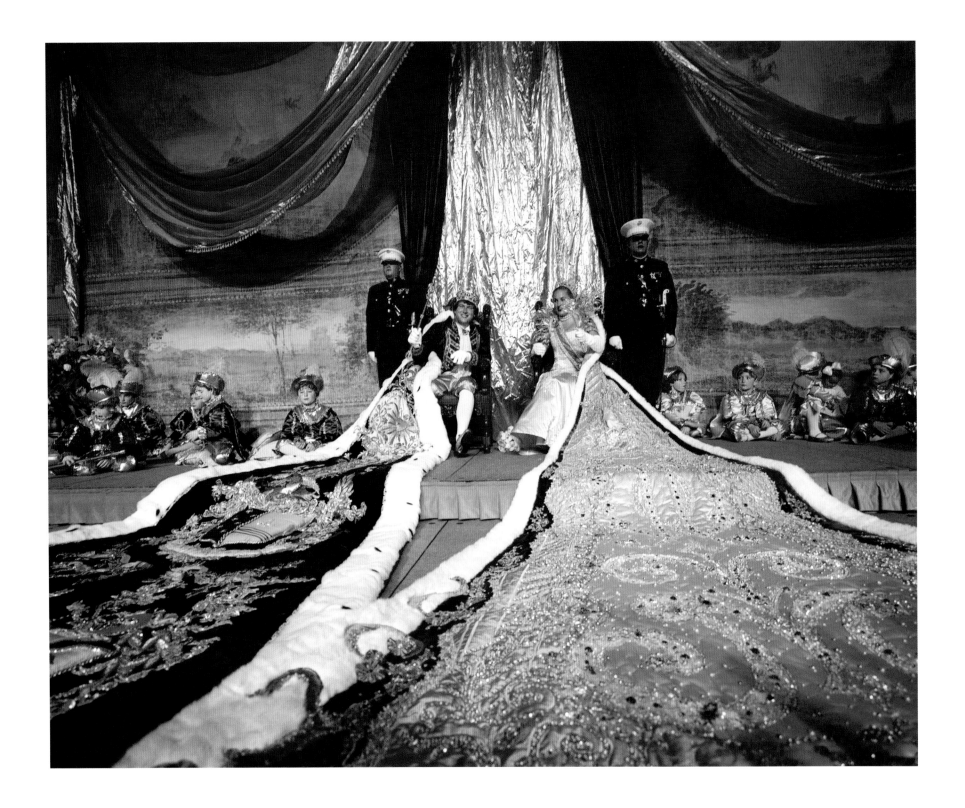

CORONATION OF QUEEN TO KING FELIX III, MOBILE CONVENTION CENTER

devolve into insignificance. A half century after the commencement of public activity in the Alabama civil rights movement, overt racism has become taboo among educated whites and blacks. Contacts between the races in Mobile are far less self-conscious and edgy than even just two or three decades ago. By and large, the two races have learned at last to relax in one another's company. Skin color no longer shouts for politically correct caution and politeness but has begun to be replaced by the vastly more important signatures of education, socioeconomic class, and personal friendships.

Yet there is no avoiding the fact that, with nearly equal numbers of blacks and whites, Mobile is a profoundly biracial city. The two races don't just look different: in great majority, they have different dialects, which in blacks grow stronger when by themselves. Especially among working-class whites, there is still a feeling of unease and suspicion — not toward their personal black friends but toward the generality of African-Americans. Individuals of each race, given a free choice, strongly prefer to socialize with people of their own kind.

"Their own kind," however, has taken on a whole new meaning as the black middle class grows in size and influence. Blacks and whites in the same professions with equivalent education are prone to form more interracial friendships and alliance. Such amity is easier to reach, because the two races are more deeply intertwined in their respective cultures than even they may appreciate. Their forebears were brought together, like it or not, in common suffering during Reconstruction and, for the poor of each race, the terrible long privation of the sharecropper era. They came to Mobile as one force to work in the shipyard and military airfield during World War II. Their children and grandchildren are now rising together in education and socioeconomic status.

The achievements of African-Americans even before the era of civil rights would in any case be hard to ignore. From the beginning of the Deep South three centuries ago, they have inserted into the common culture powerful elements of style and personality. They invented jazz, the blues, and other fundamental innovations of American music. They tested and enhanced a new moral reasoning within organized religion. Their cadences, rhythms, and counterpoint influence white evangelical services.

Increasingly today, they are also enriching science, literature, business, and all other aspects of society.

BIOLOGICAL WEALTH AND NATURAL HERITAGE

There is another unifying entity at work in Mobile, unappreciated by most of its own people. The city sits in the middle of the biologically richest part of North America. From the Ice Age ravine forests of the Red Hills just to the north and thence south to the wetlands, estuary, and oceanfront at the southern rim, the land supports an unsurpassed array of ecosystems. Its inhabitants may seldom see it that way, but Alabama is preeminently an aquatic state. Fresh water flows through it in countless rivers, creeks, and streams. Combined with the warm, shallow Gulf shore waters, the whole contains the greatest diversity of aquatic organisms in America.

The city of Mobile is surrounded by large fragments of the great longleaf pine savanna. At a distance a mature forest, with well-spaced trees bearing explosions of needles on the tips of every branch and giant cones falling heavily to the ground, has the look of a tree farm. But it is vastly more. In a single acre of its ground flora can be found a hundred kinds of shrubs and herbaceous plants or more, many unique to this region and to this habitat. Their endless variety of leaves, roots, and flowers, species upon species, when combined with the sustainability of their existence independent of human help, make them the superior of any human-made garden.

Hard by Mobile is one of the least disturbed and most beautiful of America's wildlands, the delta that lies between the Mobile River on the west and the Tensaw River on the east. Covering more than 500 square miles, this arborescent wetland is one of the largest surviving wildernesses in the eastern United States. The rains fall heavily upon it, keeping its interior as moist as a tropical rain forest and lifting further the overflow of its waterways that wash the roots and bases of its tree trunks. The land of the delta is slightly depressed, causing the flanking rivers to branch repeatedly on their final approach to Mobile Bay. They are the Raft, Apalachee, Spanish, and Blakeley, which in turn flow into and around a complex scattering of bays, the Grand, Chocalata, and others of smaller size, that open into Mobile Bay.

Within its interior the land of the delta is dissected by an intricate lacework of streams, sloughs, and oxbow lakes, edged in places by sand and clay bluffs and clothed in whole by a dense floodplain forest. The word "swamp" often applied to it does this wildland a severe injustice. "Sanctuary" is the better term. It is home to the Florida black bear, bobcat, jaguarundi, bald eagle, Mississippi and swallow-tailed kites, and large congeries of other mammals, birds, turtles, snakes, and salamanders. Cougars are said to have been persistently and consistently sighted. Its aquatic habitats harbor vast arrays of freshwater fish, among which are the rare Gulf and Alabama sturgeons, the paddlefish, and a large assemblage of darters, shiners, and suckers. The delta is a treasure not just for Mobile, only ten minutes drive away, but for Alabama—and all of America.

Scattered through the longleaf savanna all around are little islands of pitcher plant bogs. In species per unit area they are *the richest habitat in North America*.

When I was a teenager, I became marginally familiar with a piece of similar wildland that still existed south of Mobile. It was a time that I rode my bicycle or hiked, out of the city down a two-lane blacktop road to Dog River. At that particular crossing the river was a narrow but deep stream, spanned by a bridge made of crosswise-laid wooden slats. The countryside around was almost empty of houses and people. As best I can recollect, an average of only one or two cars an hour passed by in the late morning hours, crossing the bridge *clackety clackety clackety*. I rested there, peering down into the clear, moving water for sight of wildlife—bream darting back and forth in underwater stands of eelgrass, occasional soft-shelled turtles and gar swimming by to some unknowable destination.

Next, I moved on a quarter mile or so to a dirt road opening to the right and continued on until I crossed the Dog River again, located upstream and this time even narrower than at the highway, and on the other side came to a large, decrepit farmhouse owned by the husband of a relative of mine (second cousin on my father's side once removed, if you are a Southerner and care to know). His family came there only occasionally, most of the time leaving the place to invited transients like myself. The door was never locked, so I'd go in and make myself comfortable, have a cold beer from the refrigerator, and sometimes take a nap on the old porch sofa. Then I'd walk out and

into the scrub pine woods to the rear, searching for butterflies, snakes, and, in fact, any live animal that might be interesting.

I found a pitcher plant bog well back, about half an acre in extent. Like all of its kind, it was not rooted in free-standing water but was just wet and spongy underfoot. From one end to another were the trademark *Sarracenia*, their knee-high "pitchers" consisting of leaves better described as trumpets with curved lips partly covered by flaps. Insects, attracted to the scent of the lips, fall into the hollow of the stem below, then drown in rainwater accumulated at the bottom. The bodies are digested, adding to the nutrients needed by the plants. Pitcher plants, in other words, are carnivorous plants. Their insect meals allow them to thrive in places poor in nutrients.

More than sixty years later, I finally came to appreciate the significance of pitcher plant bogs. It was at Splinter Hill, north of Mobile, in the company of Bill Finch, director of the Mobile Botanical Gardens and one of a select small group of master naturalists of the Gulf states. Pitcher plant bogs in the Mobile area, he pointed out, contain on average twenty species of herbaceous plants per square meter. Yes, that is *per square meter*. The Splinter Hill Bog, an unusually biodiverse example, contains up to sixty species per square meter, possibly a record even for pitcher plant bogs. The collectivity of bogs in the Mobile area harbors as many as 1,500 herbaceous plant species, all limited to wet, nutrient-poor soil. There are to be found hatpins, milkworts, drumheads, and candyroots, among many other distinctive forms, including the extraordinarily beautiful orange-fringed orchid and twenty or more additional orchid species, as well as many species of the distinctive carnivorous pitcher plants and sundews. Some of the plants are circular in overall shape and plastered to the ground. Most send up single thin stems as high as two or three feet. Still others grow as vines that wander among the stems of their neighbors. The great majority present beautiful small flowers at one season or another. The stemmed plants are packed close together. The collectivity resembles a little prairie, sprinkled densely with the strikingly conspicuous tubes and flowers of the *Sarracenia* pitcher plants. The variety of plant life at first sight seems to be infinite.

When I hear the words "Mobile" and "childhood," with no further prompting my mind skips through a scattering of images often coming to linger at one particular place on the Mobile bayfront as it was in the summer of

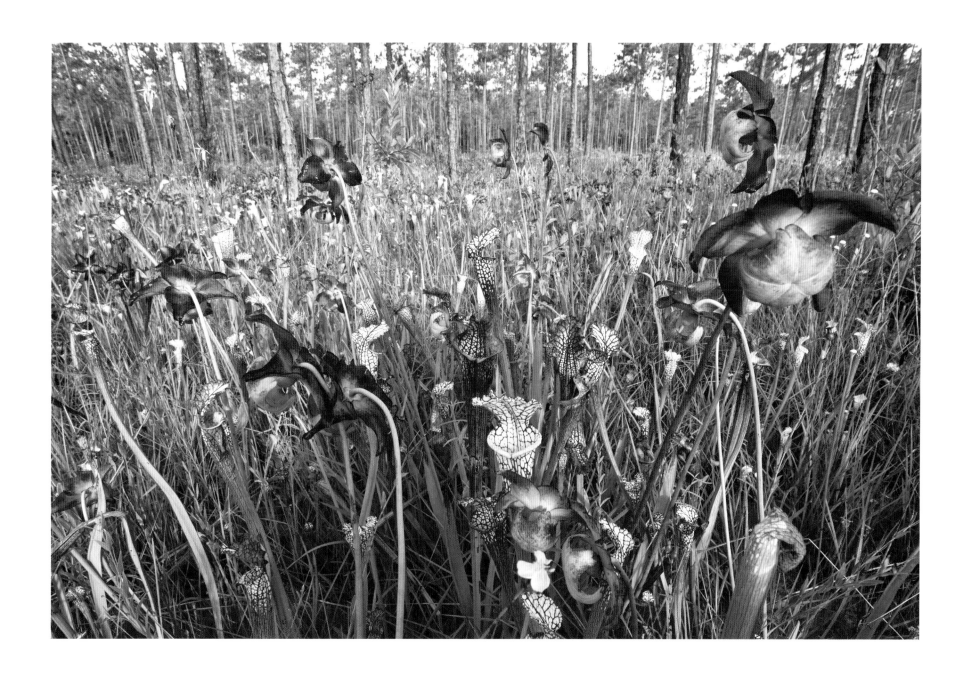

SPLINTER HILL BOG, BALDWIN COUNTY

1942. I picture myself there as a thirteen-year-old, a mile from home as I stand next to what may have been a last remnant of marsh left this close to the center of the city. There is a narrow cut in the reeds that leads to the open bay. In and out of this little space the gray waters move in a slow waveless gyre.

This is the special place of a thirteen-year-old. In the higher ground behind me is a little fragment of abused but still intact second-growth woodland, one or two acres in extent, exactly how much I could not measure. There is a clearing near the center of the plot where tall, hollow-stemmed grasses grow. The twisted, tangled branches of short trees round about have deposited a thin litter of dead leaves and twigs on top of dark, sandy soil.

No one in particular (I assume incorrectly) owns this place. At least I have never seen anyone else come here. The nearest house is a quarter mile inland. That seems to be empty, too. Perhaps my oasis of nature is lost and forgotten. Perhaps I am the only one who cares about it. I hope so. Therefore, in a deeper sense than plot maps and deeds could ever claim, I own it.

There are a profusion of butterflies here—my joy. Some I net for my growing collection: dogface sulfurs, giant and black swallowtails, gulf fritillaries, and snout butterflies. There are tiny ants in grassy patches with bodies that sparkle metallic blue in the sunlight. (I know all their scientific names now, but I won't weary you by writing them.) Colonies of another kind of ant, with cylindrical-headed soldiers, are packed into the tall grass stems of the marsh reeds. I never see them during the day, and, because they are pale-colored, I assume they must come out at night. Bright green anole lizards perch upside down on tree trunks, pumping their dewlaps up and down, emitting red flashes in the daylight, a threat to other males to stay away and an invitation for females to come forward. Rough-scaled fence lizards dart up and out of sight on the tree trunks. Striped skinks dash noisily away from me over open ground, at a distance stop, and watch to see what I'm going to do. I can't catch any, so one day I finally stun one with a slingshot in order to examine it closely.

Another day as I enter my refuge I am almost overwhelmed by a foul odor, classifiable somewhere between feces and a decaying corpse. It turns out to come from a thumb-shaped stinkhorn fungus. This bizarre entity is an unwelcome intruder, covered with slime, and I don't touch it. In later years, I will learn why the smell of the fungus is so disgusting. When ready

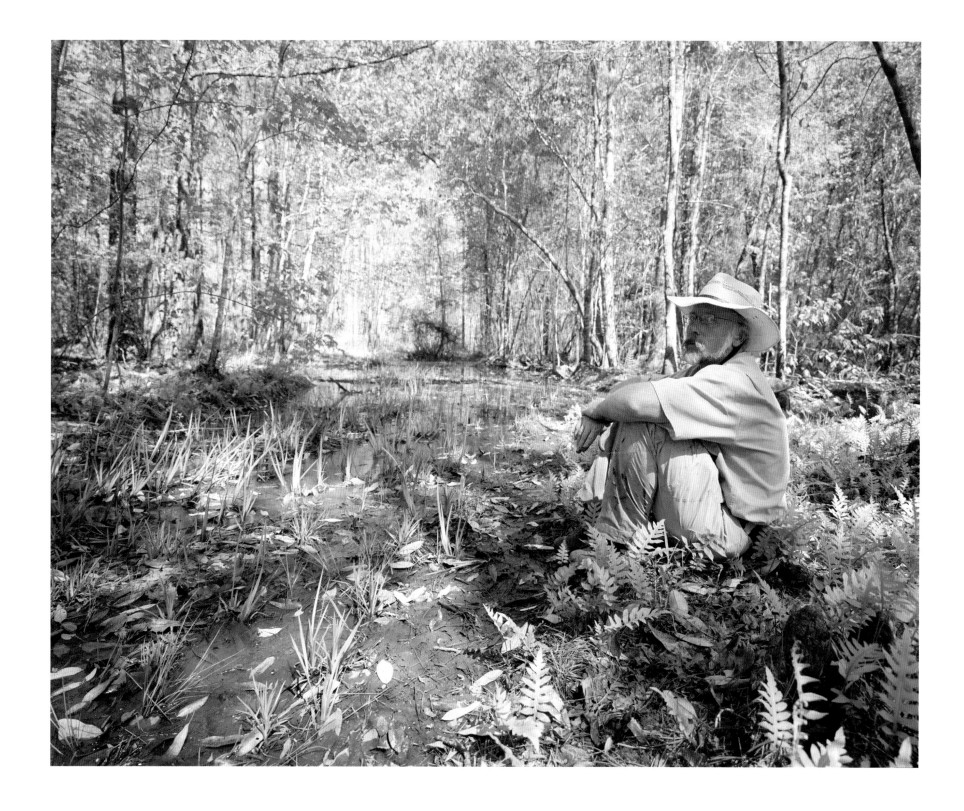

BILL FINCH, DYAS CREEK SWAMP, BALDWIN COUNTY

DALE TURNER ON THE CRESCENT TOWING TUG *NOON WEDNESDAY*, MOBILE RIVER, AND COCHRANE–AFRICATOWN USA BRIDGE

to reproduce, it attracts beetles and flies to scatter its spores, just as a flowering plant uses scent and nectar to attract bees and butterflies, which then inadvertently carry its pollen to other plants.

During another visit, I suffer a serious accident. While cutting my way through dense vegetation with a machete, imagining myself to be a naturalist explorer in the Amazon, I slip and hack my left index finger to the bone just behind the knuckle. I ride my bike calmly home, blood streaming up my arm and off my fingertips. My parents are angry at my carelessness, but thankfully they do not take away my machete. They continue to let me become what I am destined to be, a grown-up naturalist forever searching for places like this.

All around me that summer the municipality of Mobile was growing fast, pressing in on my little reserve and me. Nineteen forty-two was the critical year of America in a great war. The shipyards were racing to reach full production. Brookley Airfield was ratcheting up to becoming a regional military air base. An economic and population boom unseen since the 1830s was overtaking us, as Mobile entered a new era.

The bayside wildland, which I somehow envisioned as immortal, vanished soon thereafter. A few miles further south from the old city, where my father as a boy had walked and hunted rabbits with a .22 rifle, fighter planes and bombers now landed. The population of the city was growing almost faster than the city could handle. It was becoming more diverse in cultures than ever before.

The disappearance of my fragment of wildness was a microcosm of the large changes in the living environment occurring around Mobile. As I grew older and my solitary travels extended farther beyond the city, I came to realize that most of the stream banks and swampy pitcher plant bogs were covered by a damaged forest. By the early twentieth century, all but a tiny fraction of the South's great longleaf pine savanna forest, originally covering 60 percent of the coastal plain and piedmont, had been logged. Now a scrubland of second-growth pine and oak predominated, a desertlike terrain, unbearably dry and forbidding, especially through the long rainless summer months.

Throughout this period, I could at least still look south to the Gulf of Mexico as part of my life and heritage that remained pristine. Then, on April

20, 2010, the Deepwater Horizon oil rig exploded, killing eleven workers. Its decapitated base began to spew up to 2 million gallons of crude oil a day into the Gulf waters. The result was the worst environmental disaster in the history of the United States. The fishing industry and most of the coastal wetlands of Louisiana were soon halted as a result of the spreading oil slick. Mississippi, Alabama, and the Florida panhandle were next in the crosshairs. My friend Lynn Rabren, a filmmaker and guide who lived with his wife and partner, Joanne McDonough, at Alabama's Orange Beach, which was one of the localities east of Louisiana hit hard and early by the spreading oil, wrote to me in the midst of the effort to save the coastal habitats: "It's late. I'm tired. Extraordinary and surreal moments fill these days on the Gulf Coast. The unthinkable is suddenly possible and I'm better being busy. This is personal, paradoxical, and in my backyard."

Tom Meyer, another friend, an outdoorsman, university professor, and naturalist living in Spanish Fort across the bay from Mobile, decided to visit the Grand Bay Wildlife Refuge, part of the wetlands fronting the Gulf. He wanted what he feared would be a last look at the primeval world before the oil arrived. Three weeks later, with Alabama's coast under full assault, he wrote to me about the experience and his widely shared anxiety:

> May 29, I paddled to South Rigolets Island in Grand Bay National Wildlife Refuge on the Alabama/Mississippi line to have a last day in Eden. We were trying to find Diamondback Terrapins before the oil hit. We saw a bald eagle, many ospreys, a plethora of shore birds, rails, willets, redwing blackbirds, terns, gulls, and plovers. Porpoises and Brown Pelicans were feeding offshore. The bayous between South Rigolets and the mainland were thick with redfish tailing and roiling along the marsh edge. We found no Diamondbacks but had a grand time failing. What used to be someone's wharf is now being recycled as an egret perch, courtesy of Katrina. There were absolutely no sheen, oil, tarballs, or oiled birds.
>
> Sadly, Eden was lost within the week. It was good to have seen it before it was gone. Genesis would suggest that Eden was lost because of an apple. This time it was oil.

PERIWINKLE SNAILS ON CORDGRASS, GRAND BAY MARSH

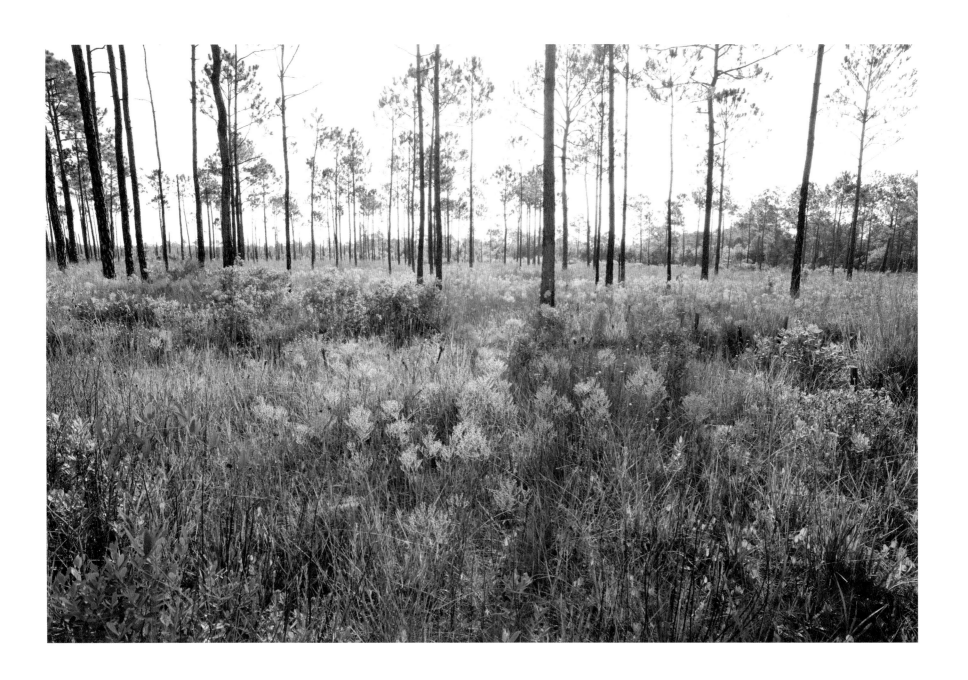

GRAND BAY SAVANNA

Alex Harris and I traveled by boat to Grand Bay three months later. A sheen of oil had indeed touched the edge of the marshes but not penetrated them as in Louisiana. Fragmented layers of heavier oil lay a few feet under the surface a short distance from the shore, damaging to still unknown extent fish and diving birds exposed to them. Eden was damaged but perhaps not destroyed. To this writing two years after the accident, we still have no measure of the oil on the bottom, especially in deeper water, or estimate of the damage it will eventually cause. We all hope that a major hurricane will not strike the central Gulf Coast and throw oil-laden waves onto the shore.

There are still beautiful wild places farther out and all around the city in woodland and on up the rivers and protected bays that have always teemed with the rich flora and fauna of the Gulf Coast. There remains the amazing great floodplain wilderness between the Mobile and Tensaw rivers, scarcely a rifle shot (to use here my final Southern idiom) from Bienville Square. Everywhere that children search there are special places like my own on the shore of Mobile Bay. I know in my heart we will save them in time.

My people are the Mobilians. For the triumphant emergence from depopulation and near extinction in their early history, for the healing of their terrible deep divisions in race and class, for their inborn exuberance, and for the unexcelled magnificence of their living environment, they have retained the better qualities of a tribe. Their cruel seasons have been endured and are now folded into the history of the city. They have a keen sense of place. For those who understand history, there is a special pride and solace in knowing who we are. It arises from a clear vision of why we are here.

Conclusion

BY ALEX HARRIS

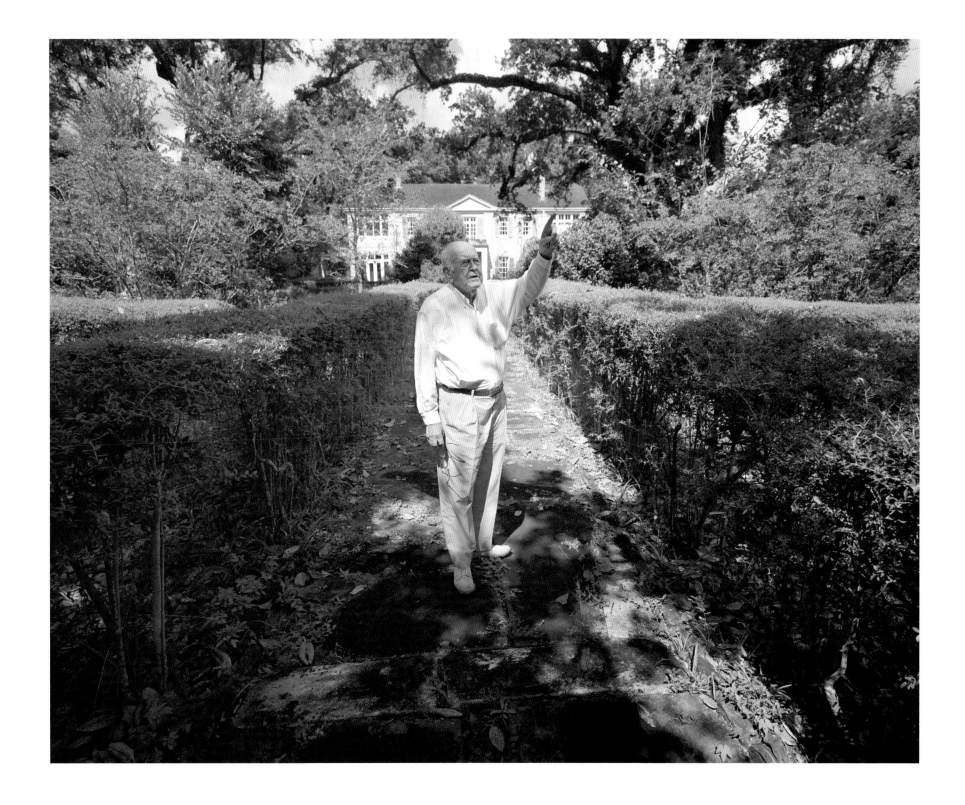

ROBERT HUNTER, SPRING HILL

WILLIE BROWN, DRY KILN SUPERVISOR AT SCOTCH & GULF LUMBER LLC, MOBILE

WRESTLERS TAYLOR JAMES *(LEFT)* AND JACOB VANDEE. *BACKGROUND:* SANDY STIMPSON *(LEFT)* AND BESTOR WARD; *FOREGROUND:* DAN ELCAN. CHOCTAW BLUFF HUNTING CLUB, CLARKE COUNTY

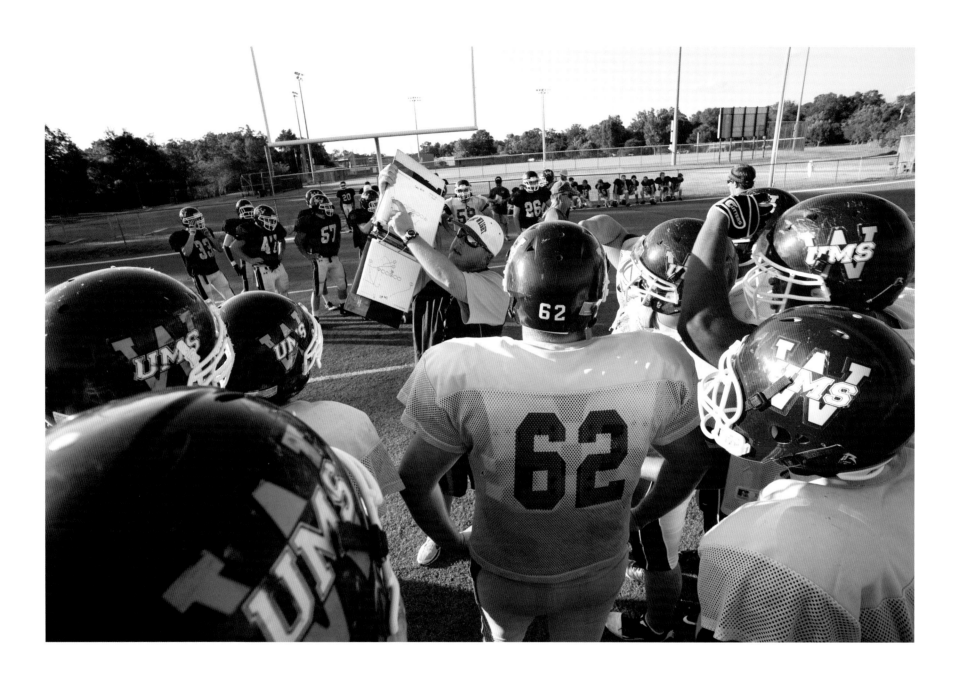

UMS-WRIGHT BULLDOGS FOOTBALL PRACTICE, MOBILE

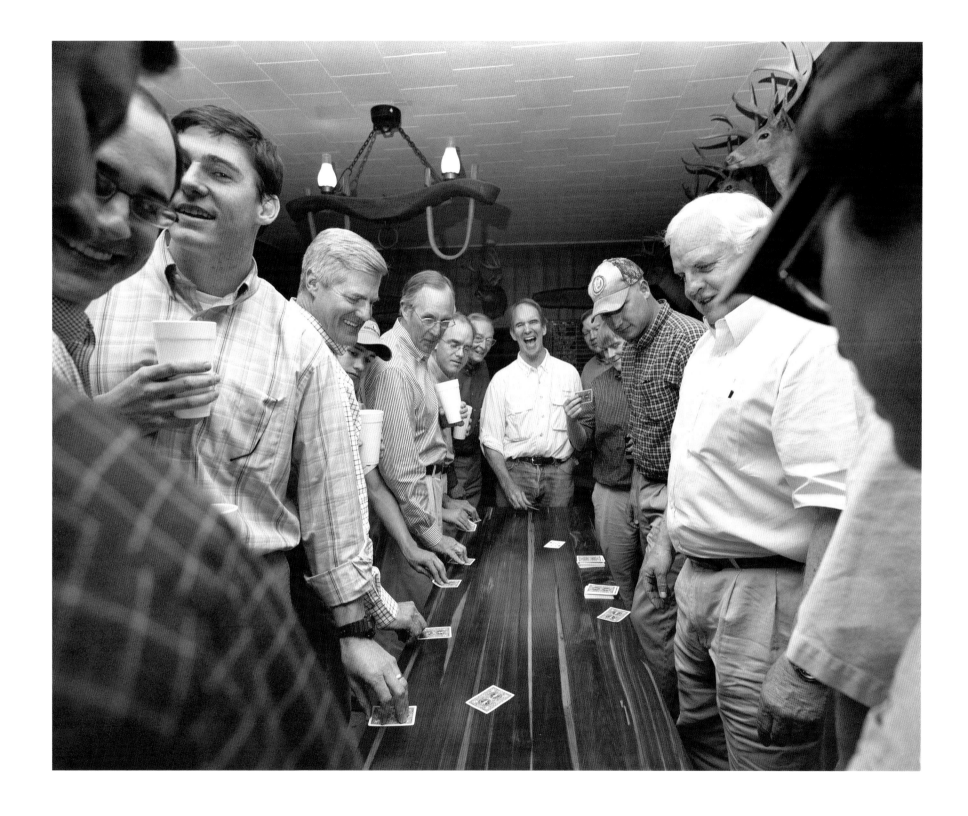

DRAWING CARDS FOR TURKEY-HUNTING TERRITORIES, CHOCTAW BLUFF HUNTING CLUB, CLARKE COUNTY

RETIRED MAJOR GENERAL GARY COOPER, MOBILE

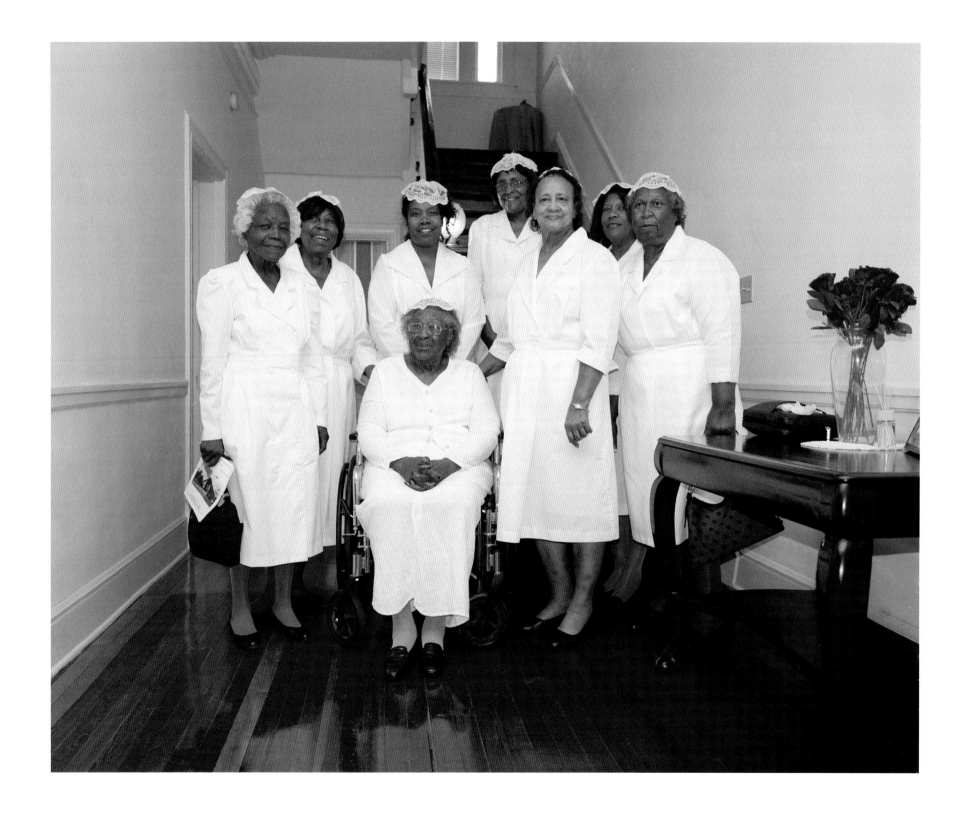

STEWARDESSES FROM STEWART MEMORIAL CHRISTIAN METHODIST CHURCH, MOBILE

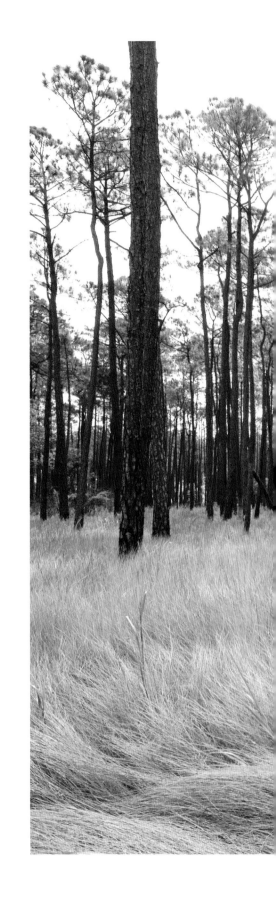

TIDAL SLASH PINE FOREST SURROUNDING THE MARSHES OF GRAND BAY

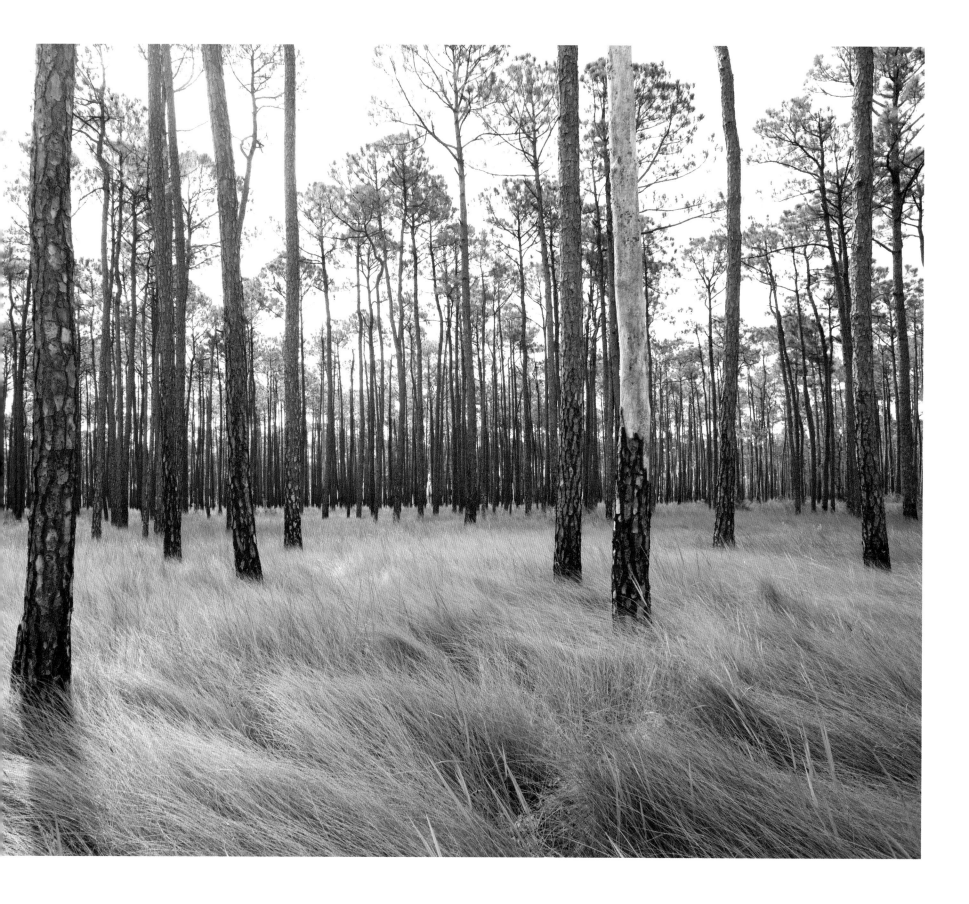

CINNAMON FERN GROWING IN THE TIDAL SLASH PINE FOREST SURROUNDING THE MARSHES OF GRAND BAY

NEW GROWTH AND SKELETONS OF WINTER, ISLANDS OF LITTLE BATEAU BASIN, MOBILE DELTA

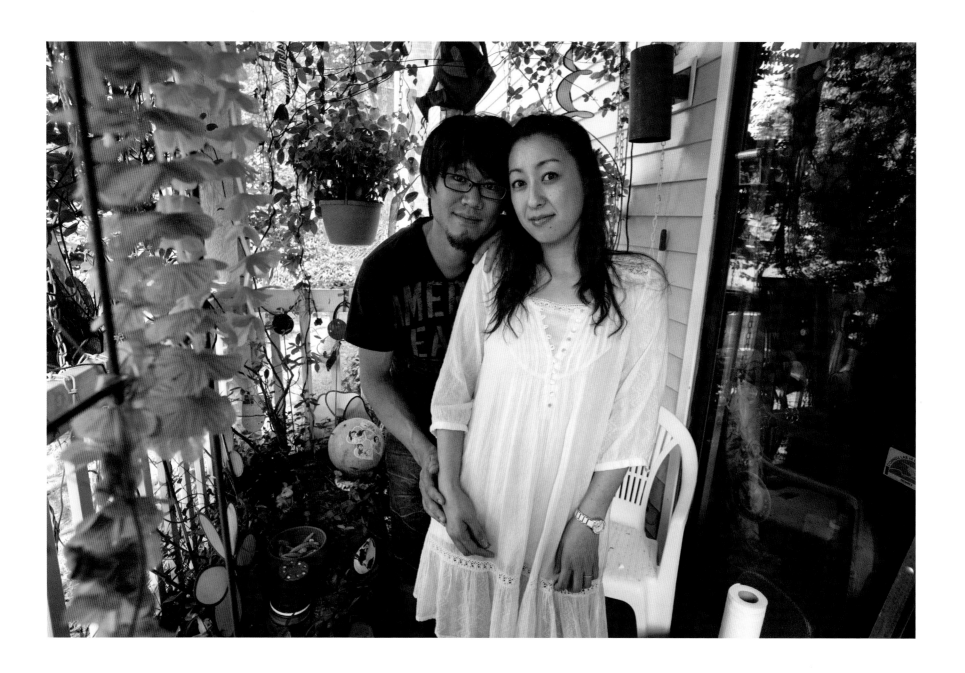

SASAGU AND JUNKO YODA, MOBILE

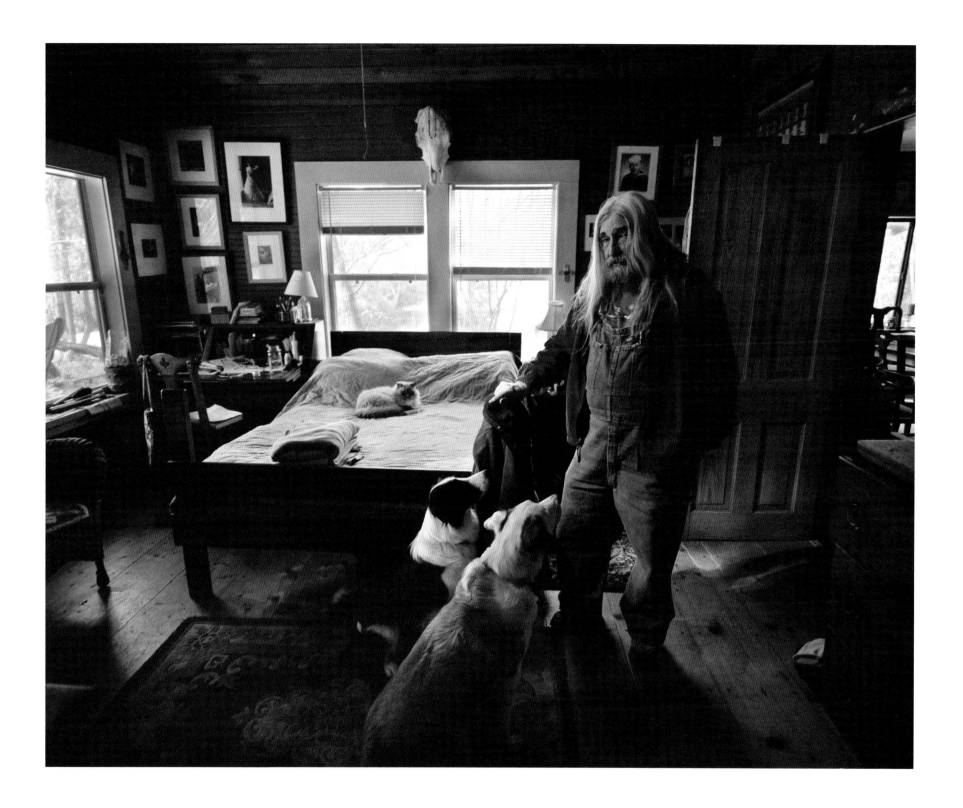

ROY HYDE, FAIRHOPE

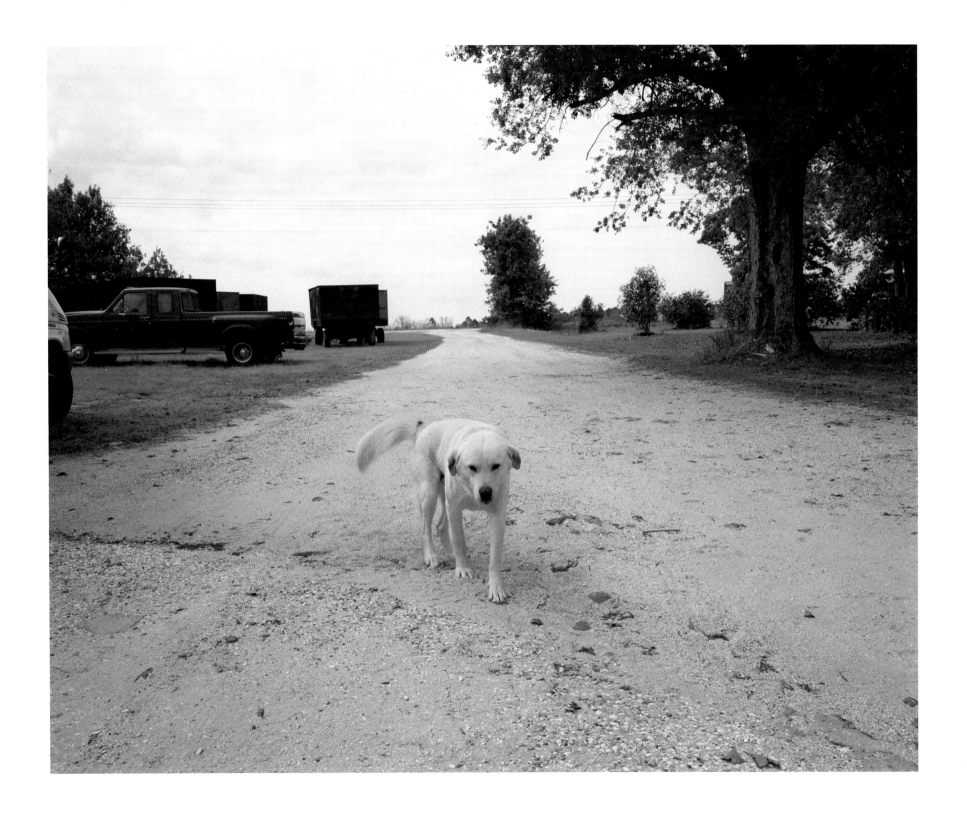

JAMIE FIDDLER'S FARM, FAIRHOPE

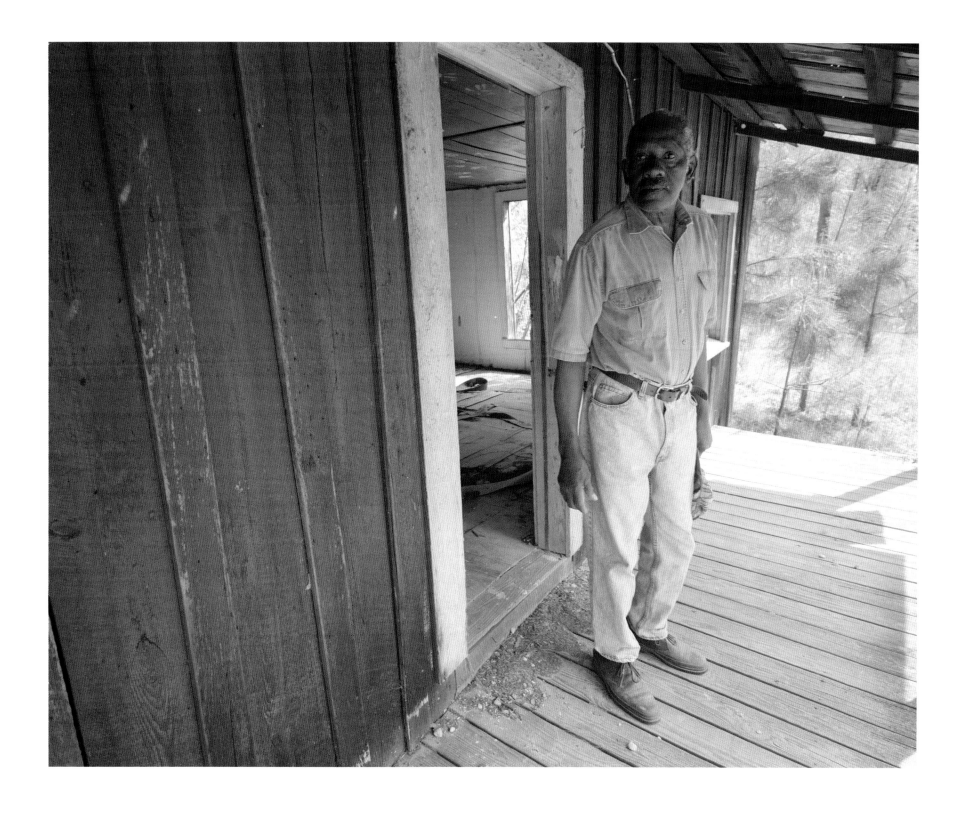

OLIVER "BULLY" JACKSON VISITS HIS CHILDHOOD HOME, CHOCTAW BLUFF, CLARKE COUNTY

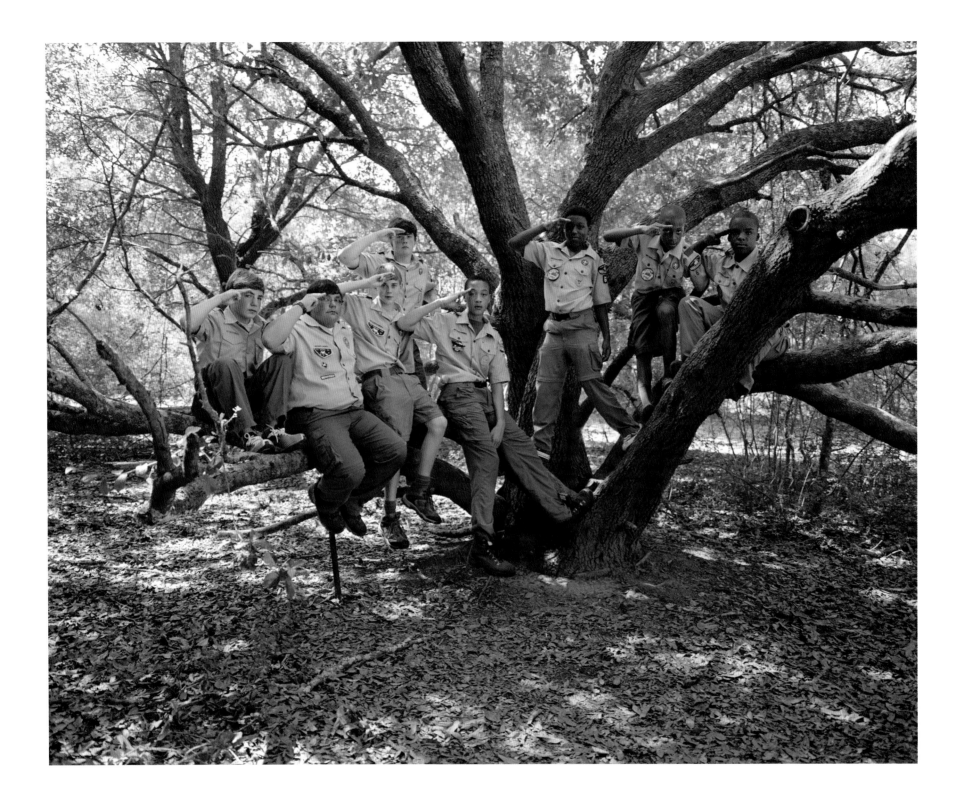

BOY SCOUTS FROM TROOPS 28, 292, AND 600, FIVE RIVERS STATE PARK

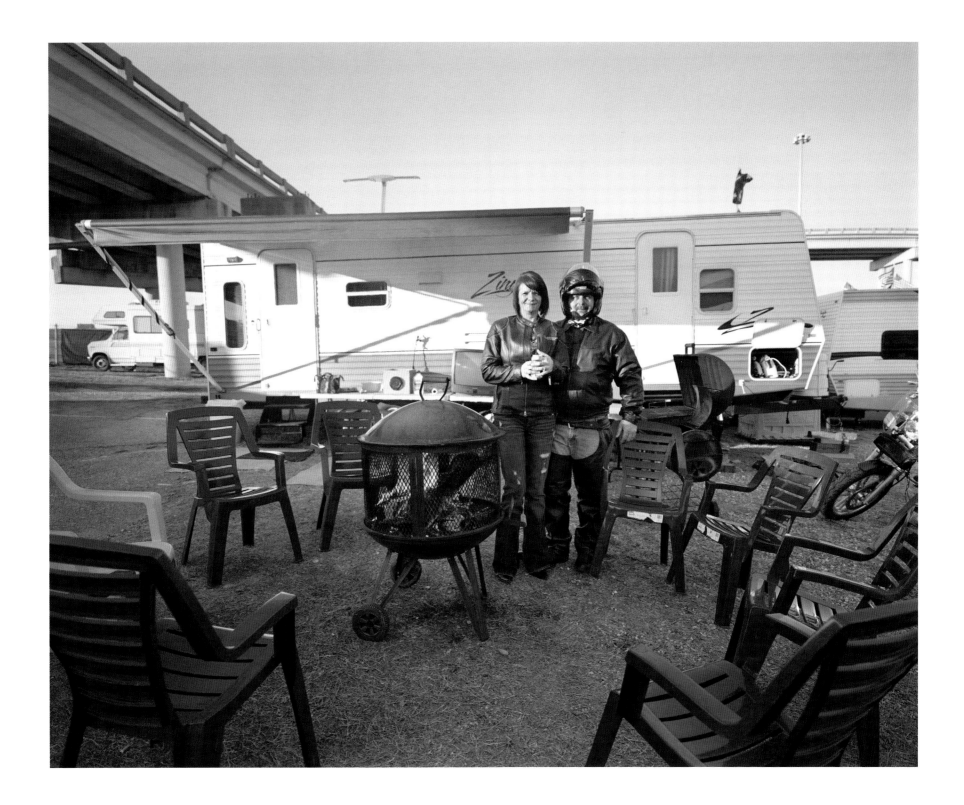

TERRILYNN AND MIKE BENINTENDE, MARDI GRAS CAMP, MOBILE

STAR AND MARTY SINGLETON'S PIER, DAUPHIN ISLAND

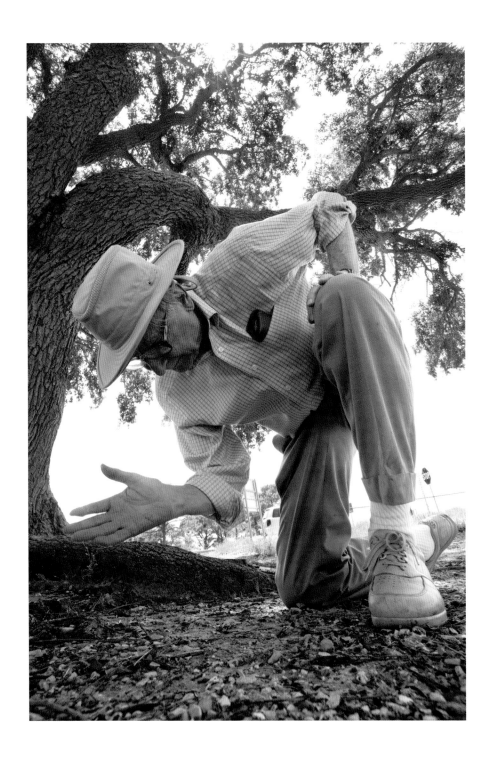

E. O. WILSON LOOKING AT ANTS, FORT MORGAN FERRY, GULF SHORES

Acknowledgments

Before we traveled to Mobile to begin work on this book, several people offered valuable advice on how to approach this project and provided important contacts within the broader community. For their early help we are grateful to Elizabeth and Gary Covan, Becky Florence, Sophie Joel, Mehri McKellar, Gay Outlaw, and Neil Patterson.

We wish to thank the many people who welcomed us to Mobile, supported the idea of this project, and/or agreed to be photographed and interviewed for this book. Among those individuals are: Lenora Ash, Terry Bailey, Rosa Barahona, Terrilyn and Mike Benintende, Willie Brown, George Cunningham, Terry Curtis, Claudette Daphins, Frank Daugherty, Sharon Delchamps, Katherine Dubose, Dan Elean, Stephen Ellison, Jimmy Fidler, Hazel Fournier, William Geiger, Tim Hall, Pete and Thomas Haring, Tony Havard, Robert Hunter, Roy and Allie Hyde, Oliver Jackson, Taylor James, Derrick Juzang, Ronn Lee, Ayanava Majumdar, Ken McGhee, Frank Mitchell, Evelyn Monterrosa, Truat Nguyen, Billy Rice, Joe Ringhoffer, Wayne and Donna Riser, Henry W. Roberts, Jasirus Rox, Walter, Crystal, and Sharon Samples, Brent and Pam Shaver, Francis Sibley, Marty and Star Singleton, John Sledge, Tammy and Riley Smith, William Smith, Emma Buck Ross St. John, Sandy Richard, and Fred Stimpson, Chad Tillman, Kyle Tucker, Dale Turner, Jacob Vandee, Mac Wolcott, and Sasagu and Junko Yoda.

In Mobile, a number of people became especially engaged in the idea of this book and went above and beyond the call of duty, collegiality, or even friendship to help. We give special thanks to Karen and Jim Atchison, Bobbie Bayne, David Cooper, Gary Cooper, John and Charlene Dindo, Estela Dorn, Bill and Vikki Finch, Palmer, Amy, and Lang Hamilton, Ralph Holmes, Russell Ladd, Martin and Gina Lanaux, Jocko Potts, and Sandy Stimpson.

For advice on the texts and photographs, and for suggestions from the most central concepts to the smallest details of the book, we thank: Paula Ehrlich, Eliza Harris, Jay Higginbotham, Margaret Sartor, and George F. Thompson.

An artist's residency for Alex Harris at A Studio in the Woods in New Orleans provided crucial time and an extraordinary atmosphere for reflection and writing. He would like to thank the founders, Joe and Lucianne Carmichael, and the staff and board of A Studio in the Woods. In New Orleans, special thanks also to Lee Ledbetter and Doug Meffert.

We also thank Mark Wilson, Kathryn Braund, and the Alabama Historical Association for the opportunity to present our book as the keynote address to its 2011 annual meeting in Point Clear, Alabama.

At the Mobile Museum of Art we are grateful to the chief curator, Paul Richelson, and the curator of exhibitions, Donan Klooz, for their support of an exhibition of Alex Harris's photographs to coincide with the publication of *Why We Are Here*.

At the Mobile Botanical Gardens we thank Bill Finch for organizing an audio tour of the longleaf pine forest adjacent to the Botanical Gardens as part of the Mobile celebration of the publication of this book.

Finally, we are especially grateful to our team who worked closely with us in putting together this book: David Cain at his map art studio; Julia Druskin at W. W. Norton & Company; Kathleen Horton at Harvard; David Skolkin in Santa Fe, New Mexico; George Thompson at George F. Thompson Publishing in Staunton, Virginia; Bob Weil and Philip Marino at Liveright and W. W. Norton; and Ike Williams at Kneerim & Williams in Boston.

References

The following are principal references used in writing the text of *Why We Are Here*.

EARLY HISTORY

Brown, Ian W., ed. *Bottle Creek: A Pensacola Culture Site in South Alabama*. Tuscaloosa: University of Alabama Press, 2003.

Fabel, Robin F. A. *The Economy of British West Florida, 1763–1783*. Tuscaloosa: University of Alabama Press, 1988.

Muir, John. *A Thousand-Mile Walk to the Gulf*. Boston: Houghton Mifflin, 1916; 1981.

Rea, Robert R. *Major Robert Farmar of Mobile*. Tuscaloosa: University of Alabama Press, 1990.

Thomasen, Michael V. R., ed. *Mobile: The New History of Alabama's First City*. Tuscaloosa: University of Alabama Press, 2001.

Wilson, Edward O. *Naturalist*. Washington, DC: Island Press, 1994.

ENVIRONMENT

Alabama Natural Heritage Program. "The Mobile-Tensaw Delta: A Community Inventory and Classification and Summary of Significant Natural Areas and Biological Elements." Special Report. Mobile, AL: The Nature Conservancy, June 2002.

Earley, Lawrence S. *Looking for Longleaf: The Fall and Rise of an American Forest*. Chapel Hill: University of North Carolina Press, 2004.

Finch, Bill. "Part 1: Delta Discovered," *Mobile Register*, Sunday, Dec. 20, 1998, pp. 3–12.

Phillips, Douglas, and Robert P. Falls, Sr. *Discovering Alabama's Wetlands*. Tuscaloosa: University of Alabama Press, 2002.

Smith, Robert L. *Gone to the Swamp*. R. L. Smith, 2004; distributed by the Stockton, Alabama, Civic Club.

Walker, Sue. *In the Realm of Rivers: Alabama's Mobile-Tensaw Delta*. Montgomery, AL: New-South Books, 2004.

Wilson, Edward O. *Naturalist*. Washington, DC: Island Press, 1994.

Ziebach, Elmo D. *The Second Head of Chocalata*. E. D. Ziebach, 2003.

RECENT HISTORY

Agee, James, and Walker Evans. *Let Us Now Praise Famous Men*. Boston: Houghton Mifflin, 1941.

Bragg, Rick. *The Most They Ever Had*. San Francisco: MacAdam/Cage, 2009.

Brown, Richmond F. *Coastal Encounters: The Transformation of the Gulf South in the Eighteenth Century*. Lincoln: University of Nebraska Press, 2007.

Butler, Broadus N. "Unforgettable Clarence Mathews," *Reader's Digest* (December 1977), pp. 139–42.

Cash, M. J. *The Mind of the South*. New York: Alfred A. Knopf, 1941.

Eichold, Samuel. *Without Malice: The 100th Anniversary of the Comic Cowboys, 1884–1984.* Mobile, AL: R. E. Publications, 1984.

Friend, Jack. *West Wind, Flood Tide: The Battle of Mobile Bay.* Annapolis, MD: Naval Institute Press, 2004.

Gosse, Philip H. *Letters from Alabama (U.S.), Chiefly Relating to Natural History.* London: Morgan & Chase, 1859.

McDonald, Forrest. Prologue in Grady McWhiney, *Cracker Culture: Celtic Ways in the Old South.* Tuscaloosa: University of Alabama Press, 1988.

McWhiney, Grady. *Cracker Culture: Celtic Ways in the Old South.* Tuscaloosa: University of Alabama Press, 1988.

Thomasen, Michael V. R., ed. *Mobile: The New History of Alabama's First City.* Tuscaloosa: University of Alabama Press, 2001.

About the Authors

EDWARD O. WILSON was born in Birmingham, Alabama, in 1929 and was drawn to the natural environment from a young age. After studying evolutionary biology at the University of Alabama in Tuscaloosa, he has spent his career focused on scientific research and teaching, including forty-one years on the faculty of Harvard University. His twenty-five books and more than four hundred mostly technical articles have won him more than a hundred awards in science and letters, including two Pulitzer Prizes, for *On Human Nature* (1979) and, with Bert Hölldobler, *The Ants* (1991); the United States National Medal of Science; the Crafoord Prize, given by the Royal Swedish Academy of Sciences for fields not covered by the Nobel Prize; Japan's International Prize for Biology; the Presidential Medal and Nonino Prize of Italy; and the Franklin Medal of the American Philosophical Society. For his contributions to conservation biology, he has received the Audubon Medal of the National Audubon Society and the Gold Medal of the Worldwide Fund for Nature. Much of his personal and professional life is chronicled in the memoir *Naturalist*, which won the *Los Angeles Times* Book Award in Science in 1995. More recently, Wilson has ventured into fiction, the result being *Anthill*, published in 2010 by W. W. Norton & Company. Still active in field research, writing, and conservation work, Wilson lives with his wife, Irene, in Lexington, Massachusetts.

ALEX HARRIS was born in Atlanta, Georgia, in 1949. He graduated in 1971 from Yale University where he also studied photography with Walker Evans. Harris has photographed for extended periods in Cuba, the Inuit villages of Alaska, the Hispanic villages of northern New Mexico, and across the American South. He has taught at Duke University for more than three decades and is a founder there of the Center for Documentary Photography (1979) and the Center for Documentary Studies (1989). Harris launched *DoubleTake* magazine in 1995 and edited the publication through its first twelve issues. He is currently Professor of the Practice of Public Policy and Documentary Studies at Duke. Harris's awards include a John Simon Guggenheim Memorial Foundation Fellowship in Photography, a Rockefeller Foundation Humanities Fellowship, and a Lyndhurst Prize. His book *River of Traps*, with William deBuys (1990), was a finalist for the Pulitzer Prize in general nonfiction. Harris's work is represented in major photographic collections, including the J. Paul Getty Museum in Los Angeles, the High Museum of Art in Atlanta, the Museum of Modern Art in New York, and the San Francisco Museum of Modern Art. His photographs have been exhibited in numerous museums, including two solo exhibitions at the International Center of Photography in New York City. As a photographer and editor, Harris has published fourteen books, including *The Idea of Cuba* (2007), *Red White Blue and God Bless You* (1992), and *A World Unsuspected: Portraits of Southern Childhood* (1987).

About the Book

Why We Are Here: Mobile and the Spirit of a Southern City is published as part of the relaunch of Liveright, one of the most distinguished literary imprints in the history of American publishing. Robert F. Weil is the editor-in-chief and publishing director of Liveright, a wholly owned division of W. W. Norton & Company. This book was also brought to publication with the editorial assistance of George F. Thompson, of George F. Thompson Publishing (www.gftbooks.com) in Staunton, Virginia, and was designed by David Skolkin, in Santa Fe, New Mexico.

The book was brought to publication in an edition of 7,500 hardbound copies. The text was set in Didot LT with Avener LT display, the paper is Sun Matte art, 150 gsm weight, and the four-color separations, printing, and binding were produced by RRDonnelley Shenzhen.

The book is published in conjunction with an exhibition, *Why We Are Here: Mobile and the Spirit of a Southern City*, at the Mobile Museum of Art, October 5, 2012–January 6, 2013. The book is also published in association with an audio tour of the longleaf pine forest adjacent to the Mobile Botanical Gardens, a documentary project organized by Bill Finch, Botanical Gardens director.

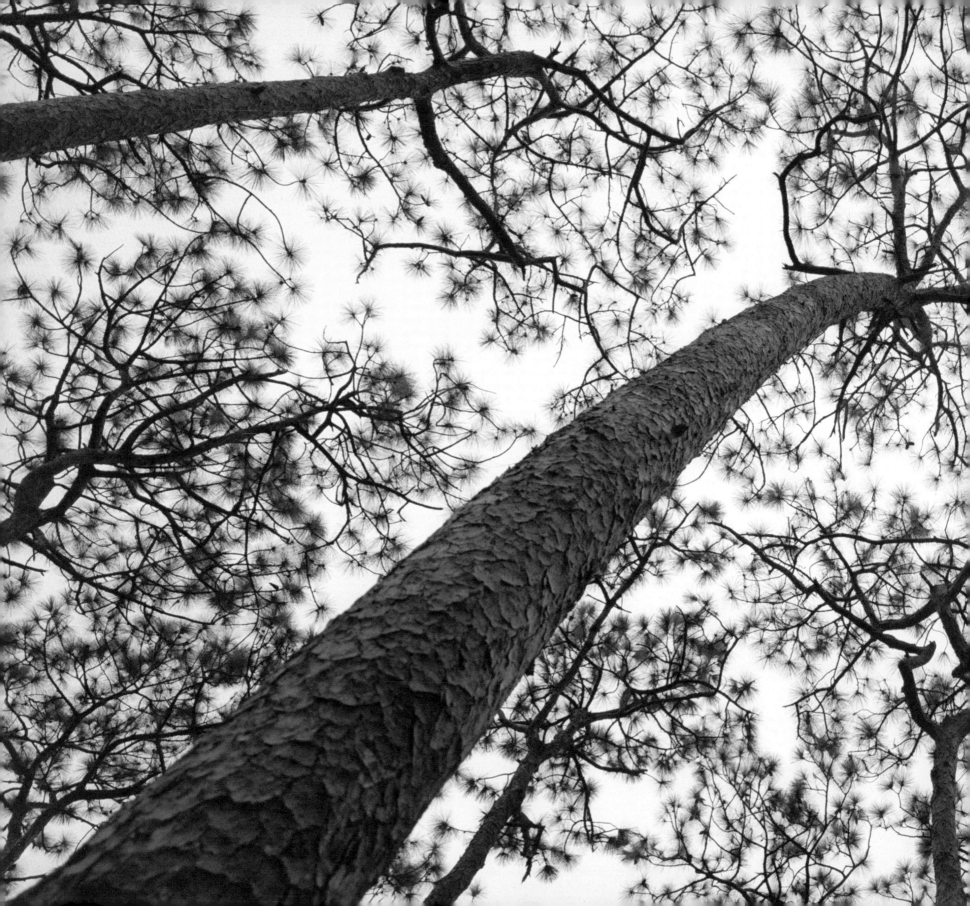